BK11175

WILLEM DE KOONING

If I stretch my arms next to the rest of myself and wonder
where my fingers are—that is all the space I need as a painter. (1951)

Whatever I see becomes my shapes and my condition. (1957)

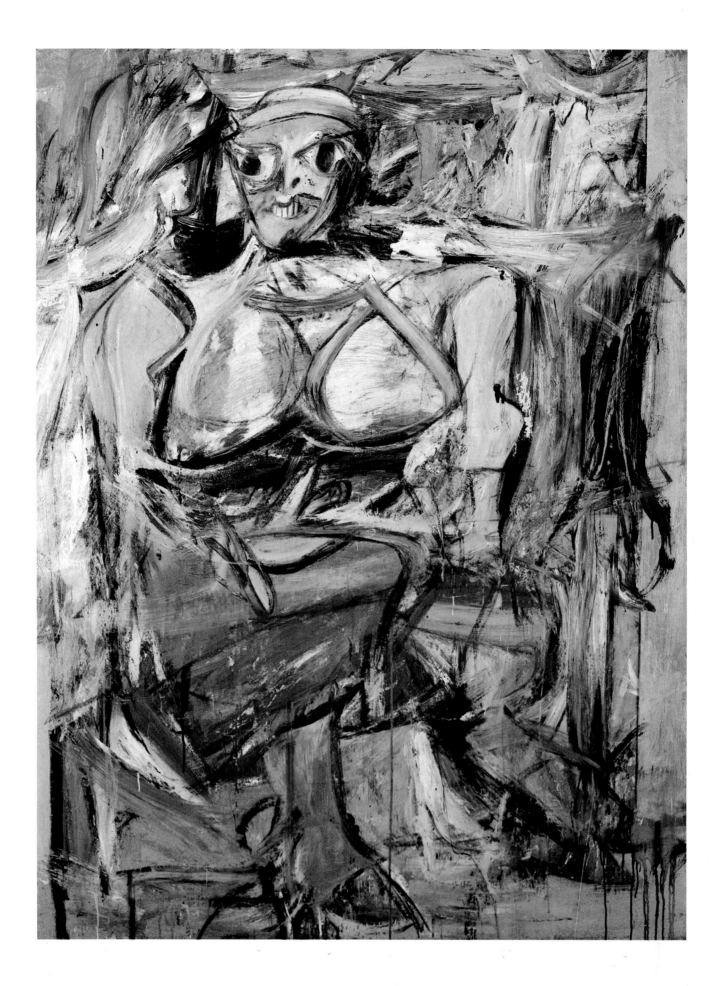

Willem de Kooning

DIANE WALDMAN

THAMES AND HUDSON

Frontispiece:
Woman I, pl. 69

Series Director: Margaret L. Kaplan
Editor: Janet Wilson
Series Designer: Michael Hentges
Designers: Doris Leath, Michael Hentges
Photo Research: Jennifer Bright

First published in Great Britain in 1988 by
Thames and Hudson Ltd, London

Printed and bound in Japan

Contents

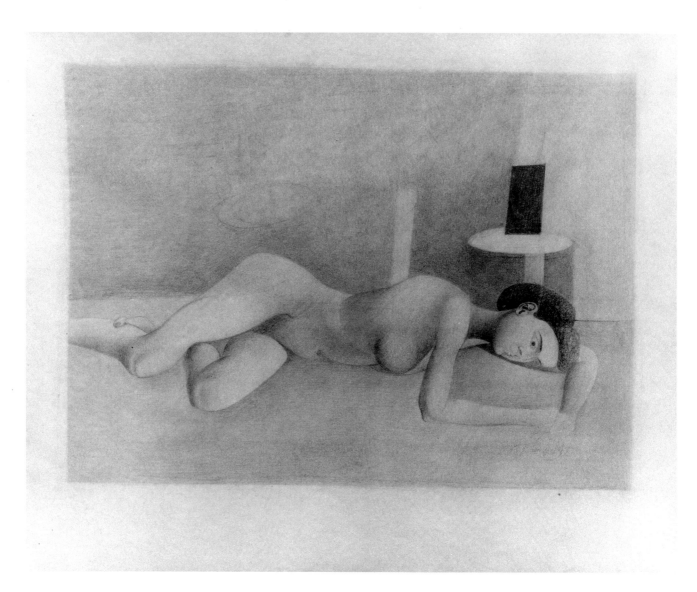

Reclining Nude (Juliet Brauner)

Preface and Acknowledgments

In 1957, when I first entered the art world, Willem de Kooning was *the* painter every young artist wanted to see. In those days the art world centered on Tenth Street in New York City, and it was a common occurrence for young artists to wait for Bill on any given Saturday, in the hope that he would stop by one of the galleries or cooperatives to look at their work and comment on it. He often did. He was open and friendly, his comments were incisive, and his presence was supportive at a time when there was little support or encouragement to be found elsewhere. It is to those memories and that spirit that this book is dedicated.

This monograph on de Kooning's life and work could not have been accomplished without the help of many individuals. I would like to thank Susan Hapgood, Elisabeth Hodermarsky, Sophie Hager Hume, and Jonathan Danziger for their assistance on the manuscript, chronology, biography, and plate captions, Carol Fuerstein for her editorial comments on early versions of the text, and Janet Wilson for her editing of the final manuscript and supplementary material. Thanks are also due to the museums, galleries, and collectors who kindly provided illustrations and documentation for the publication, to Jennifer Bright, photo researcher at Abrams, for her assistance in acquiring photographs, to Michael Hentges, designer at Abrams, and to fellow museum professionals for their insightful comments and advice so thoughtfully and generously given.

DIANE WALDMAN

Reclining Nude (Juliet Brauner),
pl. 36

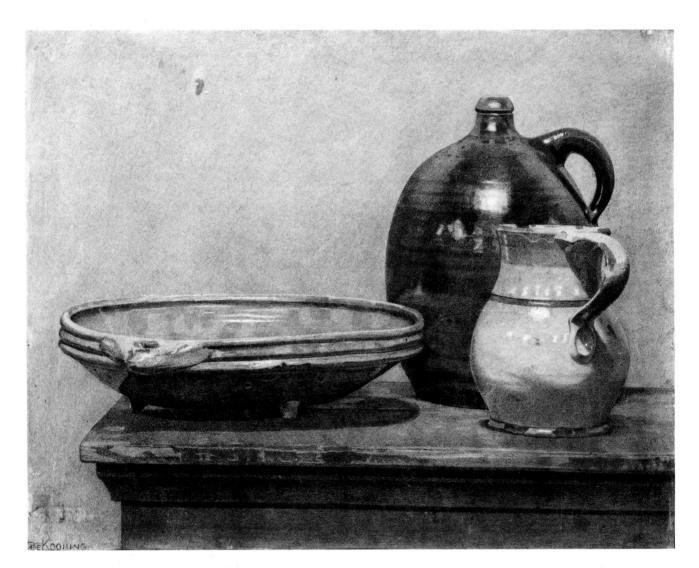

1 *Still Life: Bowl, Pitcher and Jug*

I. From Holland to New York

IN THE HISTORY OF TWENTIETH-CENTURY WESTERN ART CUBISM is unrivaled, not only in its significance as a self-contained movement but also in its impact upon successive styles throughout the world. Among the idioms it influenced was Abstract Expressionism, itself the most crucial movement in modern American art. Abstract Expressionism took shape nearly a half century after the appearance of Cubism, with the emergence of the internationally acclaimed New York School of painting and sculpture. Along with his New York School colleagues Arshile Gorky, Jackson Pollock, Franz Kline, Adolph Gottlieb, Mark Rothko, Barnett Newman, Clyfford Still, and Robert Motherwell, Willem de Kooning pioneered an art that transformed midcentury painting.

If Cubism is the invention of two men, Pablo Picasso and Georges Braque, whose destinies converged for a brief moment, Abstract Expressionism, the idiom of the New York School, was developed by many artists over the course of more than a decade. While Picasso and Braque suppressed their individualities in favor of a shared aesthetic, the painters of the New York School struggled to assert their personal identities. Where Cubism was a magnet that attracted notable artists who elaborated upon its singular style, Abstract Expressionism encompassed a wide range of styles created by a loose association of painters and sculptors of remarkably varied temperaments. Nonetheless, the artists of the New York School shared a common ambition: they saw it as their destiny to forge a new and ambitious role for American art. To accomplish this meant a break with their provincial American past and a realignment with the great European art of the modern era.

Their dream was an inspired one, fought for by a group of artists who succeeded despite the dire circumstances that faced them as well as so many Americans. Their accomplishment was the result of a dramatic shift in perception and attitude that enabled them to assimilate the entire culture of modern art and assume the role of leaders of the avant-garde. De Kooning is both heir to the Cubist tradition and a pivotal figure in the development of the New York School. Thus an understanding of his work enlarges our appreciation of the place of Abstract Expressionism in the history of Western painting.

Acclaimed by critics, admired and emulated by artists, de Kooning's impressive oeuvre spans the better part of the century. Born in Rotterdam on April 24, 1904, he was apprenticed at the age of twelve to Jan and Jaap Gidding, owners of a firm of commercial decorators and artists. With the encouragement of Jaap

1 *Still Life: Bowl, Pitcher and Jug*

c. 1921. Conte crayon and charcoal on paper
19¾ × 25⅜"
The Metropolitan Museum of Art, New York
Purchase, Van Dey Gift, 1983. (1983.436)

This early still-life work reflects de Kooning's academic training at the Rotterdam Academy of Fine Arts and Techniques. Its highly traditional composition, firmly modeled forms, and play of light call to mind well-known Old Master drawings from the artist's native Holland.

Gidding, who felt that the young boy showed exceptional talent, he decided to enroll as a night student at the Rotterdam Academy of Fine Arts and Techniques, where he remained for eight years.

The Dutch system of integrating fine and applied arts imbued in de Kooning a respect for tradition and craft that remains fundamental for his work today. Classes in lettering, perspective, drawing from casts and the model, courses in marbleizing and wood-graining, lectures on art history and theory were among the many disciplines of his academic training. Thomas Hess, in his comprehensive work on the artist, noted: "The issue of originality was never raised because both guild and academy understood that originality is the one thing that cannot be taught. Standards of quality were so obvious that they were irrelevant. . . . The guild tradition of an artist as a man in the world, a part of society, was dominant, and had become reinforced in the 1920's by the brilliant de Stijl group in Holland, which, under the leadership of Mondrian and van Doesburg, agitated for the new creed of the modern artist as a revolutionary social engineer" (Hess, 1968, p. 14).

De Kooning has talked about the Rotterdam Academy and said, in an interview with David Sylvester: "When we went to the Academy—doing painting, decorating, making a living—young artists were not interested in painting *per se*. We used to call that 'good for men with beards.' And the idea of a palette, with colors on it, was rather silly. . . . The idea of being a modern person wasn't really being an artist in the sense of being a painter" (Sylvester, *Location,* 1963, p. 45).

This attitude may have reinforced de Kooning's ambivalence about becoming a full-time painter, a decision he did not make until the mid-1930s. Until that time, he was able to adapt the skills he had learned at the Academy to work as a designer, portraitist, carpenter, and house painter. In 1920 he left the employ of the Giddings to work for Bernard Romein, the art director of a large department store. He continued to attend evening classes at the Academy but became increasingly curious about avant-garde activities both in and outside Holland. In 1924 he and a few friends traveled to Belgium; there he attended classes, visited museums, and supported himself by doing odd jobs. In 1925 he returned to Rotterdam and completed his studies at the Academy, and in 1926 he left Holland for America. After several unsuccessful attempts to emigrate legally, he boarded a ship bound for Newport News, Virginia, was hidden in the crew's quarters, and slipped off when the ship landed. He proceeded to Boston, Rhode Island, and New York, and then to Hoboken, New Jersey, where he stayed at a Dutch seamen's home. De Kooning recounted to Sylvester:

I was here only about three days when I got a job in Hoboken as a house painter. I made nine dollars a day, which was quite a large salary, and after being around four or five months doing that, I started looking for a job doing applied art-work. I made some samples and I was hired immediately. I didn't even ask them the salary because I thought if I made nine dollars a day as a house painter, I would make at least twenty dollars a day being an artist. Then at the end of two weeks, the man gave me twenty-five dollars and I was so astonished I asked him if

that was a day's pay. He said, "No, that's for the whole week." And I immediately quit and went back to house painting (Location, p. 45).

In 1927 de Kooning moved into a studio on West Forty-second Street in Manhattan and supported himself with jobs in commercial art, department-store display for such establishments as A. S. Beck, carpentry, and sign making. Although in Holland he said he was unaware that there were modern artists in America, he quickly discovered the existence of a tradition of avant-garde painting and poetry in the city. Within a few years he met many artists, among them Stuart Davis, John D. Graham, and Gorky. As de Kooning recounted to the art critic Harold Rosenberg, "I was lucky when I came to this country to meet the three smartest guys on the scene: Gorky, Stuart Davis and John Graham. They knew I had my own eyes, but I wasn't always looking in the right direction. I was certainly in need of a helping hand at times" (*Art News*, 1972, p. 54).

The aristocratic Graham, born in Kiev, Russia, was the most urbane and erudite of the three friends. Forced to flee Russia when the counterrevolution failed, he came to New York in 1920, the same year Gorky arrived in America. By the late 1920s, Graham had made several trips to Paris, where he began collecting art. He frequented avant-garde circles in Paris, meeting Picasso, André Breton, André Gide, and Paul Eluard, among others. A very gifted painter in his own right, Graham was important to younger artists in America because of his firsthand knowledge of contemporary European art. Graham's willingness to convey this knowledge to his American colleagues, his ability to formulate current ideas into systematic theory (he published the provocative and influential *System and Dialectics of Art* in 1937), his extraordinary generosity and encouragement of younger men like Gorky, de Kooning, Pollock, and David Smith made him a figure of great consequence in the 1920s and 1930s.

During the 1930s Graham championed Picasso, Karl Marx, and Sigmund Freud, as well as primitive and abstract art. He believed in the unconscious as a source of creativity and in the use of accident and automatism in art. He believed as well in two-dimensional expression, which he called "pure painting." For Graham, two-dimensional expression had develped from Greco-Egyptian and Byzantine art to Paolo Uccello and had culminated in Picasso. Graham's understanding of Picasso and the influence of African art on the Spanish artist's work was addressed in his fascinating and influential article on the subject published in *Magazine of Art* in April, 1937. Graham maintained that artists must evolve through three phases: apprenticeship to the old masters, the confusing search for one's own path, and finally mature resolution.

These ideas, and their reflection in Graham's painting, were of fundamental consequence to Gorky's growth as an artist during the 1930s and of no less importance to de Kooning. While de Kooning did not adhere to Graham's often paradoxical and contradictory program (which Gorky, on the other hand, followed), he did look to him for advice and support. Graham's theories reinforced de Kooning's feelings about the value of craft and tradition while at the same time they emphasized the role of spontaneity, improvisation, and originality.

Whereas the learned and sophisticated Graham was as active a traveler, polemicist, and catalyst as he was a painter, Gorky stood apart as an individual totally dedicated to painting. Gorky and Graham were striking figures: Gorky was tall, darkly handsome, and gaunt, given to wearing a long dashing coat; Graham was slight and dapper, very much the dandy with his neatly trimmed mustache and elegant kid gloves. De Kooning, then as now, downplayed his appearance, preferring workman's clothes. Gorky, born Vosdanik Adoian, adopted a pseudonym, the surname of the famous Russian author Maxim Gorky. Graham, on the other hand, took an American name, reserving only the initial "D" as a reference to his family name, Dombrowski (alternate spellings abound). Gorky's quest for identity led him to assume the name of a famous writer; it also led him to New York. His younger sister Vartoosh recalled: "He went to New York because it was the center of art in America, even though he was not very impressed with America's art, and he felt there they might understand him better" (Karlen Mooradian, "A Sister Recalls: An Interview with Vartoosh Mooradian," *Ararat: A Special Issue on Arshile Gorky*, vol. 12, Fall 1971, p. 15).

Although Graham, de Kooning, and Gorky were very different in origin and appearance, they shared one important bond. As displaced Europeans they were isolated from the rest of their community. All three shared a firsthand knowledge of European art that further distinguished them from their American colleagues. Both de Kooning and Gorky had suffered personal loss, although Gorky's situation was far more tragic. His father had left home when he was still very young; his mother died during a forced march as she, Gorky, and his sister Vartoosh fled Turkish persecution, leaving behind them their home in Armenia. De Kooning's parents divorced when he was only about five. While his father, a wine and beverage distributor to whom the youngster was very attached, gained custody of the child, his mother, who ran a bar, succeeded in reversing the decision and gaining custody. Gorky and de Kooning shared another equally important bond—a facility for drawing which none of their peers could match.

Gorky and de Kooning shared an intense personal dialogue during the 1930s and 1940s. While de Kooning had the advantage of training and technical knowledge, Gorky appears to have had a deeper understanding of what was happening at that time in modern art. As de Kooning has said:

I met a lot of artists—but then I met Gorky. I had some training in Holland, quite a training, the Academy. Gorky didn't have that at all. He came from no place; he came here when he was sixteen, from Tiflis in Georgia, with an Armenian upbringing. And for some mysterious reason, he knew lots more about painting and art—he just knew it by nature—things I was supposed to know and feel and understand—he really did it better. He had an extraordinary gift for hitting the nail on the head; very remarkable. So I immediately attached myself to him and we became very good friends (Sylvester, *Location*, 1963, p. 46).

In the Sylvester interview, de Kooning made an observation on his friendship with Gorky: "It was nice to be foreigners meeting in some new place." Of the two, Gorky was the more charismatic, and for a time de Kooning was thought to

be his follower. Indeed, it was commonly, if incorrectly, assumed that the two shared a studio. Their interests overlapped to such a degree that Hess spoke of a "Picasso-Braque closeness of relationship" (1959, p. 114). In fact, although their ideas were quite similar for a time, their work was still in its formative stages; ultimately both artists developed distinctively different styles.

While Graham's sophisticated approach to art appealed to Gorky and de Kooning and other young painters in New York, it was decidedly out of keeping with the tenor of American art of the period. During the late 1920s and early 1930s American art was dominated by a Regionalism or Social Realism entirely at odds with the advanced art that prevailed in Europe. In America de Kooning and his fellow artists encountered a tradition of representation exemplified by the painting of Thomas Hart Benton, Grant Wood, Reginald Marsh, Ben Shahn, and Philip Evergood. The noble experiments of such early pioneers of vanguard abstraction as Arthur Dove, Georgia O'Keeffe, Marsden Hartley, and Stanton MacDonald-Wright were too challenging to the accepted standards of American art to take root during a period of insularity, uncertainty, and confusion. Indeed, after World War I, Benton (who would be the teacher of Pollock) turned violently against the abstraction he himself had earlier embraced.

While many of de Kooning's colleagues looked upon painting of the thirties as hopelessly provincial, painters of this genre felt that they were creating an art expressive of their era, an art accessible to all Americans. For them, their painting was quintessentially American and free of European "isms." To be sure, a small band of painters, including the Alfred Stieglitz coterie and younger men like Stuart Davis—as well as Josef Albers and Hans Hofmann, Europeans who came to the United States in the early 1930s—continued to work in advanced styles. But the majority of artists here during this period were more concerned with depicting life as it existed—whether it meant depicting the mean life of the downtrodden urban masses or extolling the virtues of rural life—than they were with celebrating the triumphant new values of avant-garde painting. Thus American painting of the 1920s and 1930s was dominated by a socially and politically expressive art, while in its midst a small group of painters and sculptors, de Kooning among them, continued to search for a new imagery inspired by the European modernists of the early twentieth century.

Assessments of the impact of the Depression on progressive artists vary. For Gorky, the 1930s were a time of despair. As Agnes Gorky Phillips, the artist's widow, noted: "Gorky described it as the bleakest, most spirit-crushing period of his life and spoke with bitterness of the futility of such paralyzing poverty for the artist. Towards the end of the 30s, he felt a terrible isolation which no amount of subsequent friendliness on the part of the Surrealists or anyone else could eradicate. He often said that, if a human being managed to emerge from such a period, it could not be as a whole man and that there was no recovery from the blows and wounds of such a struggle to survive" (Patricia Passloff, ed., *The 30s: Painting in New York*, 1957, n.p.). The poet Edwin Denby noted: "At one party [at de Kooning's studio] the talk turned to the condition of the painter in America, the bitterness and unfairness of his poverty and disregard. People had a great deal to

say on the subject and they said it, but the talk ended in gloomy silence. In the pause, Gorky's deep voice came from under a table, 'Nineteen miserable years have I lived in America.' Everybody burst out laughing" (Passloff, n.p.). Nevertheless, during the 1930s, as he had before, Gorky managed to put painting ahead of all else, often going without food to buy materials.

Gorky's perceptions and the desperate economic conditions of the period notwithstanding, the 1930s were in many ways a positive time for artists. Abysmal conditions impelled them to band together into protective associations. Stuart Davis and painters of the generation of de Kooning and Gorky were deeply involved with both radical politics and artists' groups. Although de Kooning and Gorky participated in the militant Artists' Union, formed in New York in 1934, neither was as engaged as their more radical colleagues. They were, however, united with them in their protest against the existing economic and social conditions of the time and the prevailing conservative tradition in art. They were united as well by bonds of friendship and good fellowship. As Tom Hess noted:

The Depression years usually are considered the bleak, sad time in modern American history—and in the arts, which were dominated by regionalism and Social Realism. For older people, it was harsh indeed: they had lost their money, their sense of being able to cope with life, their belief in themselves and in the future. It was equally painful for children who watched their parents mourn for lost businesses, worry about the next month's rent, talk endlessly about money. But for the young men and women of the decade, especially the artists, writers, and their friends, it was a tremendously gay period. The whole question of money suddenly disappeared and everybody could do as he pleased. David Smith told me that parties were never as wonderful as in the 1930's, when everyone chipped in for whisky and all the girls were beautiful. De Kooning and Gorky, both violent anti-Stalinists, cheerfully built May Day floats for the Party on the orders of Stuart Davis, whom they revered as the senior American modernist. Harold Rosenberg remembers demonstration parades for the Workers; contingents of artists carried cardboard palettes, writers brandished big cardboard pens, one young writer carried a sign proclaiming "WE WANT BON-VIVANT JOBS!" In this ebullient atmosphere, New York painters and sculptors laid the framework for their social milieu (Hess, 1968, p. 18).

The federal government art project, the Works Progress Administration (W.P.A.), begun in 1935, for which both Gorky and de Kooning worked in the mural division, was an important force for progressive artists, both intellectually and materially. The W.P.A. engendered a sense of common cause among advanced artists who worked under its aegis and were largely isolated from conservative American society. Although the murals that Gorky and de Kooning executed for the W.P.A. did not crucially influence their great later work, the project itself marked important turning points in both their lives. For Gorky, it provided the first period of near continuous employment he had ever enjoyed. De Kooning has said that the income derived from the W.P.A. was enough to stabilize him, providing for his studio rent, art supplies, and food. The project allowed him to devote all of his energies to painting for the first time. Although he had to resign from the W.P.A. after a brief tenure because he was an alien, de

Kooning has noted, "…even the year I was on gave me such a terrific feeling that I gave up painting on the side and took a different attitude. After the Project I decided to paint and do odd jobs on the side. The situation was the same, but I had a different attitude" (Sandler, Hess, 1968, fn. 4).

The varied commentaries of witnesses to the period make it clear that despite grinding poverty the 1930s were a liberating time for many artists. By the mid-1930s, the feeling of isolation was beginning to lessen in intensity. Many artists frequented late-night cafeterias, meeting over coffee to discuss the most heated issues of the day. For de Kooning it was Stewart's on Twenty-third Street and Seventh Avenue, where, as Denby recalled, "…Rudy Burckhardt and I kept meeting Bill at midnight…and having a cup of coffee together. Friends of his often showed up, and when the cafeteria closed we would go to Bill's loft in the next street and talk some more and make coffee…." (Denby, "The Thirties," in Passloff, n.p.).

The spirit of camaraderie that had been fostered by artists' groups and the W.P.A. brought together people of very different backgrounds and temperaments who might otherwise never have become friends. Most of the artists de Kooning knew at this time were, like him, at unresolved stages in their development. Their limited resources, their need for community, their desire for change led to friendship. They exhibited together, went to shows together, drank together, fought with each other, picketed, protested, and struggled for greatness. They admired the work of Paul Klee and Joan Miró well before these artists were accepted in Paris, went to see Kandinsky's work at the Museum of Non-Objective Painting, and were especially impressed with the Picassos reproduced in the French art journal *Cahiers d'Art*. Unimpeded by consideration of the material aspects of their careers—there were few sales and few exhibitions—they were able to focus on art in the purest sense in an unending series of discussions. From these discussions there emerged a significant dialogue and a consensus about the fundamental issues in the art of the time. This dialogue, which extended into the 1950s, stimulated the development of every major artist among the Abstract Expressionists who achieved a mature style during the late 1940s and early 1950s.

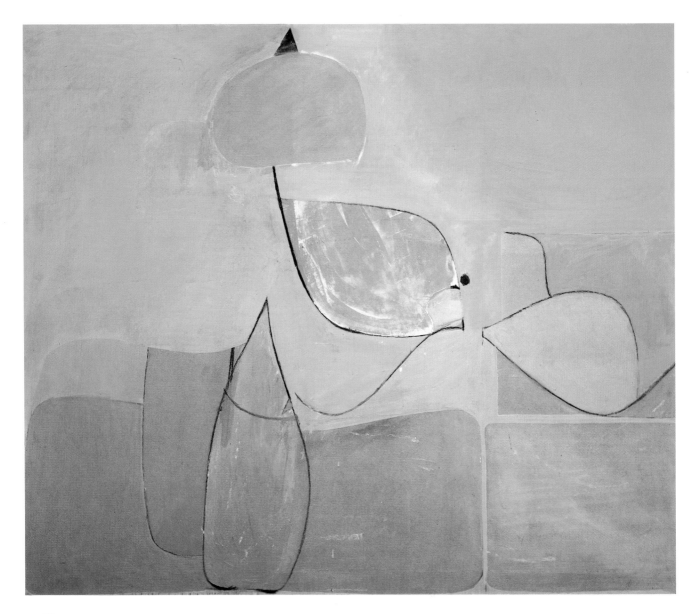

2 *Elegy*

II. Early Sources of Inspiration

Little of de Kooning's work from his youth in Rotterdam and early years in New York survives. Nonetheless, it is possible to make certain assessments about his early development. The best known of his paintings of the 1920s is a fascinating still life executed when he was a student in Holland. Like his other extant work of this initial period, *Still Life: Bowl, Pitcher and Jug*, c. 1921 (pl. 1), reflects the young painter's academic training in its traditional still-life arrangement and solidly rendered forms. Yet de Kooning's predilection for figure-ground relationships, shallow space, balanced asymmetry, and his awareness of light, line, and shape are already evident in this early student work.

From his own testimony we know that during the 1920s in Holland de Kooning admired the de Stijl group, Frank Lloyd Wright (a major influence on the de Stijl architects), and the Parisian modernists. Tom Hess has noted that the young artist experimented with a wide variety of styles in America in the late 1920s, and that he was influenced by Miró and Mondrian, Mexican Social Realism and the perspective of Giorgio de Chirico. Highly decorative paintings of 1927 (pl. 3) attest to de Kooning's admiration for Henri Matisse, whose work he saw in some depth at an exhibition at the Dudensing Gallery in New York in 1927 (he particularly admired *The Moroccans*, 1915–16, and Matisse's use of cobalt violet).

De Kooning's abstractions of the 1930s are based on simple organic forms disposed in shallow space. The forms are reminiscent of those of Miró, whose works he would have seen in New York beginning in 1927, while the space, which is divided into a series of shallow planes, recalls the gridded space devised by Mondrian and, before him, Picasso. De Kooning alternated between framing his shapes within fairly pronounced compartments (see, for example, *Untitled*, c. 1931, pl. 4) or allowing them to float freely in the field (*Elegy*, c. 1939, pl. 2).

In *Untitled* he divides the canvas into three compartments: the one to the left contains a simple band of color that is aligned to the canvas edge; the two other, wider compartments contain a series of parallelograms and one or more elliptical shapes. Working with a relatively simple format, de Kooning establishes a complex interplay of contrasting forms and vivid colors within an active, if indeterminate, space. In telescoping large and small forms and playing primary and secondary hues against each other, de Kooning creates an optical illusion that would be the envy of many artists working in a similar area in the 1960s. Here, however, de Kooning masters the illusion of a perceptible if shallow space by the

2 *Elegy*

c. 1939. Oil and charcoal on composition board
40¼ × 47⅞"
Collection Courtney and Steven J. Ross

Despite its rather evocative title and biomorphic forms, the subject of this work is virtually abstract. Like many of de Kooning's works of the 1940s, Elegy, *with its superb handling of line and color harmonies, has an air of playfulness and lyricism reminiscent of Miró.*

3 *Still Life*

1927. Oil on canvas, 32⅛ × 24″
Collection of the artist

During the 1920s de Kooning experimented with various artists' styles. His romance with Matisse's work—its composition and most importantly its color—dates from 1927 when he saw a Matisse show at the Dudensing Gallery. Matisse's painterliness and his devotion to color and shape continued to play an important role in de Kooning's development throughout the 1930s and 1940s.

EARLY SOURCES OF INSPIRATION

4 *Untitled*

c. 1931. Oil on canvas, 23⅞ × 33″
Collection of the artist

In this vivid abstract composition de Kooning's ubiquitous ovoids, now joined by parallelograms, float in an indeterminate space. The Mondrianesque division of the composition into bands of color serves both to develop and controvert a feeling of believable space. It would become an important compositional technique in de Kooning's later work of the 1930s and 1940s.

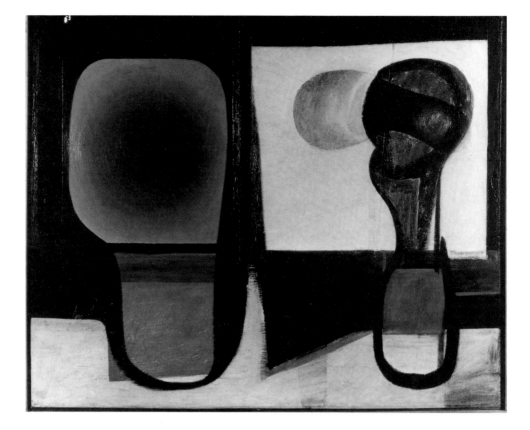

5 Untitled

c. 1934. Oil on canvas, 36 × 45⅛″
Private Collection

In this work of the mid-1930s de Kooning continues to investigate the styles of other artists. With its Arp-like biomorphic shapes in a de Chirico-inspired stage space, this composition suggests de Kooning's shift from representing objective reality toward a more nonobjective composition. The work—one of his few still lifes of the period—also illustrates de Kooning's closeness to Gorky at this time.

6 Arshile Gorky
Nighttime, Enigma and Nostalgia

1934. Oil on canvas, 36 × 48″
Present whereabouts unknown

Gorky's "Nighttime, Enigma and Nostalgia" series of drawings, begun in 1931, are among his most accomplished works of the period. Although they are stylistically indebted to de Chirico, Picasso, and Arp, in this culminating work on canvas the style is clearly Gorky's own. Nighttime, Enigma and Nostalgia has a compelling presence and is filled with elements that mark it as an important precursor of Gorky's late style.

way in which he disperses his bands of color across the picture plane. While de Kooning goes to some lengths to minimize his superb skills as a draftsman, he demonstrates his extraordinary facility by the way in which he manipulates line, color, and form. In this small early reductive painting de Kooning has very neatly summarized Mondrian's rigorous structure, incorporated Matisse's color harmonies and painterliness, and created an awesome little painting whose spatial configuration anticipates Barnett Newman's paintings of the late 1940s.

In other paintings, such as *Untitled*, c. 1934 (pl. 5), de Kooning again demonstrates his highly developed sense of organization. He appears once more to have been inspired by the simplicity of Mondrian's spatial arrangements and by aspects of Gorky's roughly contemporary work, in particular his exquisite "Nighttime, Enigma and Nostalgia" series (see pl. 6). The schematic structure and compartmentalized figures of Gorky's series undoubtedly provided a precedent for de Kooning. Moreover, de Kooning, like Gorky, has adapted de Chirico's drama and play of light and shade and the sculptural volumes of Picasso's and Jean Arp's biomorphic forms.

Unlike Gorky, who often made use of de Chirico's rapidly diminishing perspective to create the illusion of vast space, de Kooning keeps his forms flat, heavily outlined, and locked into the picture plane. Moreover, the lush eroticism of the Gorky sequence, which originates in its tactile surfaces and obsessional imagery, finds no echo in de Kooning's placid work of the period. Nor is there any suggestion at this stage of the sexual aggressiveness that was to inform de Kooning's notorious Women of the 1950s. The Surrealist tide, with its profoundly erotic

7 *Untitled*

c. 1935. Gouache on paper, 6¾ × 13¾"
Collection of Whitney Museum of American Art
Purchase, with funds from Frances and
Sydney Lewis. (77.34)

8 *Study for mural in the
Williamsburg Housing Project
Social Room, Brooklyn*

1935. W.P.A. Project
Archives of American Art
Smithsonian Institution, Washington, D.C.

*In August, 1935, de Kooning was hired,
along with his friend Gorky, to work in the
Mural Division of the newly established
W.P.A. Federal Art Project. These studies
document de Kooning's designs for a mu-
ral for a Williamsburg housing project,
which was never executed. De Kooning
has remarked that the one year he spent on
the project offered him the financial stabil-
ity to devote himself to art for the first time.
He was forced to leave the project after one
year since he was not a U.S. citizen, but the
experience encouraged him to become a
full-time artist. Like other works of this pe-
riod, these are filled with biomorphic
shapes framed in an architectonic space.*

content, which deeply affected Picasso, Miró, and other established masters, as
well as fledgling artists such as Gorky, had little impact upon de Kooning at this
time.

De Kooning made several incursions into the realm of mural painting in the
mid-1930s. In August, 1935, he and Gorky were hired to work on the newly es-
tablished Works Progress Administration/Federal Art Project under the direc-
torship of Holger Cahill. Both were assigned to the mural project supervised by
Burgoyne Diller. Between that August and July of 1937 Gorky executed a monu-
mental series of murals entitled "Aviation: Evolution of Forms Under Aerody-
namic Limitations," which ultimately was installed at Newark Airport. During

9 Arshile Gorky
*Study for a mural for
Administration Building,
Newark Airport, New Jersey*

1935–36. Gouache on paper, 13⅜ × 29⅞″
Extended loan to The Museum of Modern Art,
New York, from the United States
W.P.A. Art Program

*This gouache is one of the few studies that
exist for Gorky's ten-panel W.P.A. New-
ark Airport mural series. It is evident that
Gorky integrated Fernand Léger's simul-
taneous depiction of flat shapes and mod-
eled forms with elements derived from
Stuart Davis' roughly contemporaneous
"Egg Beater" motifs. Though the space
of the study is primarily compressed and
flat, it is nevertheless full of implied
movement.*

the year he worked for the W.P.A., de Kooning was involved with a proposed mural for the Williamsburg Federal Housing Project in Brooklyn, New York. The mural was never executed, but an untitled study, one of three, c. 1935, and photo documentation of other preliminary studies survive (pls. 7, 8).

The small study in gouache and pencil on paper is similar in certain respects to Gorky's studies for his Newark mural, in particular the *Study for a mural for Administration Building, Newark Airport, New Jersey,* 1935–36 (pl. 9). In de Kooning's study, ovoid shapes, reminiscent of the forms of Miró and Arp, are set off by rectangular frames and disposed in shallow space. While de Kooning's composition emphasizes flatness and stasis, the Gorky under consideration here, like his other mural studies and the murals themselves, is full of suggested movement. For the urban technological theme of the murals Gorky used as his models Stuart Davis' "Egg Beater" paintings and gouaches and related work of the late 1920s, as well as Amédée Ozenfant's Purist still lifes. But above all he was inspired by Fernand Léger, specifically by the French Cubist's images of *The City,* 1919. In Léger's urban imagery, machine forms, and vivid colors Gorky found the true precursor for his own compositions.

De Kooning's studies indicate that while he was fully aware of Gorky's work on the project and incorporated features of Gorky's designs into his own compositions, he had no clear antecedent for his own designs. De Kooning's studies also reflect his knowledge of Gorky's paintings of the period, such as *Organization,* c. 1933–36 (pl. 10), which are themselves clearly modeled after Picasso's studio interiors of 1927–28 or such Picassos as *The Studio,* 1927–28 (pl. 11), which could be seen at the Valentine Gallery.

Like Gorky, de Kooning has used the spare geometry of Picasso's composition; here, however, in isolating and separating his forms, he has introduced a

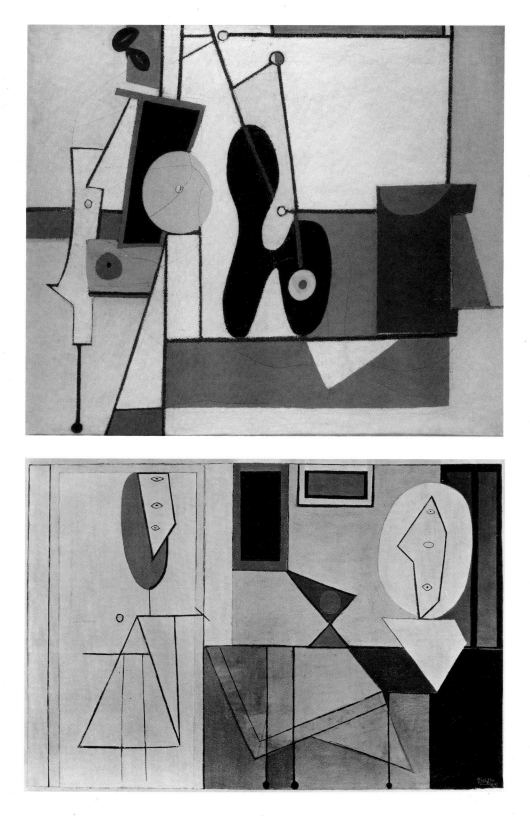

10 Arshile Gorky
Organization

c. 1933–36. Oil on canvas, 50¼ × 60″
National Gallery of Art, Washington, D.C.
Ailsa Mellon Bruce Fund

In the mid-1930s Gorky began titling a series of related paintings Organization *and* Composition. *In* Organization *Gorky segments the picture field by dividing it into colored zones separated by bold black lines. Thus Gorky makes direct reference to the work of Mondrian and, more directly, to Picasso's studio interiors of 1927–28, including* The Studio.

11 Pablo Picasso
The Studio

1927–28. Oil on canvas, 59″ × 7′7″
Collection, The Museum of Modern Art, New York
Gift of Walter P. Chrysler, Jr.

In contrast to the rounded natural forms most often seen in Picasso's work of the later 1920s, The Studio *has predominantly linear elements and a flat composition. The large rectangle on the left suggests either an artist at work in his studio or a painting of this subject, while on the right a horizontal line demarcates a tabletop holding a bowl of fruit and a sculptural bust.*

new openness into the work. Like Gorky, who approximated a form of collage based on photomontage in his murals (Gorky and Wyatt Davis actually executed a collage study for the murals), de Kooning alludes to collage where he overlaps his forms. And, despite the presence of biomorphic forms, there is a continued emphasis on structure, asymmetrical arrangement, and the equilibrium of balanced forms that we associate with Mondrian. De Kooning's studies are an amal-

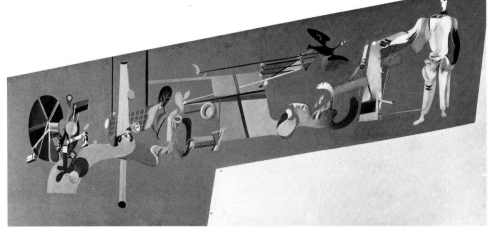

12 *Study for World's Fair Mural*
Medicine

1937. Present whereabouts unknown

In 1937, through the influence of Bur-
goyne Diller, de Kooning received a com-
mission to design one section of a three-
part mural, Medicine, *for the 1939*
World's Fair Hall of Pharmacy. The oth-
er artists were Michael Loew and Stuyve-
sant Van Veen. The mural, 92 feet long
and 29 feet high, was executed by profes-
sional muralists in 1939.

gam of shapes based on Picasso's late 1920s paintings, as filtered through Gorky, and forms that he himself had applied in his work with regularity for some years.

Gorky infused his murals and mural studies with a sense of dynamism in order to convey the spirit of aviation, and to that extent he was successful in realizing the intention of the project. De Kooning's studies, on the other hand, only tangentially relate to the project for which they were intended—lower-middle-income housing designed by the architect William Lescaze. While the subject of the project is suggested by references to architectural elements such as windows, doors, and mirrors and the forms these shapes frame, the basic content of the study is ambiguous and nonspecific. If de Kooning's study lacks the vivacity of Gorky's studies, its taut compositional arrangements, interplay between figure and field, solid and void, foreshadow important features of his later work.

During de Kooning's tenure with the W.P.A. he worked under Léger on a mural commission for the French Line pier. While a reproduction of the model for the mural indicates that the design is Leger-like and more suggestive of movement than the Williamsburg studies, it, too, is less accomplished than Gorky's work for the W.P.A. In 1937 de Kooning received a commission to design one section of a three-part mural for the New York World's Fair Hall of Pharmacy. Like the Williamsburg project studies, this design, which was executed by professional mural painters in 1939, reveals de Kooning's mural work in its most detailed, if not altogether successful, form. Although the images relate specifically to advances in modern medicine, the stylized figures in the composition, which synthesizes idealized representational forms and biomorphic imagery, lack the confidence that Gorky brought to his murals of the period. Here, however, de Kooning's splendid skills as a draftsman are very much in evidence. In his studies for the mural (see, for example, pls. 12, 13) de Kooning endows his forms with volume, his space with depth. The drawings are notable for their stylized rendering, a type of mechanical drawing common to commercial art. But despite the virtuosity displayed by the studies, they lack the intense honesty and painful investigation Gorky brought to his mural studies and other drawings of the period. This searching honesty is reflected in other works by de Kooning of the 1930s, most particularly in his penetrating portraits and figure drawings.

13 *Study for World's Fair Mural*
Medicine

1937. Pencil on paper, 9 × 12"
Private Collection

13 *Study for World's Fair Mural* Medicine

14 *The Wave*

III. Emergence of Two Stylistic Directions

As DE KOONING BEGAN TO COMMIT HIMSELF to becoming a full-time artist, two distinct stylistic directions emerged in his work. He initiated a series of figures, first embodied in the image of Men and somewhat later in the form of Women, while he continued the high-key color abstractions in which he alternated between geometric and organic forms. Many artists of de Kooning's generation were attracted to the same issues that engaged him, yet most of them felt impelled to abandon figuration in favor of abstraction. However, these opposite stylistic poles were both to play major roles in the development of de Kooning's mature art. Indeed, in much of his later work, it is precisely the synthesis of figuration and abstraction that constitutes one of his most significant achievements.

The artistic milieu in New York encouraged de Kooning's pursuit of an abstract direction by providing a conducive intellectual atmosphere as well as specific precedents. In 1937 a number of artists devoted to the cause of abstraction, including Stuart Davis, Ilya Bolotowsky, and Burgoyne Diller, banded together to form the American Abstract Artists. This association was passionately committed to the principles of geometric abstraction. Their art was based upon the European de Stijl, Constructivist, and Suprematist movements, whose central premises were rational aesthetics and ethical ideals. After war broke out in Europe, the ranks of the American Abstract Artists were strengthened by the arrival in the United States of many of the major proponents of the European movements. Mondrian, the most influential figure among them, arrived in New York in the fall of 1940 and joined the American Abstract Artists. He became something of an idol for artists working in New York. Mondrian and his fellow Neo-Plasticists upheld the standard of pure abstraction in the United States. In a country whose art was often provincial, they came to stand for a Platonic ideal in both life and art, a noble reality symbolized by hard-edge geometric form.

Although de Kooning and Gorky admired Mondrian and were interested in the goals of the American Abstract Artists (they had both attended the group's first meeting but did not join the association), they continued to work figuratively and were profoundly attracted to biomorphic abstraction, which the Neo-Plasticists disdained. While de Kooning referred to Mondrian as "...that great merciless artist...the only one who had nothing left over" (Hess, 1968, p. 145), it is evident that he considered him extremely important. De Kooning admitted that he was "...crazy about Mondrian...something happens in the painting that

14 *The Wave*

c. 1942–44. Oil on fiberboard, 48 × 48"
National Museum of American Art
Smithsonian Institution, Washington, D.C.
Gift from the Vincent Melzac Collection

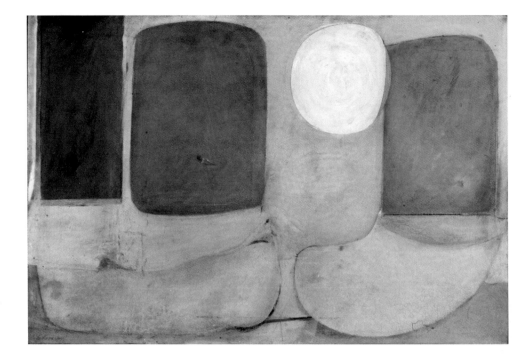

15 *Pink Landscape*

c. 1938. Oil on composition board, 24 × 36″
Private Collection

De Kooning's work during the late 1930s suggests the artist's ambivalence in producing purely abstract images. Works such as Pink Landscape *include traces of objective reality. De Kooning himself has remarked: "Even abstract shapes must have a likeness."*

I cannot take my eyes off.... It has terrific tension. It's hermetic. The optical illusion in Mondrian is that where the lines cross they make a little light. Mondrian didn't like that, but he couldn't prevent it. The eye couldn't take it, and when the black lines cross they flicker. What I'm trying to bring out is that from the point of view of eyes it's really not optical illusion. That's the way you see it" (Rosenberg, *Art News*, 1972, p. 56).

Mondrian and his followers were an influential part of the avant-garde scene in New York when de Kooning was at a formative stage in his development. Moreover, the de Stijl group had a dramatic impact on de Kooning when he was a youth, as the artist himself acknowledged years ago. Like Mondrian, de Kooning shared a predilection for the grid, derived from Cubist painting, and a feeling for color, light, and space issuing from the Dutch landscape. Furthermore, de Kooning's integration of figure and field, initiated in his geometric abstractions of the 1930s and culminating in the great black-and-white paintings of the late 1940s, is clearly indebted to Mondrian's rigorous interlocking network of forms. Similarly, the order and calm that permeate the majority of de Kooning's paintings of the 1930s and early 1940s can be attributed in part to the utopian goals advanced by the American and European advocates of geometric abstraction.

De Kooning was quick to respond to the influence of the advanced abstraction that had become a major force in New York during the late 1930s. He was at ease with his subject, integrating nonobjective forms with the picture plane in an assured, even brilliant manner in paintings such as *Pink Landscape* and *Abstract Still Life*, c. 1938 (pls. 15, 16), the aforementioned *Elegy*, c. 1939, and *The Wave*, c. 1942–44 (pl. 14). The pastel hues and subtly modulated surfaces of these paintings impart a lyric mood and a sense of the fanciful. At this time he introduced his

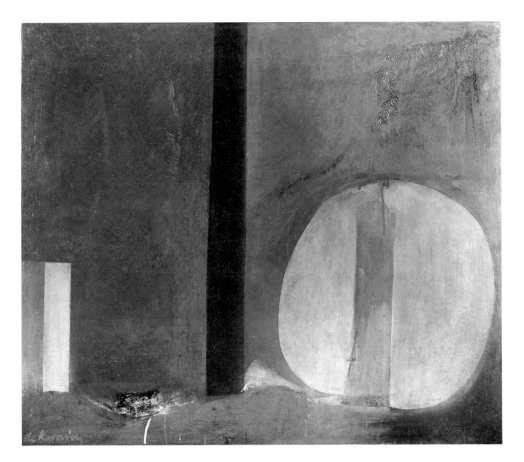

16 *Abstract Still Life*

c. 1938. Oil on canvas, 30 × 36″
Private Collection, Paris

characteristic tart pinks and greens into his paintings, drawings, and pastels, and a new immediacy appears in his work, which foreshadows the vital spontaneity of the paintings of the late 1940s and early 1950s.

But whereas Mondrian advocated a monastic devotion to the horizontal and vertical elements in painting and the allover disposition of geometric forms on the picture plane, de Kooning was torn between this method of ordering form, biomorphic imagery, and figure-ground relationships. While *Abstract Still Life* could still be said to belong within the nonobjective canon, *Elegy* deviates totally from purist theory. In *Elegy*, de Kooning employs the type of biomorphic imagery that came to dominate abstract painting in New York in the 1940s. De Kooning's imagery suggests a figure in a landscape, an image that he would have known from Picasso's 1930s bathers and Miró's 1920s figurative landscapes. In *Elegy*, de Kooning re-creates a reclining figure as a sequence of detached and overlapping forms and begins to give line a life independent of form. *Elegy* is at once the summation of de Kooning's fascination with geometric abstraction and the prelude to his later interest in synthesizing abstract form and figurative imagery.

In his contemporaneous figurative work, de Kooning was on less secure ground. Whereas he produced strikingly assured portraits, such as *Portrait of Elaine*, c. 1940–41 (pl. 17), and compelling closely studied renditions of male figures, he also made schematic, cartoon-like drawings of store mannequins and

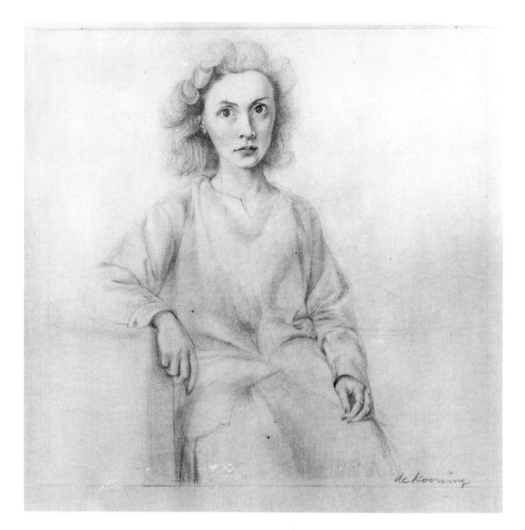

17 *Portrait of Elaine*

c. 1940–41. Pencil on paper, 12¼ × 11⅞"
Private Collection

*During the 1940s Elaine Fried, an art
student de Kooning met in 1937, and her
sister Marjorie often posed for him. In this
beautiful, technically assured portrait
Elaine appears wearing an old shirt of the
artist's.*

18 Arshile Gorky *Portrait of Myself and My Imaginary Wife*

1923. Oil on paperboard, 8⅝ × 14¼"
Hirshhorn Museum and Sculpture Garden
Smithsonian Institution, Washington, D.C.
Gift of Joseph H. Hirshhorn Foundation, 1966

*Gorky referred to the series of paintings
that included* Portrait of Myself and
My Imaginary Wife *as his "Armenian
Portraits." They were based on photo-
graphs and drawings dating from his
youth, as well as on memories of his early
years in Armenia. Perhaps because of the
deeply personal nature of these materials,
Gorky seems to have overcome his need to
identify formally with the great artists of
the past. In this painting he begins to draw
upon experiences in his life and to incor-
porate aspects of his past in his imagery.*

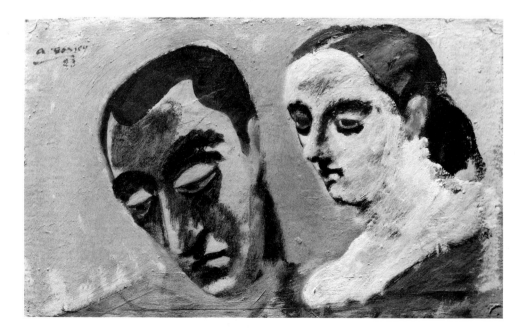

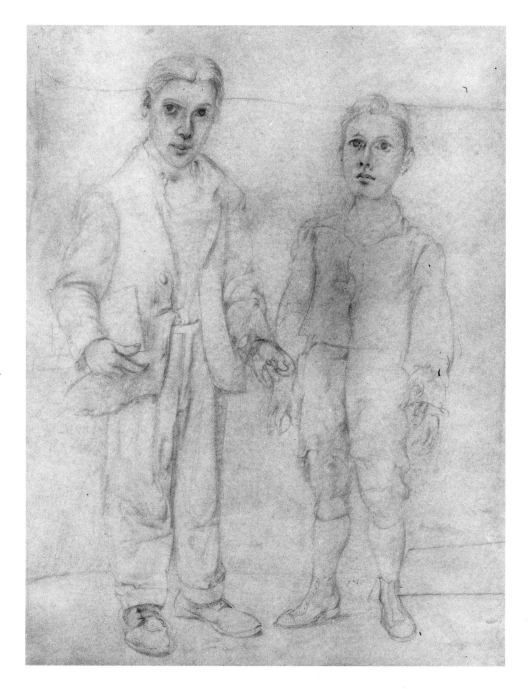

19 *Self-Portrait with Imaginary Brother*

c. 1938. Pencil on paper, 13⅛ × 10¼″
Private Collection, New York

About 1938 de Kooning painted this arresting image of two wide-eyed young men. Although de Kooning has described the work as a double self-portrait, the figure on the right clearly derives from the Le Nain genre subjects. The psychological dimension of the imagery is enhanced by the artist's family history, his immigrant status, and his sense of loneliness and isolation in his new homeland.

idealized quasi-abstract figures. The fundamental problem this genre posed for de Kooning was how to hold the plane, as he had done with such assurance in the abstractions, without compromising the figure-ground relationship. His academic training may have made it difficult for him to reject traditional volumetric form in favor of flattened, even pulverized shapes that would remain on the same plane with the ground. Braque and Picasso had offered a solution in their Cubist works by fragmenting the figure and rearranging it on the picture plane without denying its volume. But de Kooning was undoubtedly already too committed to the large shapes with rounded contours and luscious color that inhabited his 1930s abstractions to turn in his figurative work to the Analytic

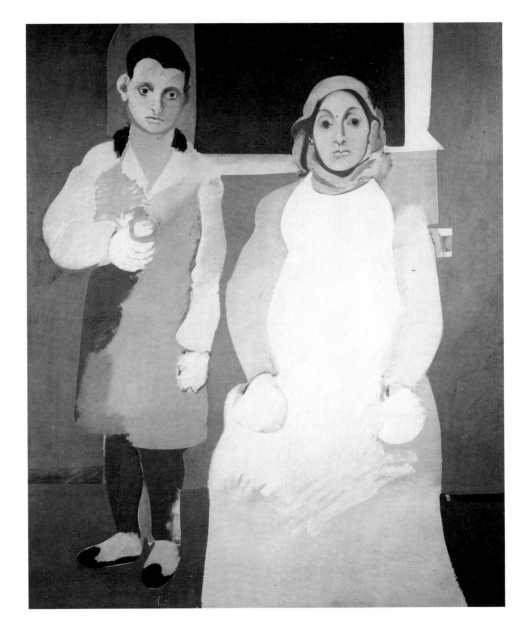

20 Arshile Gorky
The Artist and His Mother

1926–29. Oil on canvas, 60 × 50″
Collection of Whitney Museum of American Art
Gift of Julien Levy for Maro and Natasha Gorky
in memory of their father. (50.17)

The Artist and His Mother, *like* Portrait of Myself and My Imaginary Wife, *is among the works Gorky referred to as his "Armenian Portraits," inspired by his early years in his native land. The painting is based on a photograph taken in 1912 in Van City, Armenia, and carefully preserved by Gorky. He executed two versions of this image, on which he worked for more than a decade. This version—the more finished composition of the two—was begun first and concluded (though never fully completed) earlier.*

Cubist precedent of a monochromatic art with fragmented, faceted, sharp-edged forms.

Rather, like Gorky, it was to Picasso's pre-Cubist painting, to Jean-Auguste-Dominique Ingres and the Le Nain brothers that de Kooning turned for his example. Both artists frequented the Frick Collection and the Metropolitan Museum of Art. (In the spring of 1927 the Frick bought Ingres' *Madame de Haussonville*, 1845, which was first shown in 1935; his *Odalisque in Grisaille* was acquired by the Metropolitan in 1938, on view there beginning in October, 1938, and also included in the New York World's Fair in 1940.)

De Kooning interpreted Ingres' vision through Gorky's eyes in portraits of the late 1930s and 1940s. Gorky's *Portrait of Master Bill*, 1929–39, and *The Artist and His Mother*, 1926–29, prefigure a number of de Koonings, including *Two Men Standing*, 1938. Friends of Gorky and de Kooning have described their technique of scraping painted surfaces with a razor blade or sandpaper and repainting them to produce a smooth porcelain-like finish. This opalescent, reflective

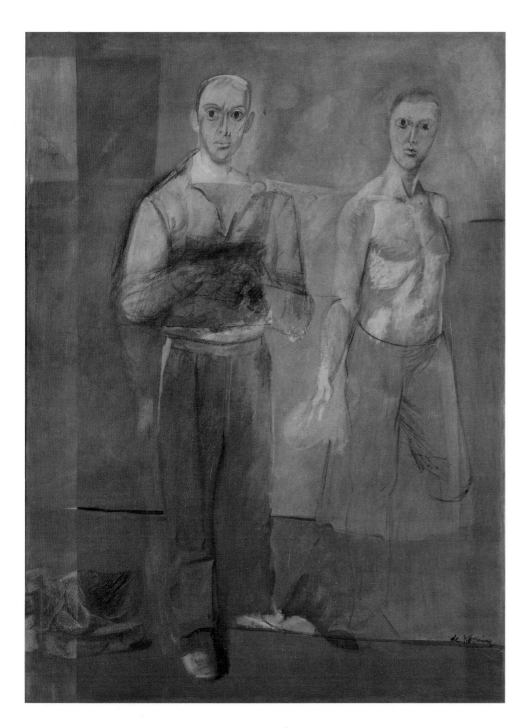

21 *Two Men Standing*

1938. Oil on canvas, 61⅛ × 45⅛″
The Metropolitan Museum of Art
From the Collection of Thomas B. Hess;
Rogers, Louis V. Bell and Harris Brisbane Dick
Funds and Joseph Pulitzer Bequest, 1984
(1984.612)

During the 1930s, along with his abstract compositions, de Kooning produced a series of paintings of somber, rather remote-looking men. Some of these allusive images are self-portraits; others resemble de Kooning's friends Gorky and Edwin Denby. They suggest the sorrow and hardship of the Depression years.

surface clearly derives from Ingres: in combination with the soft evanescent colors of their paintings, it creates a special effect of mysteriousness and remoteness. Ingres' consummate draftsmanship, exquisite contours, delicate and precise line moved and inspired both Gorky and de Kooning.

In the resplendent *Portrait of Elaine*, c. 1940–41, which de Kooning executed a few years before his marriage to Elaine Fried, the artist revels in his skill as a draftsman. Here he imbues the sitter with the boldness and authority that were to become customary in the great series of Women he painted in the 1950s. For *Portrait of Elaine* he looked to the precedent of Ingres' drawings—in particular the French master's practice of bringing the heads and hands to a highly

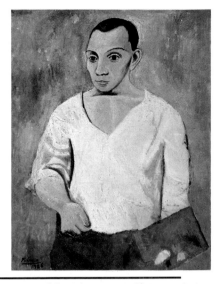

22 Pablo Picasso. *Self-Portrait*

1906. Oil on canvas, 35⅝ × 28″
Philadelphia Museum of Art
A. E. Gallatin Collection

Like Picasso's 1906 painting of Gertrude Stein, Self-Portrait—*with its large al-mond-shaped eyes and simplified facial features—shows the influence of ancient Iberian sculpture on his work. The mask-like quality of the face and the severe treatment of forms presage the immense changes that took place in 1906–7, cul-minating in what is often considered the first Cubist painting,* Les Demoiselles d'Avignon.

23 Pablo Picasso. *Two Youths*

1905–6. Oil on canvas, 59⅝ × 36⅞″
National Gallery of Art, Washington, D.C.
Chester Dale Collection 1962

This canvas shows an increased serenity of mood and form common to many of Picas-so's paintings of the years 1905–6, a time that has been called his early classic period because of its similarity to classical Greek sculpture and painting. Though the exact year in which the work was painted has not been firmly established, it may have been made while the artist was summer-ing in the Andorra Valley of the Spanish Pyrenees.

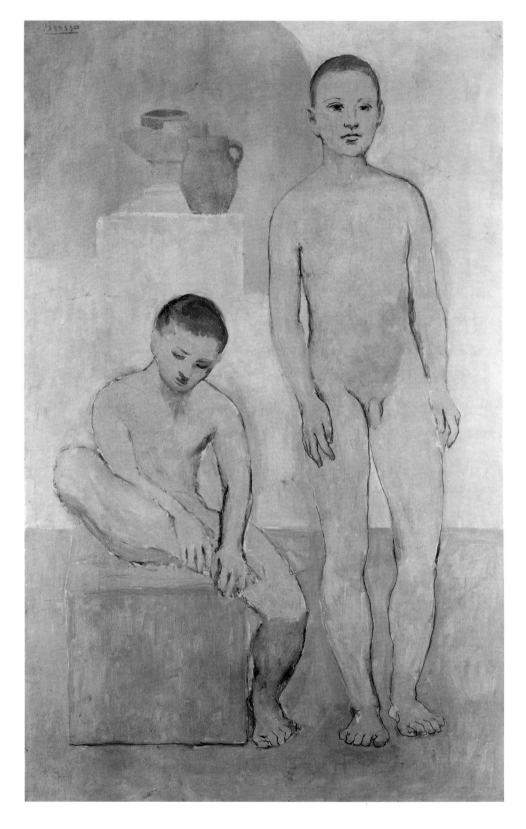

finished, detailed perfection while rendering the figure schematically.

While de Kooning and Gorky attempted to emulate Ingres' idealized figures in other works of this period, in *Self-Portrait with Imaginary Brother*, c. 1938 (pl. 19), de Kooning looked to the Le Nain brothers for his stylistic source. The right-hand figure in his drawing is clearly derived from the Le Nain lexicon of

genre subjects. The Le Nains crop up in Graham's writings and were admired by Gorky and de Kooning. Together with Georges de la Tour, the Le Nains were presented in an important loan show held at Knoedler & Co. in New York in 1936.

In general, the Le Nain brothers concentrated on rustic peasant figures. Most of the young male peasants appear in short pants; they wear wide-collared shirts and coarse high boots. Their paintings tend to feature wide-eyed figures face on. Although de Kooning's *Imaginary Brother* does not appear to derive from any particular Le Nain image, the generic type is roughly analogous. It is tempting to speculate that de Kooning drew upon the Le Nain brothers not only for his subject but also to acknowledge a more traditional source for his work as well as an ancestry connecting his art and that of the past. (This, of course, is not the way in which Ingres was perceived. He was considered a modernist who led directly to Picasso.)

Of equal interest is the mood of the drawing. The fugitive dreamlike face conveys not only a sense of the past but both figures convey a sense of estrangement and loss. Indeed, a similar mood of sadness and longing permeates the majority of de Kooning's portraits of Men, whose passivity is one of their more notable features. By contrast, his Women of this period are incisive, biting, fanciful, buoyant, and definitely alluring.

Self-Portrait with Imaginary Brother has little in common with Gorky's version of a similar subject, *Portrait of Myself and My Imaginary Wife*, 1923 (pl. 18). But de Kooning's drawing, as well as his painting *Two Men Standing*, 1938 (pl. 21), reminds us strongly of Gorky's great canvas *The Artist and His Mother*, 1926–29 (pl. 20). The compositions of all three are remarkably similar, and the compelling gazes and sense of remoteness first encountered in the Gorky double portrait reappear in the de Kooning drawing and painting. Moreover, de Kooning's portraits, like Gorky's, are an amalgam of the real and the imaginary. Gorky based his composition on a family photograph; de Kooning used himself for three of the figures and the Le Nain-derived figure for the fourth. However, in these works the nervous tension and agitated expression of de Kooning's figures contrast sharply with the monumental calm and poetic, if melancholy, mood that both de Kooning and Gorky often sought to convey in their portraits of the period.

In this period both Gorky and de Kooning turned to Picasso for inspiration. In Picasso's work they sought the purely formal relationships underlying representational imagery. Their interest in integrating three-dimensional form with the two-dimensional picture plane was reinforced by the example of Picasso. Picasso himself had adapted Ingres' method of affecting the transition from a fully modeled head to the two-dimensional picture plane by flattening the volume of portions of the figure. His *Two Youths* of 1905–6 and *Self-Portrait* of 1906 are the prototypes for Gorky's *Self-Portrait* of c. 1937 (see pls. 23, 22, 24) and de Kooning's *Two Men Standing*.

With an economy of means similar to that employed by the Spanish master, both Gorky and de Kooning successfully emulated the wide-eyed, staring faces,

24 Arshile Gorky
Self-Portrait

c. 1937. Oil on canvas, 55½ × 34"
Arshile Gorky Estate

Gorky's Self-Portrait *directly refers to Picasso's* Self-Portrait. *He has adopted not only the stance and concentrated stare of Picasso's figure but even such details as the palette-in-hand motif. In its cursory features, sketchy limbs, and brushed treatment of clothes and background, the work also pays homage to another of Gorky's champions of modern art, Paul Cézanne.*

the solemn austerity, the dreamlike melancholy, the sense of figures frozen in space and in time characteristic of Picassos of around 1905–6. Like Ingres, Picasso elected to bring his heads to a greater state of finish than other parts of the body. Gorky and de Kooning, emulating Picasso, adopted his cursory rendering of hands. However, Picasso's undefined hands are stylistically consistent with the other schematic forms in his compositions, whereas the rudimentary hands in Gorky's and de Kooning's canvases are not always successfully integrated with other details. Despite this inconsistency and certain other unresolved elements, Gorky's and de Kooning's paintings are unified by compelling imagery and a provocative use of color.

De Kooning often strove for accurate representational details in paintings and drawings during this period. In fact, in the late 1930s he decided that he needed a model. Perhaps inspired by the mannequins he had used in his commercial jobs, he set about constructing a figure:

I took my trousers, my work clothes. I made a mixture out of glue and water, dipped the pants in and dried them in front of the heater, and then of course I had to get out of them. I took them off—the pants looked pathetic. I was so moved, I saw myself standing there. I felt so sorry for myself. Then I found a pair of shoes—from an excavation—they were covered with concrete, and put them under it. It looked so tragic that I was overcome with self-pity. Then I put on a jacket, and gloves. I made a little plaster head. I made drawings from it and had it for years in my studio. I finally threw it away. There's a point when you say enough is enough (Yard, 1980, p. 50).

Several works of this period reveal de Kooning's keen observation of perceived reality. Drawings and paintings show minute details such as folds in the creases of trousers, the shape of a hat, the way in which a coat or shirt collar is turned. In some de Kooning concentrated on a detailed analysis of the body or a body part. *The Glazier*, c. 1940 (pl. 25), for example, closely examines the way a shoulder works and demonstrates de Kooning's desire to render anatomical features correctly. Yet despite such attention to detail, there is in these drawings and paintings a sense of unreality; the figures seem removed from the everyday world by virtue of the dreamlike cast of their facial features and also because they are placed against backgrounds that are only rudimentarily indicated.

Man, c. 1939 (pl. 26), on the other hand, is unusual in that it is more firmly rooted in reality than other works of the series. Like many of the male figures of the period, it resembles de Kooning and may be a self-portrait. Since the title does not identify it as a self-portrait, we can only assume that he used himself as a model and generalized the image, as he often generalized the subjects in his Women of the 1950s. Whereas the unreality of the Men is usually enhanced by their dreamy features, in *Man*, de Kooning endows the face as well as the hands and clothes with a decided sense of actuality. Atypically, the work relies more on observation than imagination. Yet it, too, is a portrait of a figure removed in time, distant and remote, ultimately as elusive as his other figures of Men.

De Kooning's habit of distancing his figures derives from Gorky's contem-

25 *The Glazier*

26 *Man*

c. 1939. Oil on paper, mounted on composition
board, 11¼ × 9¾"
Private Collection, New Orleans

Man, *one of the most realistic of de Koon-*
ing's paintings of men, may very well be a
self-portrait. He painted a number of
figures of solitary men; in this work the
sense of isolation reaches new heights.

poraneous work and Picasso's images of 1905–6. In their work the sitter rarely
looks directly at the spectator; even when this occurs, the gaze is mournful and
turned inward. Because these figures are isolated in the space that surrounds
them, their sense of alienation is further heightened. De Kooning's method of
working from the figure may have helped him generalize his forms. Since the
artist had very little money, he was often forced to use himself as a model. He
worked with mirrors, a method that lessens the immediacy of working directly
from the model. Regardless of the way in which he worked, however, the process
of distancing and generalizing seems to be what he wanted to accomplish at this
time. Indeed, his preliminary drawings indicate how observant he could be when
he chose. His paintings are far more synthetic, hence more abstract.

Despite their generality, in paintings and drawings of the period, such as
Two Men Standing and *Man*, as well as *Standing Man*, c. 1942 (pl. 28), de Kooning
fully conveys the sadness of life in those depressing days: times when artists sold
their blood to help support themselves and when people lived huddled in tents

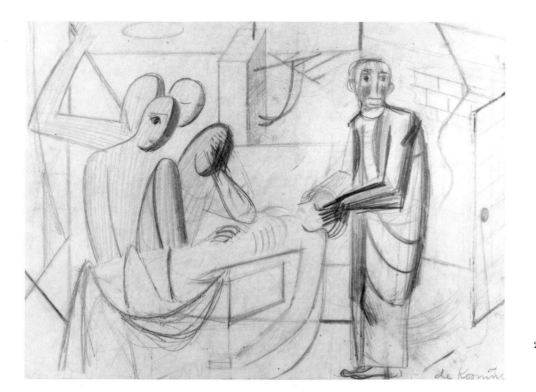

27 *The Dead Man*

c. 1938. Pencil on paper, 8 × 11¼"
Private Collection

along Spring Street, warming themselves at fires in barrels on the street. In its pathos, de Kooning's work of this genre recalls Picasso's Saltimbanques of the Rose Period. De Kooning—like so many artists, including Alexander Calder, Walt Kuhn, and Yasuo Kuniyoshi—has said that he befriended acrobats, clowns, and vaudeville performers; he painted several works based on these subjects, and he continues to be fascinated by the magic of the circus and the down-to-earth nature of the performers.

De Kooning has painted some of the most telling subjects of the Depression and prewar era. Through them de Kooning also reveals his awareness of the plight of the common man and expresses a theme familiar in the work of the Social Realists. Paradoxically, in choosing to depict these subjects in a representational genre, he is closer here to Benton, Shahn, and Marsh than to the advanced artists of his milieu who were committed to social and political reform while they argued militantly for utopian abstraction.

Whereas Benton, Shahn, and Marsh convincingly portrayed the turbulence and disorder of the period, an air of resignation claims de Kooning's calm figures of the 1930s. These men are muted, victims of their circumstances, unable to fight back. Moreover, the Social Realist oeuvre, exemplified in paintings such as Shahn's *The Passion of Sacco and Vanzetti*, 1931–32, represents a pictorial narrative of the political and social strife of the times. In contrast, although de Kooning occasionally drew upon explicit Depression-era subjects, in certain works, such as *The Dead Man*, c. 1938 (pl. 27), he displayed little interest in portraying the ills of society in political terms. Instead, his figures are largely isolated victims, separated from the society that has defeated them. The protagonists of *Man* and related

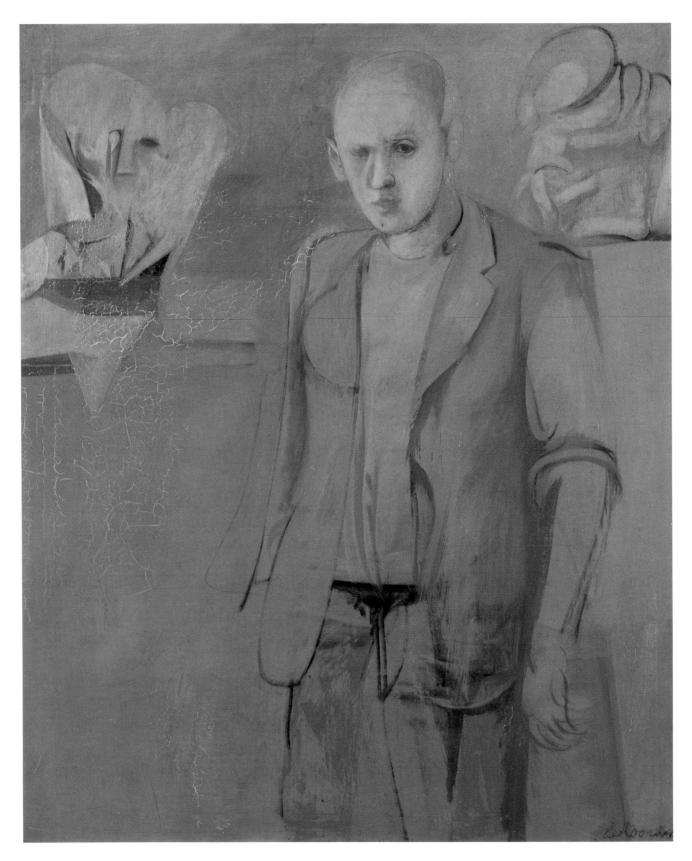

28 *Standing Man*

works may be indebted to the haunted 1930s figures of Alberto Giacometti, an artist whose work de Kooning knew and deeply admired. The disjunction between man and his environment, rather than active conflict between the two, is not only a key theme of de Kooning's figurative work of the 1930s but also one that underlies much of his mature work.

Although de Kooning produced two extraordinary "genre" paintings in *Two Men Standing* and *Man*, they were as close to a realistic idiom as he would ever come. In other works he turned to idealized and abstracted imagery in the form of the male figure. Indeed *The Glazier* can be said to summarize certain aspects of de Kooning's idiom and his aesthetic position around 1940. Thus, the sense of harmony and order that informs his geometric abstractions of the 1930s and his biomorphic images of the mid-to-late 1930s and early 1940s, so at odds with the expressive nervous vitality of *Two Men Standing* and *Man*—characteristics that interestingly come to dominate the Women of the late 1940s and 1950s—is epitomized in this canvas.

The painting also reveals the artist's indifference to political narrative and his parallel lack of interest in allegory. *The Glazier* was influenced by the Boscotrecase murals de Kooning saw at the Metropolitan Museum, and although he makes some reference to antiquity and to his subject, specifically in the representation of the vessel, it is ancillary to his main concerns. In fact, de Kooning's remarks in an interview with Harold Rosenberg suggest that the murals were important to him primarily because of their abstract qualities:

I was often with Gorky when I saw those murals, and he couldn't get over the idea of painting . . . a terracotta wall like the Pompeiians were doing. I had that yellow ochre, and I painted a guy on the yellow ochre and the wall was really like the yellow ochre, a flat thing. It was never completely successful, but it still had that feeling. Then slowly I changed, and when I started to make those landscapes, I had the idea of a certain kind of light from nature. The paintings I was doing of men had another kind of light, not like on a wall. . . . (Art News, 1972, p. 57).

The Glazier and other paintings of the period make abundantly clear the fact that, like other advanced artists who hoped for social and political change, de Kooning was not interested in making "poor art for poor people," to use Gorky's phrase. Although he occasionally made specific reference to the period, particularly in his choice of subject and in the mood conveyed by some of his figures, he was not given to grandiose rhetorical statements nor to glorifying the poverty of the period. He was, above all, committed to making paintings about light, color, and plane—abstract elements found in all significant art regardless of its time and context—paintings that did not merely record civilization but rather ennobled it.

The aforementioned *Glazier* and *Seated Woman*, c. 1940 (pl. 29), are among the most significant portraits of the period in that they represent de Kooning's first attempts to reinterpret traditional male and female figures in a relatively abstract mode. De Kooning idealized his forms and interpreted his figures as nearly flat objects on the picture plane in much the same manner as he had earlier when

28 *Standing Man*

c. 1942. Oil on canvas, 41⅛ × 34⅛″
Wadsworth Atheneum, Hartford
The Ella Gallup Sumner and Mary Catlin
Sumner Collection

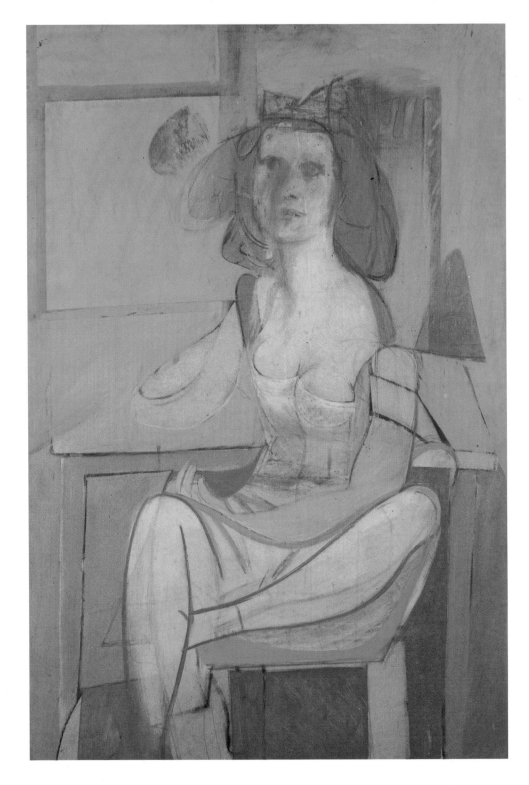

29 *Seated Woman*

c. 1940. Oil and charcoal on composition board
54¼ × 36″
Philadelphia Museum of Art
The Albert M. Greenfield and
Elizabeth M. Greenfield Collection

In the 1940s de Kooning abandoned his series of Men and took up the theme of Women, producing ebullient images in vivid colors. The Women were one theme de Kooning would return to time and again throughout his career. This seated dreamlike figure, one of the earliest resolved paintings of Women, affirms de Kooning's interest in Ingres and Picasso.

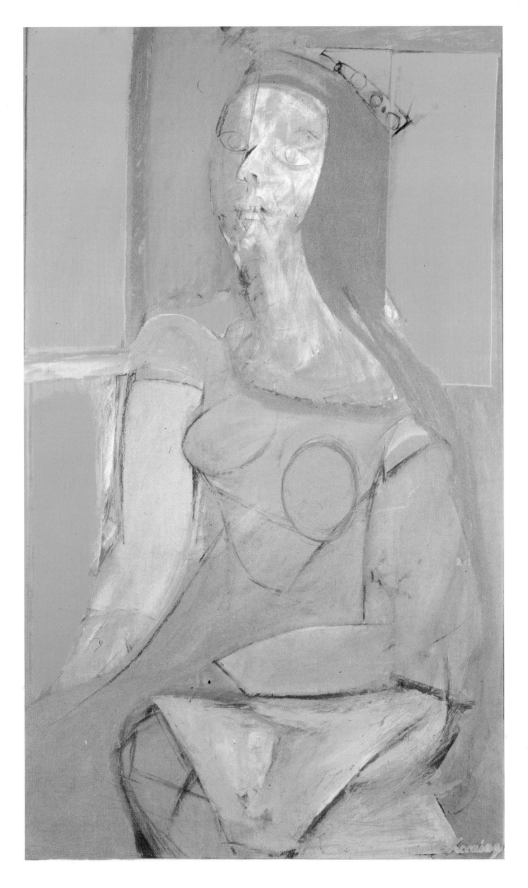

30 *Queen of Hearts*

1943–46. Oil and charcoal on fiberboard
46⅛ × 27⅝″
Hirshhorn Museum and Sculpture Garden
Smithsonian Institution, Washington, D.C.
Gift of Joseph H. Hirshhorn Foundation, 1966

De Kooning's Queen of Hearts, *like many of the Women of the 1940s, appears close to the picture plane before a backdrop of geometric shapes vaguely reminiscent of architecture or furniture. The artist referred to the indefinable space of such paintings as "no-environment."*

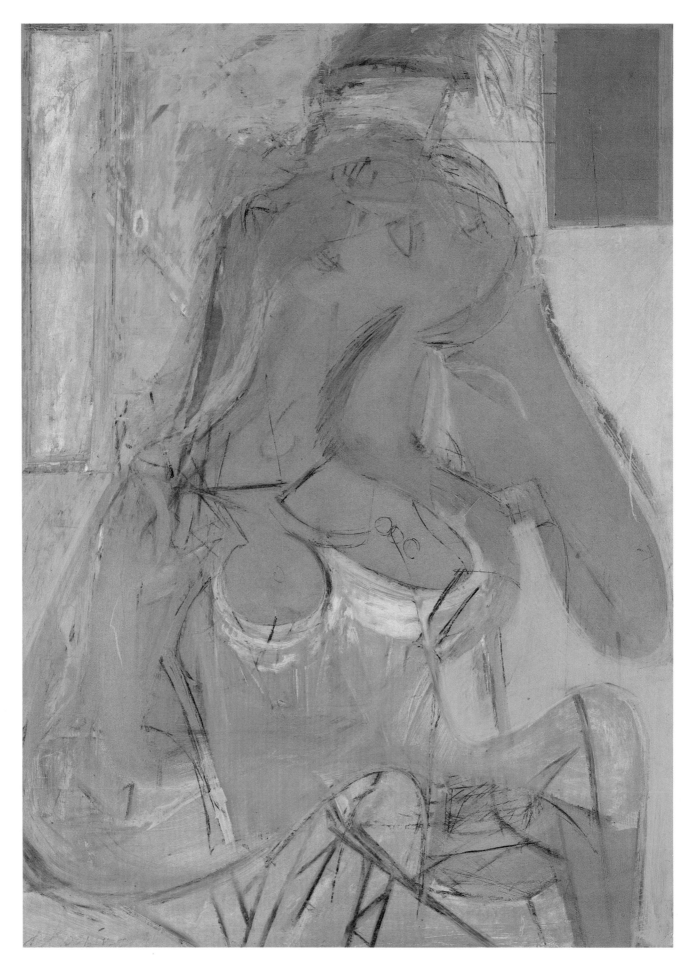

31 *Pink Lady*

he aligned his geometric and biomorphic forms on the picture plane in his "abstract" paintings. In these two paintings de Kooning retains the schematic interior space he employed so effectively in *Man* and *Two Men Standing*. Mere suggestions of a doorway or a window establish architectural setting, and use of color and paint handling blur the distinction between figure and ground.

Seated Woman is the more resolved of the two: in it de Kooning has crystallized his approach to the figure. The woman is seated in or near the corner of a minimally defined room. Her spatial integration is more successful than that of the male in *Glazier*: she drifts in and out of the field, holding the plane and also seeming to inhabit three-dimensional space. De Kooning takes his cue here from Ingres, modeling parts of the figure, boldly outlining others, and flattening portions by enclosing them within the field. Though the features are partially obliterated, the face, like that of *Portrait of Elaine*, suggests a powerful personality. Particularly compelling is the sense of composure conveyed by the carefully balanced asymmetry of the composition. This equilibrium of forms, together with the careful, albeit incomplete, rendering of the face and body, produces a strong feeling of harmony. The overwhelming sense of harmony and placidity persists despite the sharply contrasting colors, the blurring of features, repositioning of limbs, areas of inpainting and overpainting, erasures, and other evidence of changes—elements that foreshadow the characteristics of de Kooning's later Women, such as *Queen of Hearts*, 1943–46, and *Pink Lady*, c. 1944 (pls. 30, 31).

The war years were a period of great change for the artist. In January, 1942, de Kooning, then thirty-seven, participated in his first gallery group show. (Although he had been included in an exhibition at the Museum of Modern Art in 1936, his study for a mural for the Williamsburg project went unnoticed and was subsequently destroyed [Hess, 1968, p. 18].) The exhibition was organized by his friend John Graham for McMillen Inc., a decorating firm. The exhibition, entitled "American and French Paintings," included Lee Krasner and Jackson Pollock (both also exhibiting for the first time), Picasso, Braque, and Matisse. De Kooning showed *Man*. He and Pollock met for the first time and became friends and rivals. Although de Kooning was included in a few group shows during the 1940s, his first one-man show did not take place until 1948. This exhibition, held at the Egan Gallery, consisted primarily of black-and-white paintings and immediately launched de Kooning as a major American artist of international stature.

In 1943 de Kooning married Elaine Fried and remodeled his studio on Fourth Avenue between Tenth and Eleventh streets in Manhattan. It was in this small studio that he made some of his most important work of the 1940s. Here de Kooning continued to paint a series of Women that expands upon the ideas he first explored in *Seated Woman*. Now, however, in figures such as *Queen of Hearts* and *Pink Lady*, there are signs of increased activity. The smooth Ingres-like surface and equally fluid contours are in danger of being replaced by random marks, in charcoal and oil, that have virtually nothing to do with the idealized, if distorted, form of the figures. The activity of painting begins to take on a life of its own.

31 *Pink Lady*

c. 1944. Oil and charcoal on composition board
48⅛″ × 35⅜″
Private Collection

The erotic content of many of de Kooning's images of Women is especially obvious in Pink Lady. *The provocative nature of his* Women *of the 1940s predicts the later even more notorious* Women *of the 1950s.*

32 *Still Life*

IV. The Influence of Surrealism

GEOMETRIC ABSTRACTION CONTINUED TO COMMAND a devoted following in the United States, but its influence was challenged during the war years by the arrival in New York of leading members of the Surrealist movement. The Surrealist influence was twofold: it came directly from the Surrealists themselves and indirectly, but more eloquently, from Picasso and Miró, two of the most important artists for members of the New York School. This was an influx that profoundly altered the course of American art.

The Surrealists Max Ernst, André Masson, Yves Tanguy, Matta Echaurren, and the poet laureate of the movement, André Breton, came to these shores en masse to escape the Nazi onslaught on the continent. The young Americans now had increased access to the work of these pioneers and occasionally enjoyed personal contact with the painters and poets themselves. Some, like Gorky, Joseph Cornell, Robert Motherwell, and William Baziotes, not only were befriended by the group but also participated frequently in their activities.

In Breton, Gorky found his spiritual mentor; from him he received a kind of acclaim he had not known before and was not to experience again in his lifetime. Artists such as Cornell received critical support from Breton and other Surrealists during the formative stages of his career. Motherwell met most of the European and Surrealist artists in exile in 1941; he remained closely associated with the Surrealists for years, even though they considered his painting too "abstract." Gorky's new alliance was disdained by Stuart Davis, who, as an unyielding Cubist, felt that the younger artist's drift toward Surrealism was a betrayal of his innate gifts as an artist and a capitulation to a frivolous and decadent movement. While de Kooning and Gorky never had a falling out, they drifted apart after Gorky started to spend time in Connecticut and Virginia (1943–44). De Kooning, never a believer in aesthetic doctrines of any kind, had met and become close friends with Franz Kline. While some members of the New York School, Kline among them, were never attracted to Surrealism, the majority found in the movement new and revolutionary concepts. With its commitment to the new, the unorthodox, the experimental, Surrealism provided the impetus and momentum the New York-based artists needed; it enabled them to cut the few remaining ties they had with a provincial American art. From this alliance with European Surrealism they forged a new and profound American art.

Although Surrealist imagery, with its sexually charged subject matter and ambiguous thematic content, permeated American painting and sculpture in the

32 *Still Life*

c. 1945. Pastel and charcoal on paper
13⅜ × 16¼"
Collection Frederick Weisman Company,
Los Angeles

The collage-like compositions of this work and Pink Angels *are animated by the dynamic energy of their abundant biomorphic forms. The suggestiveness of these images is derived from de Kooning's adoption and subsequent reworking of the Surrealists' technique of automatic drawing.*

47

1940s, it was automatism and the concepts it engendered that radically altered the course of American art. Automatism liberated painters of the burgeoning New York School from the external world of reality and freed their art from conscious control, allowing them to explore the inner universe of the subconscious. Like the Surrealists before them, the New York-based artists exploited the irrational and the elements of chance and accident. Unlike many of the European Surrealists, who remained committed to representation, narrative, and illusionism, Americans used automatism as their point of departure in the formation of a radical, new, two-dimensional abstract imagery. Automatism made it possible for artists as diverse in background and intention as Motherwell, Baziotes, Gorky, de Kooning, Pollock, Newman, Still, and Rothko to transcend representational subject matter and explore both their inner vision and the elemental forces lying beneath the surface of perceived reality. The Surrealist emphasis on automatic technique and accidental effects inspired artists of the New York School to elevate process to the level of subject matter, content, and style and to exploit the role of improvisation and chance.

For the gestural painters—among them, Pollock, de Kooning, Kline—the mark, the drip, the brushstroke became vital evidence of the artist's activity, documents of the process of painting. Of all the gestural artists, however, it was Pollock who capitalized to the utmost on chance and spontaneous effects with his revolutionary drip technique. His allover drip paintings are remarkable for their powerful, dynamic abstract imagery and large scale. Pollock's drip technique involved the use of his entire body and inevitably led him to abandon easel-sized pictures in favor of mural-scale canvases.

Although far from committed to the totality of the Surrealist experience, de Kooning found in automatism a fundamental source of inspiration. The very act

34 *Portrait of Max Margulis*

of painting became central to the content of his art. Like Pollock, de Kooning made improvisation and process an integral part of his painting. However, de Kooning was unwilling to go to the extremes that Pollock did and deliberately chose to retain easel scale, references to landscape, the figure, and the traditional figure-ground relationship. Whereas the dynamism of Pollock's canvases issues from their resolute abstraction and allover imagery, in de Kooning's paintings it is the monumental pictorial tension created between figure and ground, figuration and abstraction and allover composition that is so remarkable. In contrast to Pollock's allover paintings, de Kooning's canvases are composed of expressive forms and brushwork wedded to the shallow, planar space of Analytic Cubism. He thereby achieves a unique synthesis of spontaneity and control in a wide-ranging oeuvre that encompasses figure, landscape, and abstraction.

As we have seen earlier, the seemingly antithetical poles of figuration and abstraction coexisted in de Kooning's work as early as the 1930s. Not only did he pursue these two idioms simultaneously in separate series, the Men and the Women on the one hand and the abstractions on the other, but he also incorporated abstract elements in his figurative work and figurative elements in his abstractions. That de Kooning gave titles such as *Pink Landscape* and *Abstract Still Life* to related abstractions of the 1930s is suggestive in this context. In the 1940s he alternated between giving the figure or so-called "abstract" forms greater prominence in his paintings, with the former appearing to dominate during the early part of the decade. As he had done in the 1930s, the figure is pictured against a backdrop of what can best be described as a no-man's-land or, to use the term de Kooning preferred, "no-environment." "No-environment" is an indefinable location, which may be indoors or outdoors but is in actuality the artist's studio and the objects and places to which he is attached. (As Hess has explained, the studio and its trappings, the surroundings de Kooning has passed through, all merge in his painting [1959, p. 19].)

Prior to the Women, De Kooning's strongest commitment to integrating abstraction and figuration came at the end of World War II. In a series of paintings, drawings, and pastels he indicated a decisive shift away from geometric abstraction and realism, although both continued to figure in work throughout the 1940s (see, for example, *Untitled*, c. 1944, and *Portrait of Max Margulis*, 1944, pls. 33, 34), and away from the abstracted or idealized figure placed in "no-environment," toward a new and provocative series of images that merge figure and field. In such works as *Still Life* and *Pink Angels*, both c. 1945 (pls. 32, 35), de Kooning collaged fragments of forms, many recognizable from earlier works, which he reassembled into new, often less legible figures. The degree of distortion de Kooning brought to these images is new; so, too, is the heightened confidence and increased authority and abandon that characterize all the work of this period. The distortion implicit in earlier figures such as *Reclining Nude (Juliet Brauner)*, c. 1938 (pl. 36), is made explicit in de Kooning's postwar works. The reconstruction of the figure—as abstracted form—signals the beginning of de Kooning's mature work.

Pink Angels is one of the most distinguished paintings of the mid-1940s. It is

35 *Pink Angels*

c. 1945. Oil and charcoal on canvas, 52 × 40"
Collection Frederick Weisman Company,
Los Angeles

35 *Pink Angels*

36 Reclining Nude (Juliet Brauner)

c. 1938. Pencil on paper, 10¼ × 12¾"
Collection Courtney and Steven J. Ross

In 1936 de Kooning lived for a short time with Juliet Brauner, who later married Man Ray.

37 Study for Backdrop

1945. Pastel and pencil on paper
9¾ × 10"
Collection Mr. and Mrs. Donald M. Blinken,
New York

about light, color, and the tension between flatness and the illusion of depth. It is also about a release of energy that springs from within the artist, the release that comes from self-discovery and self-confidence. As such, *Pink Angels* is both a distillation of de Kooning's earlier work and a portent of the bold new direction that his paintings would take in the next few years. Familiar from previous paintings are several exquisite ovoid forms and the motif of the rectangle or window frame; to these he has added a series of shapes based on the female figure. While the vocabulary is in part a known one, the ease with which de Kooning handles his imagery is entirely new. So, too, is the way in which he disposes these elements upon the picture plane, with form overlapping form in the shallow space of the picture plane. De Kooning dismembers his figures and rearranges them in seemingly random order. Limbs, eyes, buttocks are displaced; the fragmented figure that we recognize from earlier Cubist-derived examples is segmented even further in this painting.

Pink Angels is notable not only for this conflation of planar structure, organic form, and scattered imagery but also for the new dialogue with great artists of the past that de Kooning, as a mature artist, establishes in his painting. Here he confronts issues he would have encountered in paintings by such masters as Vermeer and Velázquez. The latter's *Maids of Honor (Las Meninas)* thrives on an ambiguity created by the relationship of the artist, his subject, and their mirror images. And in the paintings of both artists the visible world is resplendent with reflected and refracted light. Although he does not duplicate the representational veracity of the images in these great prototypes, de Kooning appears to have been inspired by their formal relationships. He has flattened and compressed the world that exists within them, just as earlier he had begun to compress his figures

37 *Study for Backdrop*

38 Arshile Gorky
The Unattainable

1945. Oil on canvas, 41⅛ × 29¼″
The Baltimore Museum of Art:
Blanche Adler Bequest; Frederic W. Cone;
William A. Dickey, Jr.; Nelson and Juanita
Grief Gutman Collection; Wilmer Hoffman;
Mr. and Mrs. Albert Lion; Saidie A. May Bequest;
Philip B. Perlman Bequest; Leo M. Rogers, New
York; Mrs. James N. Rosenberg; and Paul Valloton
Funds. By exchange

Only eight paintings created by Gorky in 1945 have survived, as many works were destroyed in a studio fire in late January, 1946. The Unattainable is characteristic of his work of that year. Through his use of a "liner" brush, the work achieves a pen-and-ink look, even though it was executed in oil on canvas. The painting is replete with fanciful and weightless forms that hover in an ambiguous space.

in space by placing them in the most meager environment. He reiterates Veláz-quez's ambiguity of forms in space, and he begins to indicate his awareness of and appreciation for a light that emanates from within the painting.

A comparison of *Pink Angels* with Gorky's roughly contemporaneous *The Unattainable*, 1945 (pl. 38), reveals both the similarities and the differences be-tween the two artists and sheds light on de Kooning's relationship with Surreal-ism. Much critical opinion to the contrary, Surrealist imagery was an important influence on *Pink Angels* and indeed on the majority of de Kooning's work of the mid-to-late 1940s. The Surrealists were obsessed with sexual content, which took several forms in their art. Often this content was expressed in terms of Freudian symbols. For Miró, it meant procreation, birth, and renewal; it was allied to an at-titude that was for the most part playful and humorous. Dali's sexual imagery, in contrast, suggests voyeurism and violence; Matta's, aggression, violence, and death. The sexual content in Gorky's erotic paintings, with its depiction of male and female genitalia, can in some instances be compared with that of Matta's work, but more often it is similar in form and spirit to Miró's imagery. A compari-son of *The Unattainable* and *Pink Angels* demonstrates that de Kooning's vocabu-lary of erotic images is related to Gorky's. Both include references to sexual anatomy; where Gorky's imagery is flamboyant, however, de Kooning's is tem-pered; and where Gorky's is complex, multileveled, and fraught with Freudian meaning, de Kooning's appears to be a simple repertory of shapes grafted onto other formal systems.

De Kooning and Gorky differ not only in the degree and nature of Surreal-ist-derived erotic content in their work but also in their relationship to Surreal-ism. Gorky was not only liberated by Surrealist techniques and inspired by its imagery but also flourished within the Surrealist milieu. Breton saw no difficulty in classifying Gorky as a Surrealist, although his original inspiration was in nature while that of the Surrealists was, by Breton's definition, in pure psychic automa-tism. This difference was a significant one, for it separated Gorky from the Sur-realists, as it was later to separate him from the Abstract Expressionists. In fact, Gorky and the Surrealists proceeded in opposite directions, with the Surrealists cultivating images from random marks, moving, in Breton's term, "in favor of the subject." Gorky, on the other hand, was moving from nature toward abstrac-tion. De Kooning, unlike Gorky, was not actively involved with the Surrealists. Nor did he encourage a Freudian or Jungian interpretation of his work, as many of the other Abstract Expressionists did. Nevertheless, Surrealist automatism and sexual imagery were crucial for de Kooning, as they were for Gorky, Pollock, Gottlieb, Rothko, and the other members of the emerging New York School. Thus de Kooning was nourished by Surrealism; perhaps more than any other factor it influenced his great abstractions of the late 1940s.

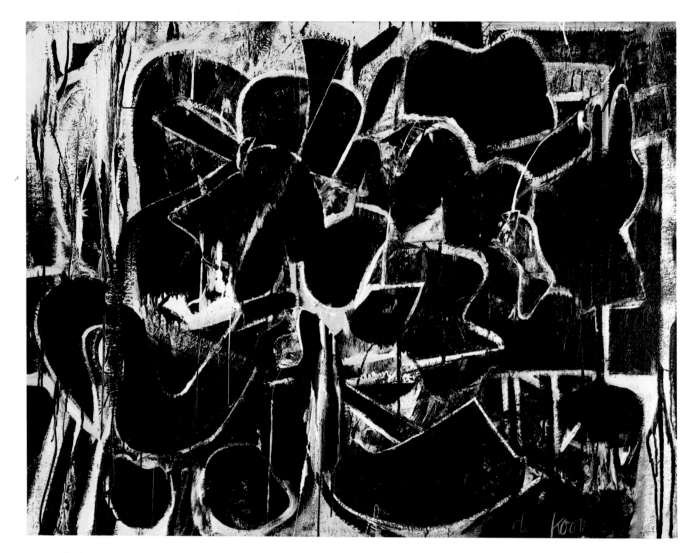

39 *Painting*

V. De Kooning and the New York School

I N 1946 ROBERT COATES, the critic for the *New Yorker*, applied the term "abstract expressionism" to the work of certain New York-based painters. The term had first been used in 1919 to describe Kandinsky's early abstractions, and it was employed again in this context by Alfred Barr, the first director of the Museum of Modern Art in New York. Partisans of the movement like Harold Rosenberg coined other terms, such as "action painting," in an attempt to define a new idiom. Rosenberg described the canvas as an arena, emphasized the primacy of the "act" of painting, and stressed the importance of accepting the image as an "event." Furthermore, the critic maintained:

The apples weren't brushed off the table in order to make room for perfect relations of space and color. They had to go so that nothing would get in the way of the act of painting. In this gesturing with materials the aesthetic, too, has been subordinated. Form, color, composition, drawing, are auxiliaries, any one of which—or practically all, as has been attempted, logically, with unpainted canvases—can be dispensed with. What matters always is the revelation contained in the act. It is to be taken for granted that in the final effect, the image, whatever be or not be in it, will be a tension (*Art News*, 1952, p. 23).

Rosenberg saw Action Painting as an existential experience in which the artist struggled to assert his identity through the medium of paint. Existentialism, introduced into America shortly after World War II, reinforced the Freudian belief in the power of the subconscious and the Jungian belief in the collective unconscious by introducing the concept of possibilities. With the notion of possibilities came a belief in paradox, the paradox of reconciling possibility and impossibility, and a belief that unfettered freedom to act results in anguish. The struggle for self-creation and the crisis in painting, stemming from the act and the angst of painting, became two of the most hotly discussed issues among the Abstract Expressionists.

Rosenberg believed that the "new painting has broken down every distinction between art and life" (*Art News*, 1952, p. 23). In the struggle for self-creation, the Abstract Expressionists attempted to capture the primary experience, the moment of inspiration. Painting had to be direct, immediate, spontaneous. The leap of the imagination favored by the Surrealists was transformed into a belief in the act of painting. Breton's desire to "move in favor of the subject" was translated into an art that was becoming ever more abstract while it was, nonetheless, an art that the painters insisted was still deeply involved with subject matter and content. For the artists of the New York School, everything was subject to question.

39 *Painting*

1948. Enamel and oil on canvas, 42⅝ × 56⅛"
Collection, The Museum of Modern Art, New York
Purchase

In his first one-man exhibition at the Egan Gallery in 1948, acclaimed by such noted critics as Clement Greenberg, de Kooning showed black-and-white abstractions begun around 1946. The Museum of Modern Art, New York, immediately purchased Painting, *the largest work in the exhibition. Although de Kooning had a substantial underground reputation by this time, these paintings marked his emergence as a painter of major distinction.*

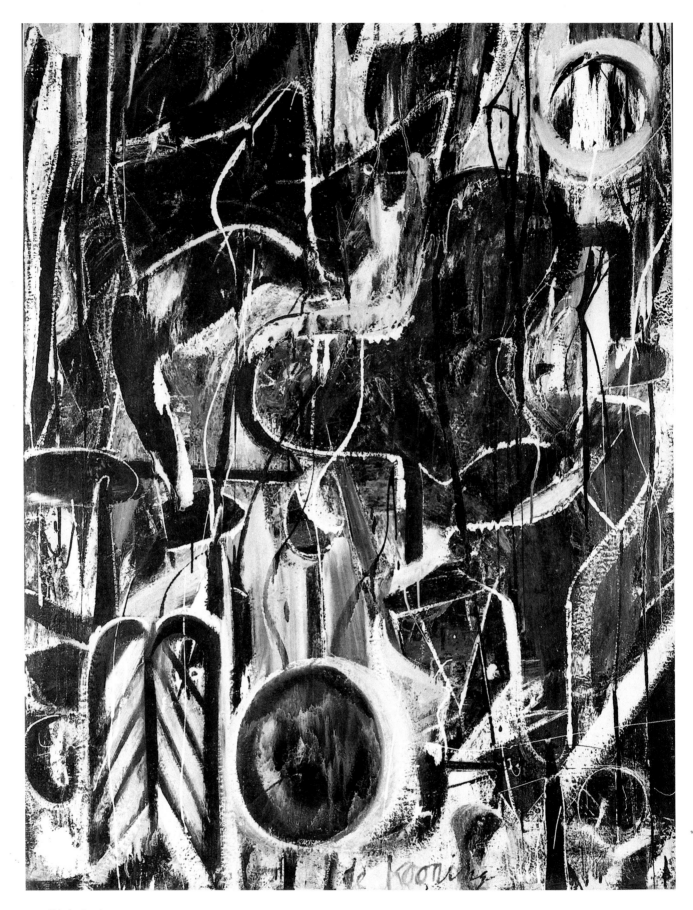

40 *Light in August*

41 *Orestes*

1947. Enamel on paper, mounted on plywood
24⅛ × 36⅛"
Private Collection

Words and letters were important to de Kooning since his early years as a sign painter in Rotterdam and New York. In works such as Orestes *and* Boudoir, *1950, he would begin painting by scattering a word ("Rapt" in* Orestes) *or letter ("B" in* Boudoir) *across the canvas in his constant search for new forms rich in ambiguity and associations.* Orestes *was titled by the publishers of the magazine* Tiger's Eye, *which reproduced de Kooning's work in an issue devoted to myth.*

The rejection of tradition per se (which was not a rejection of the great artists of the past) opened up all avenues of thought and creativity. Everything was possible—even the seeming impossibility of crossing the abyss, of breaching the void, of reaching the point of revelation through the act of painting.

The notion of when a painting was considered finished was a subject of lively debate. Among the artists who made statements on the subject were Newman, de Kooning, and Reinhardt, who spoke at artists' sessions held at Studio 35. The forerunner of Studio 35 was a school called Subjects of the Artist, which had been formed in late 1948 by Baziotes, Motherwell, Rothko, and the sculptor David Hare, soon after joined by Newman. (A primary objective of the school was to stress that abstract art has subject matter.) When they were unable to continue the school, it was reconstituted by others as Studio 35 and continued in existence until April, 1950. From April 21 to 23 of that year a three-day meeting was held to sum up the artists' sessions.

Newman considered the idea of a "finished" picture a fiction and stated: "I think a man spends his whole life-time painting one picture or working on one piece of sculpture. The question of stopping is really a decision of moral considerations. To what extent are you intoxicated by the actual act, so that you are beguiled by it? To what extent are you charmed by its inner life? And to what extent do you then really approach the intention or desire that is really outside of it. The decision is always made when the piece has something in it that you wanted."

De Kooning, who had a reputation for being unable to complete a painting, said, "I refrain from 'finishing' it. I paint myself out of the picture, and when I have done that, I either throw it away or keep it. I am always in the picture somewhere. The amount of space I use I am always in, I seem to move around in it,

40 *Light in August*

c. 1946. Oil and enamel on paper, mounted on
canvas, 55 × 41½"
Teheran Museum of Contemporary Arts

Many of de Kooning's black-and-white abstractions were done in zinc white and commercial black enamel, which he viewed as durable, on large sheets of paper, then mounted on Masonite with zinc white as an adhesive.

and there seems to be a time when I lose sight of what I wanted to do, and then I am out of it. If the picture has a countenance, I keep it. If it hasn't, I throw it away. I am not really very much interested in the question."

The existential dilemma of being involved with process and determining when a painting was finished was perhaps best stated by Ad Reinhardt: "It has always been a problem for me—about 'finishing' paintings. I am very conscious of ways of 'finishing' paintings. Among modern artists there is a value placed upon 'unfinished' work. Disturbances arise when you have to treat the work as a finished and complete object, so that the only time I think I 'finish' a painting is when I have a dead-line. If you are going to present it as an 'unfinished' object, how do you 'finish' it?" (*Artists' Sessions at Studio 35*, 1950, p.12).

In many ways as daring as the issue of finishing a painting was the decision to work in black and white. De Kooning began his now-famous black-and-white abstractions around 1946. The black-and-white paintings *Light in August*, c. 1946, *Orestes*, 1947, *Black Friday* and *Painting*, both 1948 (pls. 40, 41, 42, 39), are among the most remarkable examples of a body of work that some critics have ranked as the artist's highest achievement. Like many of his colleagues—Pollock, Motherwell, Gorky, Gottlieb, and Kline in particular—de Kooning worked in black and white during a period in his life when money was short. This lack of funds has often been cited as the chief reason for his sudden fascination with black and white as well as for his use of such common materials as household enamels. More probably, his rapid shift away from a figurative mode toward near abstraction demanded such a drastic change in materials and colors. De Kooning temporarily abandoned the luscious hues he had used until that point and substituted a palette that encouraged images of dark and dramatic intensity.

De Kooning, ever fascinated with the life of the city, drew inspiration for his black-and-white abstractions from the rich imagery of New York. It was common in the 1940s, as it had been in the 1930s, for painters to find in the city's peeling tenement walls and cracked pavements a wealth of source material. Newspapers, newsreels, and the news were sources of inspiration for many artists, de Kooning among them. Their enthusiastic admiration for New York extended to its billboards and ads, its neon lights, Times Square, cafeterias, secondhand bookstores. The brightness, darkness, and grittiness of the city provided its special character. New York is a black-and-white city, remarkable for its wealth of textures, dramatic contrasts of light and dark; it is hardly surprising that the special quality of the city, its profile, strong shadows, and equally strong light would be captured by a generation of artists that responded to its particular energy and vitality.

Light in August, *Orestes*, and *Dark Pond*, 1948 (pl. 43), to cite just a few examples, share a vocabulary of mythic imagery with the paintings of de Kooning's contemporaries Rothko, Gottlieb, Newman, Pollock, and Still. During the early 1940s Rothko and Gottlieb had developed a body of archetypal images based upon the Jungian theory of the collective unconscious, which they often substituted for the Freudian dream imagery of Surrealism without, however, abandoning their belief in the power of the subconscious. In a now-famous letter of 1943 addressed to Edward Alden Jewell, art critic of the *New York Times*, Rothko

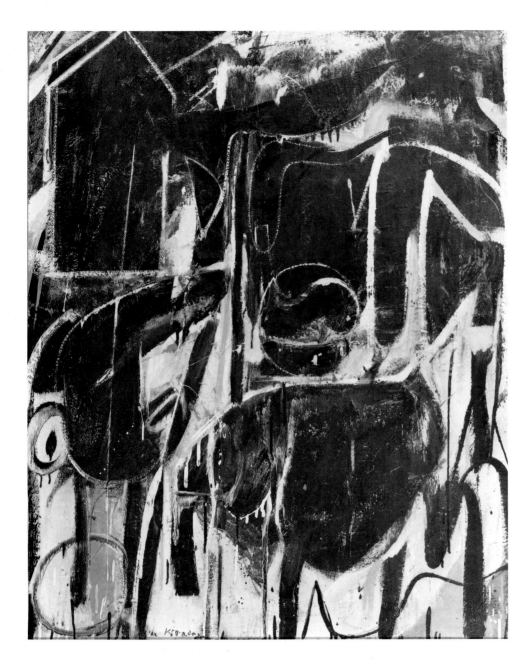

42 *Black Friday*

1948. Oil on composition board, 49¼ × 39″
The Art Museum, Princeton University
Partial and promised gift of Mr. and
Mrs. H. Gates Lloyd

and Gottlieb, assisted by Newman, asserted "that subject matter is valid which is tragic and timeless. That is why we profess spiritual kinship with primitive and archaic art."

In keeping with this belief, Rothko created a series of totemic images. Titles such as *Ritual*, 1944, *The Source*, 1945–46, and *Vessels of Magic*, 1946 (see, for example, pl. 45), indicate his interest in myth, in the archaic and the hieratic, while his organic shapes attest to his ongoing interest in the human form, biological life and marine organisms, and the elemental forces of nature. Although one can comb his imagery and find specific references to ear and flamelike forms (derived, as was much of the vocabulary of the time, from the specific imagery of Miró's Surrealist painting), it is too complex in its derivation and too ambiguous in its final form to be strictly interpreted as either nature- or myth-derived.

Gottlieb's pictographs, begun in 1941, combine a lattice-like grid, derived

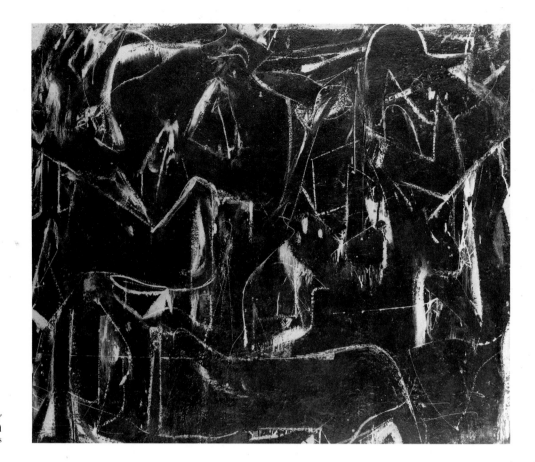

43 *Dark Pond*

1948. Enamel on composition board, 46¾ × 55¾″
Collection Richard L. Weisman and
The Frederick Weisman Company, Los Angeles

from Cubist precedents, with a highly charged vocabulary of signs and symbols (see, for example, pl. 46). References to an eye, a hand, a face, to teeth and other parts of the human anatomy constitute the residual data of his earlier involvement with the figure. They are part of a repertory of image-symbols—including snakes, birds, masks, and eggs—that he discovered in earlier art forms, in American Indian art and African sculpture, and which appeared to him to have universal significance as part of the collective unconscious. While Rothko abandoned references to the exterior world and the realm of mythic imagery as he increasingly withdrew into the inner world of existence, the grid provided Gottlieb with a fecund working formula for well over a decade. Both the random pattern of the grid and the equally random selection and juxtaposition of images were based on techniques of chance and automatism. As Gottlieb's work evolved during the late 1940s and early 1950s, he, too, gradually abandoned all but the most subliminal references to representation; he did not, however, relinquish his interest in nature-related phenomena. In contrast to Rothko, Gottlieb's paintings exude a palpable physical dimension that links his work to the Impressionists and the world of the senses.

Like Rothko and Gottlieb, Pollock was familiar with the doctrines of Freud and Jung. His introduction to the role of the unconscious in art and the power of myth and the collective unconscious originated, as it had with Gorky and de Kooning, in the writings of John Graham. Pollock's paintings of 1938–41 are

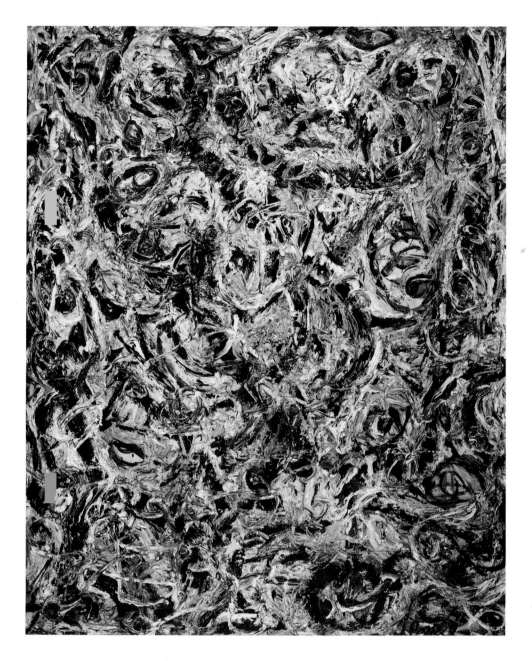

44 Jackson Pollock
Eyes in the Heat

1946. Oil on canvas, 54 × 43"
The Peggy Guggenheim Collection, Venice
Solomon R. Guggenheim Foundation, New York

This is one of seven paintings from the "Sounds in the Grass" series, a body of work that signaled major changes in Pollock's art. The image of the eye, which occurs frequently in the Surrealist vocabulary, was commonly used by such artists as Pollock, Gottlieb, and de Kooning. During the winter of 1946–47 Pollock began to integrate fully the surface of his paintings, which was one of the qualities that soon became characteristic of his all-over style.

crammed with images of serpents, skull, plant and animal forms. One of the most important images favored by Pollock in these paintings (one much favored by Gottlieb and de Kooning as well) was the eye; its usage indicates Pollock's familiarity with its role in Surrealist iconography in which the eye serves as a symbol of the juncture between inner and outer states of existence. Pollock continued to favor such images in the 1940s (see, for example, his *Eyes in the Heat*, 1946 [pl. 44]); like Rothko and Gottlieb, he began to group his repertory of signs into a compartmentalized structure. In *Guardians of the Secret*, 1943 (pl. 47), for example, he creates a rectilinear system that, like Gottlieb's, has its basis in the Cubist grid. As with Rothko and Gottlieb, titles allude to both the ritualistic and the totemic, while male and female forms remain ambiguous, part of the vocabulary of images that serve a dual role as mythic symbols.

45 Mark Rothko
Ritual

1944. Oil, pencil on canvas, 53¹⁵⁄₁₆ × 39½"
Walker Art Center, Minneapolis
Gift of The Mark Rothko Foundation, Inc., 1986

The titles of Rothko's paintings from this period reflect his interest in myth and ritual, prehistoric themes, and biological life. Here the calligraphic forms seem to relate specifically to marine organisms and more generally evoke the climate of organic abstraction prevalent in the 1940s among artists of the burgeoning New York School.

But myth, as it was interpreted in the new American painting, failed to capture the dynamic potential of the collective unconscious. Although Pollock was probably the most successful (certainly the most driven) in linking the role of the subconscious to the search for a genuinely modern form and content during the early and mid-1940s, he, like the others, personalized the subject rather than elevating it to the level of epic meaning. Although many New York School artists attempted to convert symbols of the subconscious into a universal language, they failed to do so because they were, in fact, moving away from a generalized vocabulary of symbolic forms toward a highly individual private mythology. Only a

46 Adolph Gottlieb
Alkahest of Paracelsus

1945. Oil on canvas, 59¼ × 43⅜″
Courtesy, Museum of Fine Arts, Boston
The Tompkins Collection, 1973.599

*During World War II Gottlieb contin-
ued to paint pictographs, symbol-laden
works structured by loosely formed grids.
At the same time his interest veered from
the mythical toward the alchemical, as
evidenced in the title of this painting,
which refers to a universal solvent intro-
duced by the sixteenth-century physician
Paracelsus.*

few Europeans, Picasso and Miró among them, could convert an event of tragic
consequences—the Spanish Civil War—into aesthetic statements that fused in-
ner meaning with external reality. In *Guernica*, Picasso's great lament on the
Spanish Civil War, 1937 (pl. 48), which was exhibited at the Valentine Gallery in
1939, myth takes on the meaning of the profoundly relevant. *Guernica* is at once
shocking in its forcefulness and brutality and timeless in its references to both
past and present. Because Picasso could ennoble a modern drama with the force
of legend, he was able to surpass the particular event, as momentous as it was, and
reveal in his subject the "tragic and timeless."

Picasso's achievement was unparalleled, however, and although the Ameri-

47 Jackson Pollock
Guardians of the Secret

1943. Oil on canvas, 48⅜ × 75⅜"
San Francisco Museum of Modern Art
Albert M. Bender Collection
Albert M. Bender Bequest Fund Purchase

Many of Pollock's paintings from the early 1940s reveal a concern for mythology and ritual, which was paralleled in the work of Rothko, Gottlieb, and others during the same period. Also evident in this painting is Pollock's interest in the technique of automatism, a method adopted from Surrealism by numerous artists of the New York School.

cans found inspiration in his painting, they could not imbue their work with the relevance they felt was inherent in myth. Nonetheless, many members of the New York School sought in myth a linkage with archaic art from which they hoped to draw inspiration for a new vocabulary of forms. For many of the Americans the combination of ancient myth and Freudian and Jungian symbolism was a way out of realism. They drew upon it in an interim period, creating paintings that were poetic in their metaphors and transitional in form, as they were driven toward a new, if uncharted, art. While the Surrealists sought archetypal images to represent the highly charged world of their subconscious minds, many of the future Abstract Expressionists developed a vocabulary of signs to give meaning to abstract art. Their art achieved a new resonance when they sublimated all but the most cursory vestiges of primitive signs and literary symbols and consecrated themselves to the realm of pure painting.

Although de Kooning never developed a programmatic vocabulary of signs and symbols for his paintings to the extent that Rothko and Gottlieb did, his work of the mid-to-late 1940s indicates his interest in incorporating mythic imagery into his painting. Paintings such as *Light in August* and *Orestes* achieve a measure of their dramatic intensity by the amalgamation of symbolic images with other more mundane forms. In paintings such as *Light in August*, for example, the orb located near the lower center of the painting radiates an intense presence that suggests supernatural phenomena. Shapes like these are not unlike the allegorical imagery favored by his friend and colleague Barnett Newman.

Like most of the painters and sculptors of the New York School, Newman had been an admirer of the Surrealists during the mid-1940s. During this period he produced a number of Surrealist-influenced drawings and watercolors, executing his automatic, frottage-like drawings first in black and white and in 1944 adding color with grease and oil crayons, as in *The Blessing* (pl. 49). (Frottage is a

48 Pablo Picasso. *Guernica*

1937. Oil on canvas, 11′5½″ × 25′5¾″
Museo Nacional del Prado, Madrid

A potent evocation of agony and terror, Guernica *stands as a monument in twentieth-century art. Commissioned by the Spanish government to paint a mural in 1937 for the upcoming Paris World's Fair, Picasso began work on this project two days after it was reported that the Basque town of Guernica had been destroyed by German bombers in the service of General Franco.*

technique pioneered by Max Ernst, who made rubbings from sheets of paper placed over floor boards, for example; these rubbings suggested images to the artist.)

Calligraphic, heavily textured, and improvisational oils followed, often featuring circular (female) and vertical (male) elements. Newman's *Genesis–The Break*, 1946 (pl. 52), features orblike shapes; its title affirms its meaning as symbolic, suggesting divinity and creation. *Light in August* shares with these paintings a sense of divine mystery and power; unlike Newman's quiescent paintings, de Kooning's canvas resonates with an energy and forcefulness that herald his more expressive and dynamic Women of the 1950s. *Orestes*, on the other hand, despite its title and the eyelike form looming near the top left-hand side of the painting, is more compelling as allover composition than notable for its mythic content.

For many of the painters of the New York School, titles were an important clue to the meaning of the work. Certainly for Rothko, Gottlieb, Pollock, Newman, and Gorky, to mention just a few, titles offered poetic enhancement, reference to ancient civilizations, rites of passage, so to speak, that linked the work of the painters with the work of artists and art that they admired. Many of Gorky's titles make reference to his lost home and country, Armenia, while others are a key to his agonized emotional state. Newman's titles have biblical connotations.

De Kooning, however, seems the least committed of his colleagues (with the exception of his friend Franz Kline) to the literary and poetic allusion that other artists encouraged with their titles. *Orestes*, for example, was not de Kooning's choice but a title given to the painting by the publishers of *Tiger's Eye*, a periodical that functioned primarily as a forum for Surrealist, Abstract Expressionist, and Existentialist ideas. (*Orestes* and Newman's *Death of Euclid*, 1947, were published in the same issue of *Tiger's Eye*.) As de Kooning acknowledged a few years later, the matter was an open issue. He felt, in fact, that if an artist could always title his picture, "that means he is not always very clear" (*Modern Artists in America*, pp. 14, 16). The role of the subject remains somewhat ambiguous here, as in de Kooning's work of the previous decade. In the paintings of the 1940s de Kooning extended this sense of ambiguity to the role of myth in his work.

49 Barnett Newman
The Blessing

1944. Mixed media on paper, 25½ × 19″
Collection Annalee Newman, New York

*Like many of Newman's drawings from
1944,* Blessing *shows an interest in bo-
tanical and biological growth. Its shapes
suggest seedlings stretching roots and
sprouts toward the paper's edges, while
the overall effect is one of organic
abstraction.*

Just as myth played an important, if not decisive, role in de Kooning's work
of the 1940s, so biomorphic imagery, which lent itself to mythic interpretation,
figured prominently in the black-and-white paintings. As he had before, de
Kooning looked to the example of Miró for a source of imagery that was connect-
ed both to the realm of the imagination and the realm of the ordinary. In works
such as *The Tilled Field*, 1923–24 (pl. 50), Miró embedded fragments of actual
forms into an imaginary landscape. Miró's transformation of objects into signs is
clearly adapted by de Kooning in his paintings of the period. Unlike Miró, how-
ever, de Kooning compressed his "form-signs" into a relatively shallow space so
that they read much closer to the surface plane than the Miró in question. Miró's
composite imagery, pieced together from human and animal anatomical frag-
ments, fed the New York-based artists' need for dislocated biomorphic forms.
The Surrealist device of dislocation and juxtaposition of disparate elements on
the same plane was used to great advantage by de Kooning in his paintings of the
1940s.

Similarly, his appreciation of Arp was undoubtedly based on the European's
use of biomorphic forms and his development of chance collage. In Zurich, in
1915, Arp made a number of "concrete" collages resembling the collages of Pi-
casso, Braque, and Juan Gris, using printed papers, fabrics, anything he could
get his hands on. Chance played a fundamental role in Arp's philosophy, stem-
ming apparently from his appreciation of Zen Buddhism and a belief in the sig-
nificance of the chance aspects of events. The philosophy that Arp devised for his
"papiers déchirés" was based on an acceptance of the idea that a work of art could
result from tearing up paper and throwing it on the floor, with the disposition of
the pieces assuming a sort of occult significance. Crucial to Arp was the idea that
these collages were impersonal. De Kooning appears to have elaborated on Arp's
experiments with collage in cutting up and splicing different images together,
creating a hybrid that was partly based on randomness and partly the result of
deliberate calculation. The method that he devised for the black-and-white
paintings, which he continued to use in the Women series, was described by
Hess: "He will do drawings on transparent tracing paper, scatter them one on
top of the other, study the composite drawing that appears on top, make a draw-
ing from this, reverse it, tear it in half, and put it on top of still another drawing"
(Hess, 1968, p. 47).

In contrast to the near-black of *Light in August, Orestes* is a more evenly paced
composition in black and white. The horizontality of this small painting gives it a
sense of openness and lateral expansion and a suggestion of space that is missing
in the densely impacted, vertically oriented *Light in August*. Like Pollock, de
Kooning experimented with common household paints; cheap, easy to use,
quick to dry, they became an ideal medium for both artists. De Kooning used Sa-
polin and Ripolin paints, often mixing his paint with pumice to alter its viscosity;
he frequently worked on paper, which he then mounted on canvas, plywood,
and composition board. The majority of the works in this series are small or me-
dium in size, many measuring less than four-by-five feet; yet they are so success-
fully resolved that they have the impact of big pictures. When Pollock began, in

50 Joan Miró
The Tilled Field

1923–24. Oil on canvas, 26 × 36½″
Solomon R. Guggenheim Museum, New York

Generally considered to be the first work painted in the artist's mature style, The Tilled Field *is an early Surrealist canvas that introduces symbolic images from the imagination while retaining vestiges of a conventional landscape view. With abrupt shifts in scale, Miró juxtaposes plant and animal motifs with wit and fantasy.*

late 1946 and early 1947, to drip and pour liquid enamel and aluminum paint onto large-sized, unprimed canvas laid out on the floor of his studio, it was with a sense of urgency and an awareness of the potential of using the means of painting as an end in itself. As he stated:

On the floor I am more at ease. I feel nearer, more a part of the painting, since this way I can walk around it, work from the four sides and literally be in *the painting. This is akin to the method of the Indian sand painters of the West.*

When I am in *my painting, I'm not aware of what I'm doing. It is only after a sort of "get acquainted" period that I see what I have been about. I have no fears about making changes, destroying the image, etc., because the painting has a life of its own. I try to let it come through. It is only when I lose contact with the painting that the result is a mess. Otherwise there is pure harmony, an easy give and take, and the painting comes out well* (Possibilities, Winter 1947–48, p. 78).

In his classic drip paintings of 1947–50, Pollock evolved a labyrinthian network of paint skeins that created a sense of continuous movement and an illusion of shallow space that extends behind the picture plane or laterally beyond the canvas edges while at the same time drawing attention to the flatness of the field. As in paintings like *Eyes in the Heat*, there is implicit in many later canvases a vortex motion that probably derives from the way in which he worked. This whirling or circular movement occurred despite Pollock's attention to flatness; it sets up a tension in many of his best drip paintings that relieves them of the stasis that would otherwise occur as the result of his allover imagery.

De Kooning has acknowledged that Pollock "broke the ice"; indeed, he led other painters of the New York School in disassociating automatism from asso-

51 *Painting*

52 Barnett Newman
Genesis—The Break

1946. Oil on canvas, 24 × 27"
Collection Dia Art Foundation, New York

Between 1944 and 1946 the vertical element characterizing Newman's mature style began to assume prominence in his work. In 1946 and 1947, gradually losing its suggestion of plant growth, this vertical element was often combined with symbolic circular shapes, while titles such as this one allude to allegorical and biblical subjects.

ciational imagery and thus in developing large-scale gestural abstract imagery. While by no means as extensive a group, de Kooning's black-and-white paintings rival Pollock's canvases in their powerful formal organization, compelling imagery, and masterful improvisation. Here de Kooning achieved a synthesis of emblematic imagery, calligraphic stroke, and gestural painting without peer. In such paintings as *Black Friday*, *Dark Pond*, and *Painting*, all of 1948, de Kooning made his strongest commitment to abstraction to date. But he could never yield to a completely abstract imagery, and even in these paintings, as in *Light in August* and *Orestes*, there is evidence of the real world (a mailbox or a house), fragments of the lettering that captivated him, and shapes that are reminiscent of portions of the figure. As others have noted, de Kooning revels in paradox; it is precisely the paradoxical quality of intermingling these seemingly contradictory elements that de Kooning capitalizes on in these extraordinary paintings. This, together with his unrivaled command of shape, stroke, and pigment, enabled him to produce the superb body of work represented by the black paintings.

Having created this body of work (de Kooning continued working on them into the early 1950s), the artist went on to paint their exact opposite—a number of white or near-white canvases that culminate in *Attic*, 1949, and *Excavation*, 1950 (pls. 56, 58). Here, for the first time, de Kooning worked on a large scale and produced in *Excavation* his most epic painting to date. As he had in the black paintings, de Kooning continued to be obsessed by shape; both paintings are no-

51 *Painting*

c. 1950. Oil and enamel on cardboard, mounted on composition board, 30⅛ × 40"
Collection Mr. and Mrs. S. I. Newhouse, Jr., New York

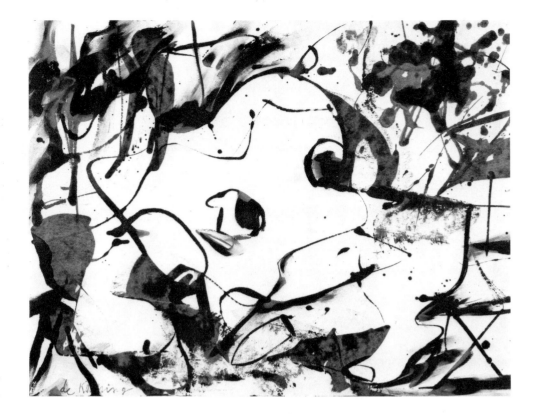

53 *Black and White Abstraction*

c. 1948. Sapolin enamel on paper, 21¼ × 31¼"
Collection Andrew and Denise Saul, New York

table for their mixture of abstract forms and images culled from his vocabulary of figures. References to *Guernica* abound in some of the imagery, in the artist's use of black and white, and in the impression of newsprint that is occasioned, in *Attic*, by his use of newspaper transfer. Above all, there is a sense of agitation and anguish in both paintings that is represented not so much by the subject as by the way in which de Kooning manipulates paint. Although individual images pierce the continuity of both paintings, the allover integration of shapes is far more pronounced in these white canvases than it was in the black paintings.

De Kooning took several months to complete *Excavation*; this process is evident in the painting. The painting has a density to it that belies its color; in fact, as Harold Rosenberg has noted, the artist was obsessed by the canvas, doing and undoing it, painting out and repainting it numerous times. It has a built-in layering that few paintings of the period achieve. In contrast to the lustrous surface or lacquer-like finish of many of his black paintings, the white paintings seem much more opaque; light soaks into, rather than bounces off, their surfaces. In both paintings, de Kooning continues to use the sexual imagery prevalent in earlier Surrealist-inspired canvases; now, however, the imagery is more threatening, the shapes more angular, the brushwork more active. In *Attic*, de Kooning contrasts shape by rimming its outline with yet another stroke; in other areas he obliterates the contours of a form by brushing over it with a thick layer of paint. In some passages of the painting, de Kooning appears to layer shape upon shape; in other areas he flattens out forms or submerges them in the field of the canvas.

As remarkable as *Attic* is, *Excavation* is that much more extraordinary. It is de Kooning's *Les Demoiselles d'Avignon*, the painting in which he reached beyond the

54 *Sail Cloth*

1949. Oil on canvas, 24 × 30"
Collection Donald and Barbara Jonas, New York

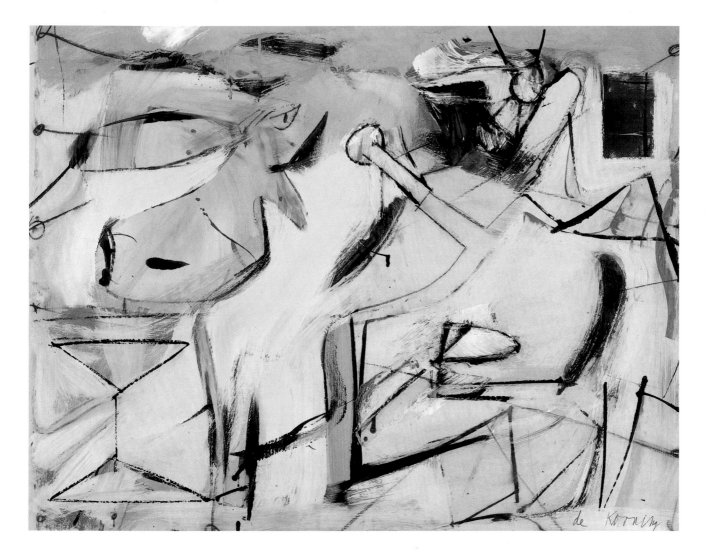

54 *Sail Cloth*

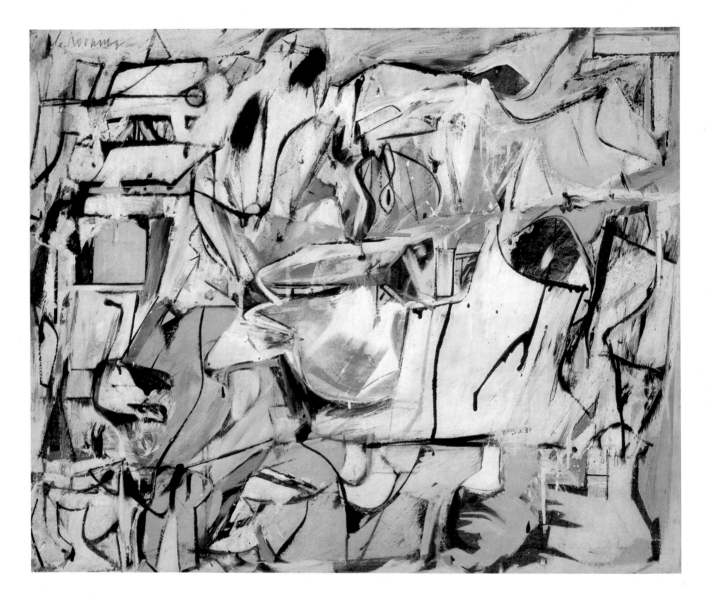

55 *Asheville*

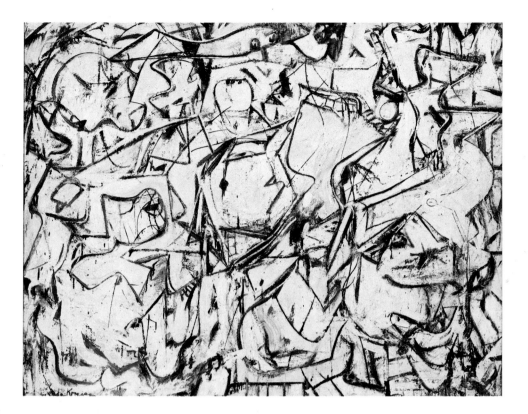

56 *Attic*

1949. Oil, enamel, newspaper transfer on canvas
61⅞ × 81″
Jointly owned by The Metropolitan Museum of Art
and Muriel Kallis Newman, in honor of her son
Glenn David Steinberg
The Muriel Kallis Steinberg Newman Collection,
1982. (1982.16.3)

This dense, highly complex composition exposes de Kooning's inventive method of slicing drawings. He would draw on transparent papers, place them one on top of another, and prepare a new drawing from the forms that emerged. Then he would slice this drawing and place it atop still another in order to discover new, provocative motifs.

known into the realm of the inspired, just as his friend Gorky had done a few years earlier in his climactic painting, *The Liver Is the Cock's Comb*, 1944 (see pl. 57). It is the painting in which de Kooning freely synthesizes figure and field, shape and line, black and white, the painting in which he skillfully reintegrates color into the field and allows it to activate the surface without dominating the image. As Picasso had flattened form and distorted his figures, so de Kooning continues the process, flattening and compressing forms until all the space in the canvas is squeezed out. Here, too, de Kooning continues his practice of collaging forms together without, as he had before, allowing one shape to dominate another. In doing so, *Excavation* is both a summation of de Kooning's near-abstraction and predicates his renewed interest in the figure expressed in his much heralded series of Women.

Although *Excavation* was included in the Museum of Modern Art's exhibition "Abstract Painting and Sculpture in America," held in the winter of 1951, the painting does not fit the definition of abstraction, if by that term we mean nonobjective or nonassociational. As de Kooning himself said, "Even abstract shapes must have a likeness" (Hess, 1968, p. 47). De Kooning developed his shapes from objects in the real world; as in *Excavation*, the shapes become familiar as part of a vocabulary of forms that we now acknowledge as one of the artist's own invention. To the extent that de Kooning's paintings, like those of all great artists, are about form, line, and color, they are fundamentally abstract. But even though de Kooning was a successful, if occasional, painter of abstract, nonobjective subject matter, those subjects were wedded to the real world from which, for him, all form stems. This, of course, does not mean that de Kooning could not

55 *Asheville*

1949. Oil on illustration board, 25½ × 32″
The Phillips Collection, Washington, D.C.

In Asheville de Kooning placed a piece of painted cardboard directly on top of a painted surface and then proceeded to paint it into the composition to foster ambiguity in the work. De Kooning's unwavering fascination with chance effects is underscored by this arbitrary juxtaposition of two unrelated paintings.

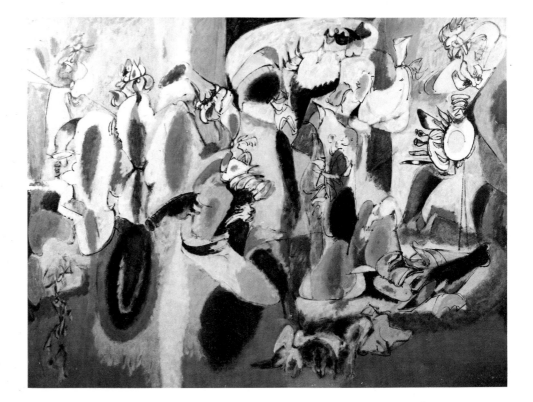

57 Arshile Gorky
The Liver Is the Cock's Comb

1944. Oil on canvas, 72 × 98"
Albright-Knox Art Gallery, Buffalo, New York
Gift of Seymour H. Knox, 1956

Gorky's focus on sexuality, most pronounced in the 1940s, is one of his closest links to Surrealism. Here this ranges from literal depictions of male and female genitalia in the lower middle and left side of the composition to more ambiguous allusions through color, shape, and placement, similar to those used by Miró and Matta. In this painting the intense color and uninhibited line convey a heightened sense of erotic ecstasy.

58 *Excavation*

1950. Oil on canvas, 6'8⅛" × 8'4⅛"
The Art Institute of Chicago
Mr. and Mrs. Frank G. Logan Purchase Prize
Gift of Mr. Edgar Kaufman, Jr.,
and Mr. and Mrs. Noah Goldowski, 1952.1

One of the largest paintings executed by de Kooning, Excavation was completed in time to be included in his one-man exhibition in the Venice Biennale of 1950. In 1951 this work was the highlight of the Museum of Modern Art's "Abstract Painting and Sculpture in America" show and won the Logan Medal and Purchase Prize in the "60th Annual American Exhibition" at the Art Institute of Chicago.

capitalize on the world of the imagination; it does mean that he chose not to give it literal shape, as did many of the Surrealists. Nor did he allow the process of painting to take him into the realm of total abstraction, the path that Pollock chose, or into the realm of the transcendental, like Rothko and Newman. In a statement that he prepared for a symposium held at the Museum of Modern Art on February 5, 1951, de Kooning illuminated his feelings about abstraction:

The word "abstract" comes from the light-tower of the philosophers, and it seems to be one of their spotlights that they have particularly focussed on "Art". . . . As soon as it—I mean the "abstract"—comes into painting, it ceases to be what it is as it is written. It changes into a feeling which could be explained by some other words, probably. But one day, some painter used "Abstraction" as a title for one of his paintings. It was a still life. And it was a very tricky title. And it wasn't really a very good one. From then on the idea of abstraction became something extra. Immediately it gave some people the idea that they could free art from itself. Until then, Art meant everything that was in it—not what you could take out of it. There was only one thing you could take out of it sometime when you were in the right mood—that abstract and indefinable sensation, the esthetic part—and still leave it where it was. For the painter to come to the "abstract" or the "nothing," he needed many things. Those things were always things in life—a horse, a flower, a milkmaid, the light in a room through a window made of diamond shapes maybe, tables, chairs, and so forth (MoMA, Bulletin, XVIII, no. 3, Spring 1951).

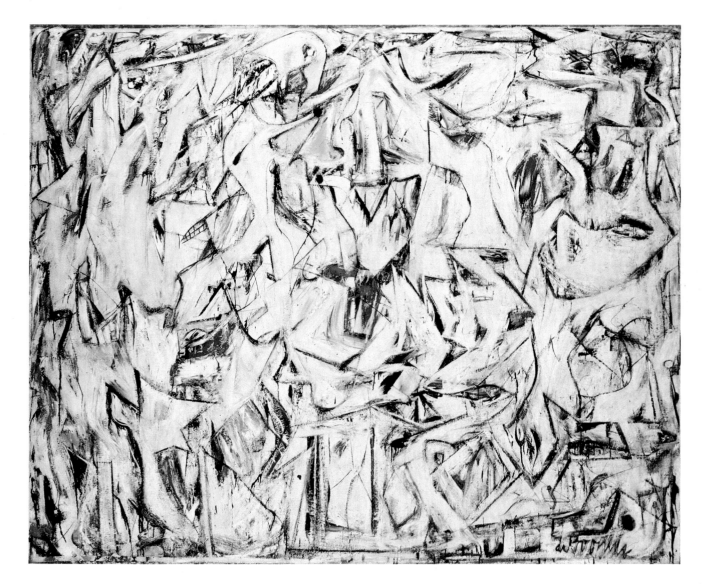

58 *Excavation*

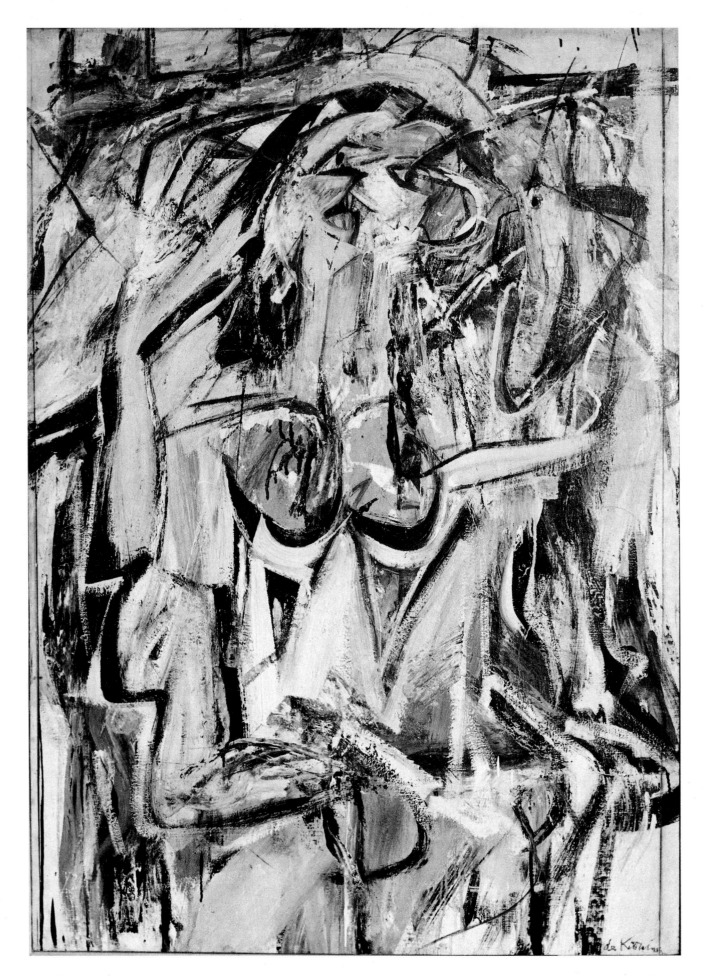

59 *Woman*

VI. The Image of Woman

Excavation left de Kooning's studio in 1950; shortly thereafter he tacked a large canvas to his studio wall and began to paint *Woman I* (pl. 69). Tom Hess has noted that "it was not finished until two years later, having been abandoned after about eighteen months' work, then retrieved at the suggestion of de Kooning's friend, the art historian Meyer Schapiro, and finally finished along with five other Women. They were exhibited in the artist's third one man show, at the Sidney Janis Gallery, in March 1953" (1968, p. 74). Of the Women, de Kooning said:

Certain artists and critics attacked me for painting the Women, *but I felt that this was their problem, not mine. I don't really feel like a non-objective painter at all. Today, some artists feel they have to go back to the figure, and that word "figure" becomes such a ridiculous omen—if you pick up some paint with your brush and make somebody's nose with it, this is rather ridiculous when you think of it, theoretically or philosophically. It's really absurd to make an image, like a human image, with paint, today, when you think about it, since we have this problem of doing or not doing it. But then all of a sudden it was even more absurd not to do it. So I fear that I have to follow my desires* (Sylvester, *Location*, 1963, p. 46).

Although much has been made of de Kooning's return to the figure, the fact remains that he never abandoned it. From 1947–49 de Kooning painted a number of significant images, all of them of women. Paintings such as *Woman*, 1948, *Two Women on a Wharf*, 1949, and *Woman*, 1949–50 (pls. 61, 60, 59), attest to his ongoing fascination with the subject. The paintings themselves relate to the black-and-white and color "abstractions" of the period for which de Kooning was acclaimed as a vanguard painter. Although these works lack the resolution of his more acclaimed "abstract" paintings, they are similar in shape, line, and color to *Attic*, 1949, and other paintings of the period. They are also predictive, not only of his more resolved Women of the 1950s but of other avenues open to the artist that he had yet to explore.

Such paintings as *Two Women Standing* and *Two Women on a Wharf* hint at de Kooning's subsequent landscape paintings. Both works summarily reject the sealed interior of the earlier figurative paintings for the suggestion of the out-of-doors. Still other works, such as *Woman, Wind and Window I*, 1950 (pl. 62), suggest an interior, the bedroom and reclining figures. Although the majority of these paintings are as accomplished as others of this time, they lack the monumental configuration that de Kooning achieved with *Woman I*. Of all the paintings, only

59 *Woman*

1949–50. Oil on canvas, 64 × 46"
Permanent Collection of Weatherspoon Art Gallery
University of North Carolina at Greensboro
Lena Kernodle McDuffie Memorial Gift, 1954

De Kooning's superb handling of line, so apparent in his black-and-white paintings, can also be seen in his Women of the 1940s and 1950s. With a thick black line he literally shapes his Women on the canvas, producing works that combine expressive drawing with painting.

79

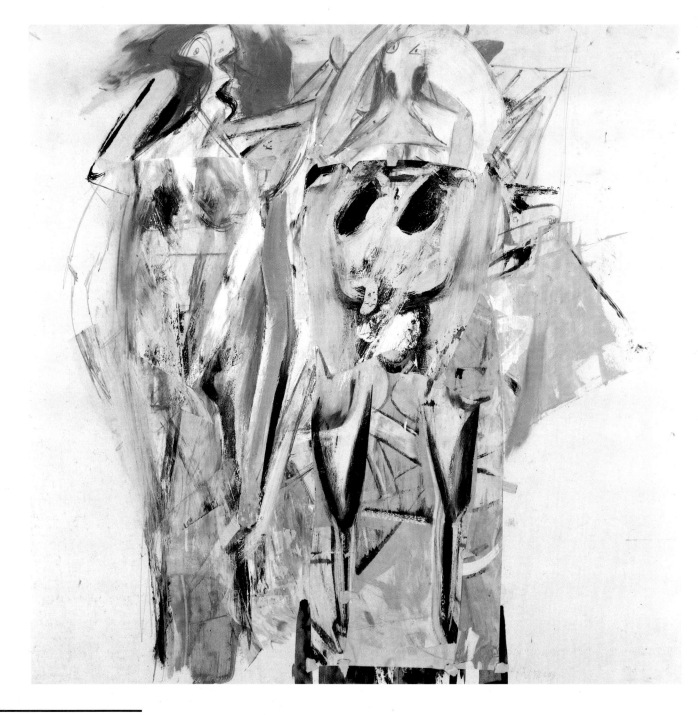

60 Two Women on a Wharf

1949. Oil, enamel, pencil, collage on paper
24⁷⁄₁₆ × 24⁹⁄₁₆″
Art Gallery of Ontario, Toronto
Purchase, Membership Endowment Fund, 1977

Generally de Kooning's Women were painted singly. When they appear in pairs, as in Two Women on a Wharf, *their bodies often intertwine, producing a complex mélange of forms and colors. This composition is further enriched by the addition of collage elements. In de Kooning's second series of Women he introduced the standing or full-length figure.*

61 Woman

1948. Oil and enamel on board, 53½ × 44½″
Hirshhorn Museum and Sculpture Garden
Smithsonian Institution, Washington, D.C.
Gift of Joseph H. Hirshhorn Foundation, 1966

In 1947 de Kooning embarked on his second series of Women paintings, which would continue through 1949. Like Woman, 1948, *these figures are marked by a greater ferocity and aggressiveness than those in the earlier series.*

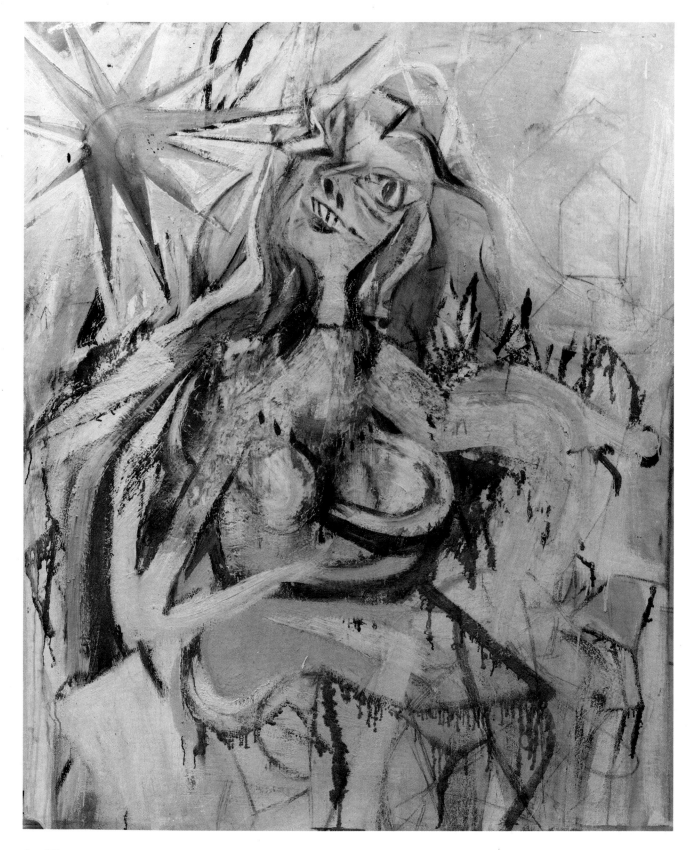

61 *Woman*

62 *Woman, Wind and Window I*

1950. Oil and enamel on paper mounted on board
24⅛ × 36″
Warner Communications, Inc., New York

*The tension between abstraction and ob-
jective reality that characterizes this work
continued to engage de Kooning through-
out his career. Here, however, his idea of
ambiguity has achieved even greater
heights as he plays with the relationship be-
tween figure and window, interior and
exterior.*

63 *Woman*

1950. Oil, enamel, and pasted paper
on paper, 14⅝ × 11⅝″
The Metropolitan Museum of Art
From the Collection of Thomas B. Hess
Jointly owned by The Metropolitan Museum of Art
and the heirs of Thomas B. Hess, 1984
(1984.613.6)

Woman, 1949–50, approaches the size of *Woman I*, but even here the figure has a fragility and vulnerability that set her apart from the commanding and authoritative *Woman I*.

De Kooning's image of Woman has been much discussed and often described in negative terms. However, the Women, like the rest of his oeuvre, are not easily classified. Although here as before he patterned certain features of the female anatomy after Surrealist prototypes, de Kooning's figures relate more closely to the prostitutes of Manet's *Olympia* or Picasso's *Les Demoiselles d'Avignon*. In fact, they fit quite comfortably within the tradition of such depictions of demi-mondaines but are also rooted in popular fantasy. The smiling female of the magazine ads and the sex goddess as incarnated in Marilyn Monroe are transformed into modern icons. Too aggressive and turbulent to recall Titian's reclining pastoral nudes, they nevertheless echo Rubens and reflect a Baroque concept of beauty.

But there is also an undeniable element of parody in de Kooning's approach that prefigures Pop Art attitudes. Moreover, de Kooning, like Stuart Davis, Gerald Murphy, and certain other earlier Americans, predicted Pop Art in drawing inspiration from many facets of popular culture as well as in his choice of specific images. For example, a detail of the T-zone from a Camel cigarette ad that appeared on the back cover of *Time* magazine in 1949 was incorporated into a study for *Woman*, 1950 (pl. 63). This is the type of imagery James Rosenquist might have used in the early 1960s, and the kind of subject Andy Warhol depicted in his Marilyn paintings. De Kooning's remarks on collaging the mouth in the Camel ad throw light on some of the many levels of his imagery:

THE IMAGE OF WOMAN

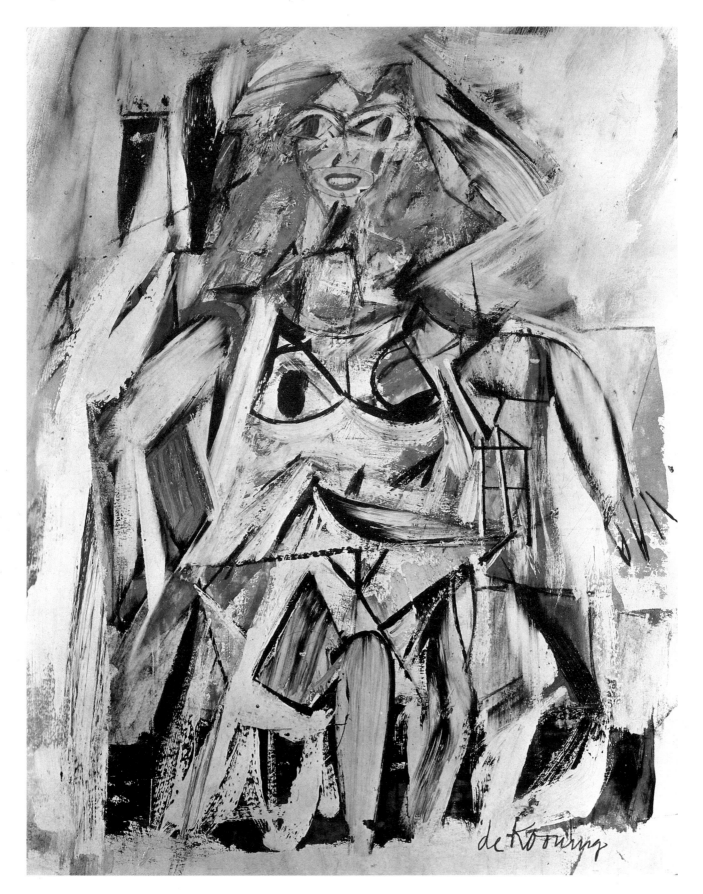

63 *Woman*

64 *Montauk Highway*

I cut out a lot of mouths. First of all, I thought everything ought to have a mouth. Maybe it was like a pun. Maybe it's sexual. But whatever it is, I used to cut out a lot of mouths and then I painted those figures and then I put the mouth more or less in the place where it was supposed to be. It always turned out to be very beautiful and it helped me immensely to have this real thing. I don't know why I did it with the mouth. Maybe the grin—it's rather like the Mesopotamian idols, they always stand up straight, looking to the sky with this smile, like they just were astonished about the forces of nature you feel, not about problems they had with one another. That I was very conscious of—the smile was something to hang onto (Sylvester, *Location*, 1963, p. 47).

De Kooning has been inspired by ads and by idols and fascinated by the image of the movie star. He tacked up on his studio wall photographs of sports events and named his paintings after such embodiments of contemporary life as superhighways, for example, *Montauk Highway* of 1958 (pl. 64). Since the late 1940s, de Kooning had been attracted to the radiant American female pictured on billboards and trucks. He commemorated them in several works entitled *Woman on a Sign*, of which *Woman on a Sign II* of 1967 (pl. 65) is an example. He used such banal stereotypes as the movie queen to serve a dual function: he exploited his subjects' loaded meanings as symbols of cultural phenomena and gave them more profound significance in his exploration of the abstract potential of the human form. It is but a short step from the transformation of this kind of popular imagery into abstract form to the flags and targets of Jasper Johns.

Although de Kooning has generally been acknowledged as one of the founders of Action Painting and the major influence on subsequent generations of abstract painters, his contribution was based on the style rather than the substance of his art. De Kooning's broad sweeping gestures, the speed with which he executes his paintings, their facture are echoed in all the mannerisms of his followers. Far more fascinating, however, is the effect de Kooning had on Pop Art, which touched on both attitudes and specific imagery, and especially his influence on Johns and Robert Rauschenberg, precursors of this movement.

Both Johns and Rauschenberg employed a form of brushstroke that called to mind, even parodied, if not specifically de Kooning's paint handling certainly the technique of Abstract Expressionism in general. While the two artists are usually regarded as linking Abstract Expressionism and Pop Art, it is Johns' consistently painterly style and iconic treatment of his subjects and Rauschenberg's constructed, additive art that are most aptly compared with de Kooning's work. Although de Kooning, Rauschenberg, and Johns all exploited the tension created by the opposition of figure and ground, de Kooning dematerialized his subject in order to effect a reconciliation of its three-dimensional form with the flat picture plane. Johns and Rauschenberg, on the other hand, emphasized the materiality of objects. As de Kooning tested the nature of illusion by incorporating images drawn from the vernacular into his painting, so Johns and Rauschenberg did by inserting actual objects from the real world into their work.

Synthetic Cubism set a historical precedent for de Kooning's integration of representations of commonplace things into his painting, but such precedent is by no means the paramount factor in this aspect of his art. Equally important is a

64 *Montauk Highway*

1958. Oil on canvas, 59 × 48″
Los Angeles County Museum of Art, California
The Michael and Dorothy Blankfort Collection
TR.5663/L.76.68

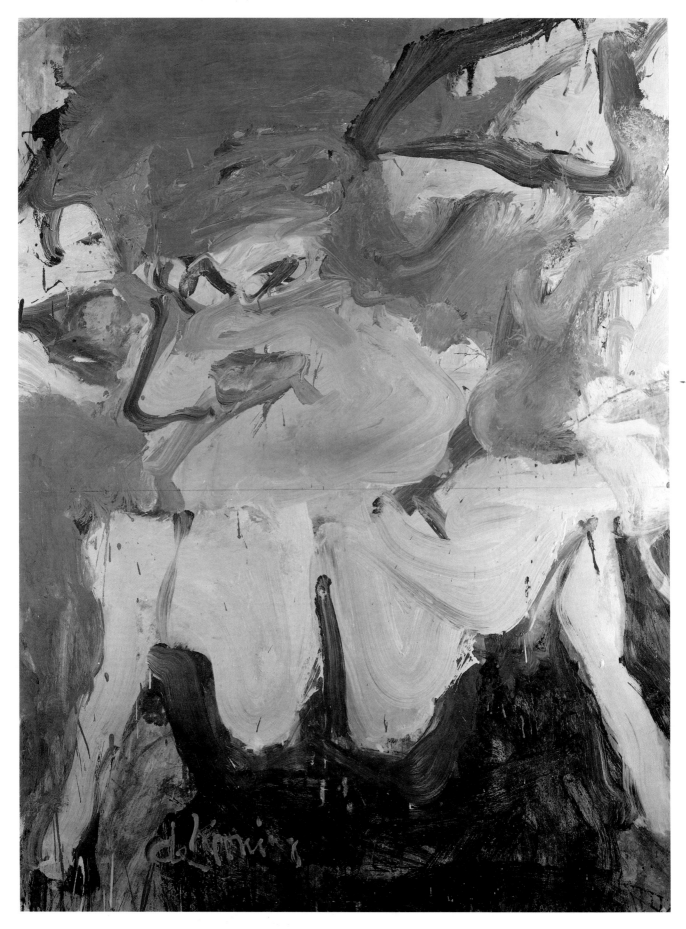

65 *Woman on a Sign II*

catholic attitude that allows him to embrace parody, bawdy humor, even slapstick as a part of his work and to draw inspiration from film, TV, and that master of the double entendre, Marcel Duchamp.

Duchamp can be credited with challenging the sanctity of the art object by calling common everyday things, such as the urinal and the bottle rack, "Ready-mades" and dubbing them works of art by virtue of his having chosen them and added his signature to them. Successive generations of American artists in the 1950s and '60s, inspired by his example, used art to question the nature and identity of both art and reality. De Kooning, Rauschenberg, and Johns, elaborating upon Duchamp's use of commonplace subjects, have transformed them into twentieth-century secular icons.

As the father of Dada, Duchamp loosened the ties that bound twentieth-century artists to fixed concepts or rigid standards. His heretical ideas must surely have been important in helping to free de Kooning from the strictures of the craft tradition in which he had been trained in Europe. But de Kooning never entirely renounced his background, as he chose to keep his revolutionary acts within the framework of painting. Duchamp was captivated by the problem of reconciling the contradictory poles of tradition and innovation. His solutions were ironic commentaries on this dilemma. For example, his *Nude Descending a Staircase, No. 2*, 1912 (pl. 68), is at once a highly skilled example of Futurism and Cubism and a pointed commentary on these styles. This painting may be seen as a precursor of de Kooning's Women of the 1950s. Clearly de Kooning understood Duchamp's position, although he did not in any sense emulate the form of his work.

As Hess points out, "The concept of the American banal has always intrigued de Kooning: advertising, commercial art, giant industries for such intimate things as deodorants and toilet paper. He found it romantic, vulgar, and in its own way poignant" (Hess, 1968, p. 76).

More than any other image in de Kooning's entire repertoire, the Women are a subject that derived in good measure from American pop culture. Although both Rauschenberg and Johns have parodied the common object, only Warhol approaches de Kooning in his portrayal of the American sex symbol in such a biting and poignant manner.

Unlike some of the more politically engaged Dadaists or Pop artists, de Kooning did not mock the ordinary, the commonplace; he embraced it, much as he later embraced the highway and highway signs as prototypically American. Indeed, the banal motif gave him the exact subject that he needed for his painting, a multifaceted character that he could play out in a heroic-comic drama. The figure of Woman unleashed de Kooning's power, releasing him from any lingering feelings that he may have had for abstract imagery. It was the image of Woman that gave him the opportunity to explore and exploit his capacity as a painter to its fullest, just as Pollock had realized himself most fully in his classic drip paintings just a few years earlier.

De Kooning worked incessantly on *Woman I*, repainting it many times (see earlier versions, pl. 66) and executing hundreds of studies, drawings, and oils in

65 *Woman on a Sign II*

1967. Oil on canvas, 56 × 41½″
Private Collection, Kansas City

In 1967 de Kooning began a series of "Woman on a Sign" paintings. The works point to the artist's enchantment with such elements of everyday life as advertisements on billboards or trucks.

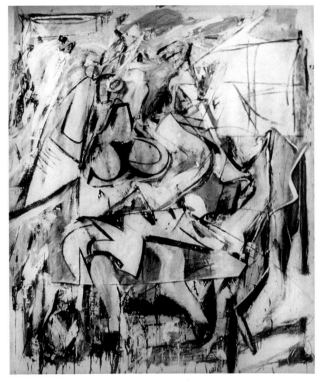

A

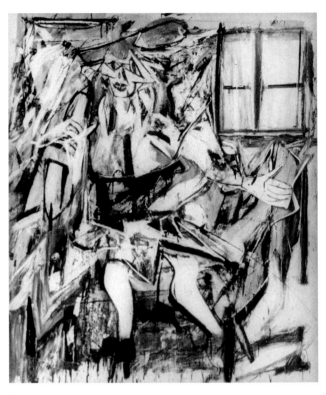

B

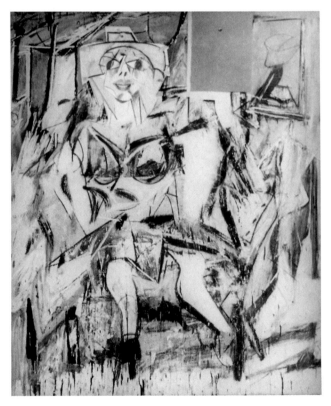

D

66 Six Stages of *Woman I*

1950–52

The photographer Rudolph Burckhardt, a friend of de Kooning's and his neighbor during the 1930s, produced some note-worthy photographs of the young de Kooning in his studio. He also photographed Woman I *at various stages of its development.* Woman I, *the result of hundreds of studies, was also completely painted out hundreds of times as de Kooning strove to capture the exact image he desired.*

THE IMAGE OF WOMAN

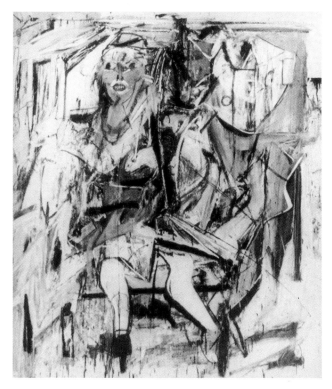

C

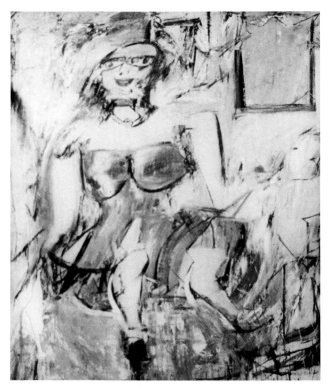

E

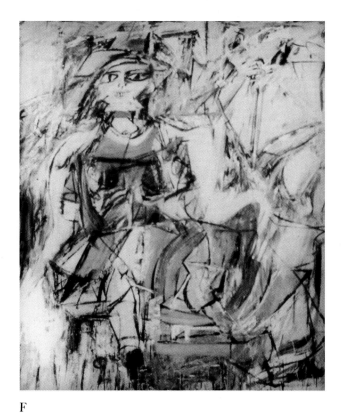

F

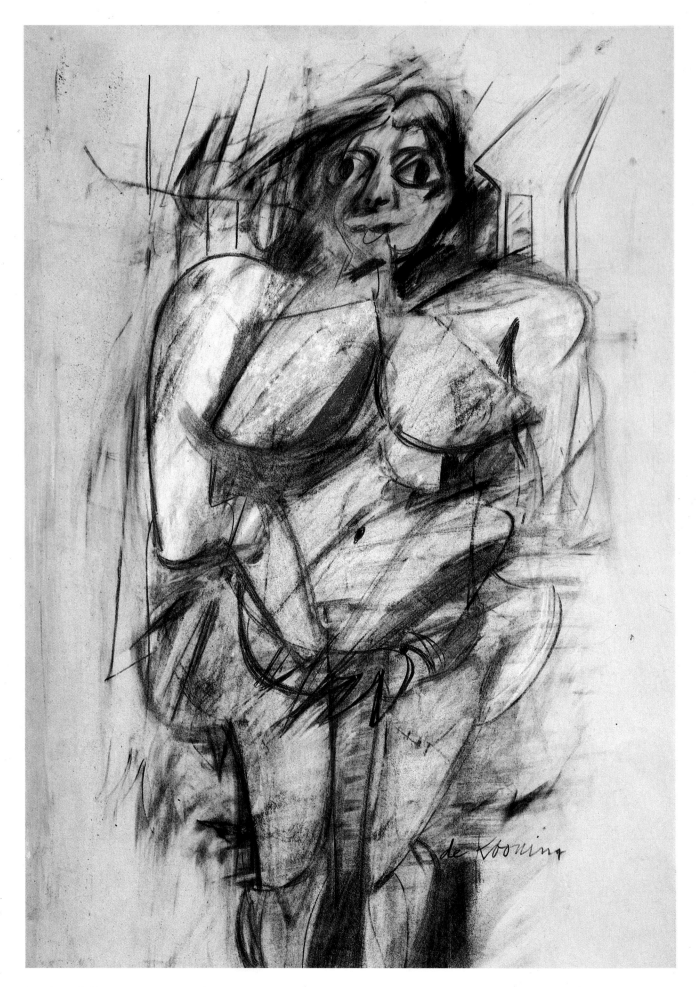

67 *Seated Woman*

preparation for the final work. In several of the smaller works, such as *Seated Woman*, 1952 (pl. 67), the female figure appears more at ease, certainly more classic than in the painting, yet in others (see pl. 70) the fragmentation of form and ferocity that we associate with the large figure is clearly evident. To achieve the impact he wanted in this painting, de Kooning evolved a concept of intimacy by enhancing detail (a concept favored by many of the Abstract Expressionists, who believed that a well-placed mark, no matter how small, would have a big impact) so that it read as importantly as a limb, buttock, or breast. De Kooning described his concept of "intimate proportions" as "the feeling of familiarity you have when you look at somebody's big toe when close to it, or a crease in a hand, or a nose, or lips or a necktie" (Hess, *Art News*, 1953, p. 32).

Like Newman, Rothko, Kline, Pollock et al., de Kooning wanted to draw the viewer into the arena of the painting. Since the majority of the painters employing this device worked on a relatively large scale, they depended upon the incident or the detail to engage the viewer in intimate contact with the painting. With many of the other artists, Newman and Pollock, for example, the detail served to make the viewer aware of the immense size of the painting; for de Kooning, the detail served to magnify the force of the figure. Although *Woman I* is large and over lifesize, it is small in comparison to Newman's *Vir Heroicus Sublimis*, 1950–51, or Pollock's *Autumn Rhythm, Number 30*, 1950. Pollock and Newman relied not only on large scale but also on large imagery, in keeping with that sense of scale to convey the sense of the big picture, and on the small detail to vitalize the surface of the painting. Unlike them, de Kooning relied not only on magnification of the detail but also on the isolation and enlargement of one or more parts of the body to capitalize on size without resorting to mural-scale paintings. In fragmenting, isolating, and collaging parts of the figure together, de Kooning could convey the semblance of a figure of goddess-like proportions without rendering it as such through conventional means. In choosing his means, de Kooning made his figure warp and distort the picture plane in much the same way that Picasso, in his Cubist forms, created figures that seem to burst forth from the picture plane. But whereas Picasso relied on sculptural volume to suggest three-dimensionality, de Kooning relies on the compression of his anatomical forms and a heavily impastoed surface to hint at the figure as volume.

As important to de Kooning as his concept of "intimate proportions" was his ongoing need to position the figure in an ambiguous environment. As Tom Hess relates, "He used to keep pinned near his easel a *Daily News* photograph of a huge crowd at a sports event; you could not tell whether it was being held indoors (at Madison Square Garden) or outdoors (at Yankee Stadium), although a number of architectural clues were visible—piers, girders, balconies, etc. Here an increase in size and quantity destroyed the identity and special quality of the context" (Hess, 1968, p. 79). Hess points out that although de Kooning indicates a window in *Woman I*, it is difficult to tell where the figure is placed. The "no-environment" favored by de Kooning allowed him to allude to a specific environment, but because the cues are ambiguous the environment remained generalized and undefined. They are at one further remove from the more spe-

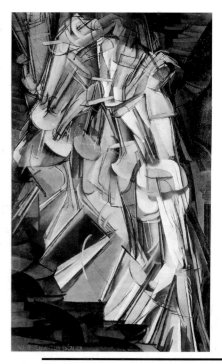

68 Marcel Duchamp
*Nude Descending a Staircase,
No. 2*

1912. Oil on canvas, 58 × 35"
Philadelphia Museum of Art
Louise and Walter Arensberg Collection

Painted in a combination of Cubist and Futurist styles, Nude Descending a Staircase, No. 2 *suggests the schematized progression of a figure in motion. The inclusion of this early Duchamp in the 1913 Armory Show in New York City generated controversy from critics, who had great difficulty accepting the painting as art.*

67 *Seated Woman*

1952. Graphite, charcoal, and pastel on paper
18 × 20" (approx.)
Private Collection, Boston

As in the grand-scale Woman I, *the figure in this small study dominates the pictorial space. This figure, however, is more demure and less threatening than the commanding, rather ferocious figure of* Woman I.

69 Woman I

1950–52. Oil on canvas, 6'3⅞" × 58"
Collection, The Museum of Modern Art, New York
Purchase

In March, 1953, de Kooning exhibited this work, along with five other Women paintings, at his third one-man show at the Sidney Janis Gallery. De Kooning's effrontery in resurrecting the human figure scandalized critics who considered representation a taboo subject. Beginning in 1950, de Kooning worked on this image for two years; he abandoned it after about eighteen months but then retrieved it at the urging of the art historian Meyer Schapiro.

70 Woman

1952. Pastel on paper, 11⅜" × 7¾"
Collection of Mr. and Mrs. Sherman H. Starr,
Boston

cific, if equally ambiguous, environment in which he placed his figures of the late 1930s to the mid-1940s. At that time, the figure was positioned against a neutral backdrop, a hermetic sealed-in space that vaguely suggests an interior. In *Woman I*, on the other hand, this space is less distinctly an interior; it may be an indoor or outdoor location, land or water, but it is decidedly nonspecific.

In subsequent paintings of Women, de Kooning altered his seated figure and brought her even closer to the picture plane. *Woman IV*, *Woman V*, and *Woman VI* (pls. 72, 73, 74), painted during 1952 and 1953, are truncated forms, cut off near the knee, all thickly painted and enveloped in their "no-environment." As in

THE IMAGE OF WOMAN

70 *Woman*

71 *Torsos of Two Women*

c. 1952–53. Pastel on paper, 18⅞ × 24″
The Art Institute of Chicago
The Joseph H. Wrenn Memorial Collection,
1955.367

72 *Woman IV*

1952–53. Oil and enamel on canvas, 59 × 46¼″
The Nelson-Atkins Museum of Art
Kansas City, Missouri
Gift of Mr. William Inge

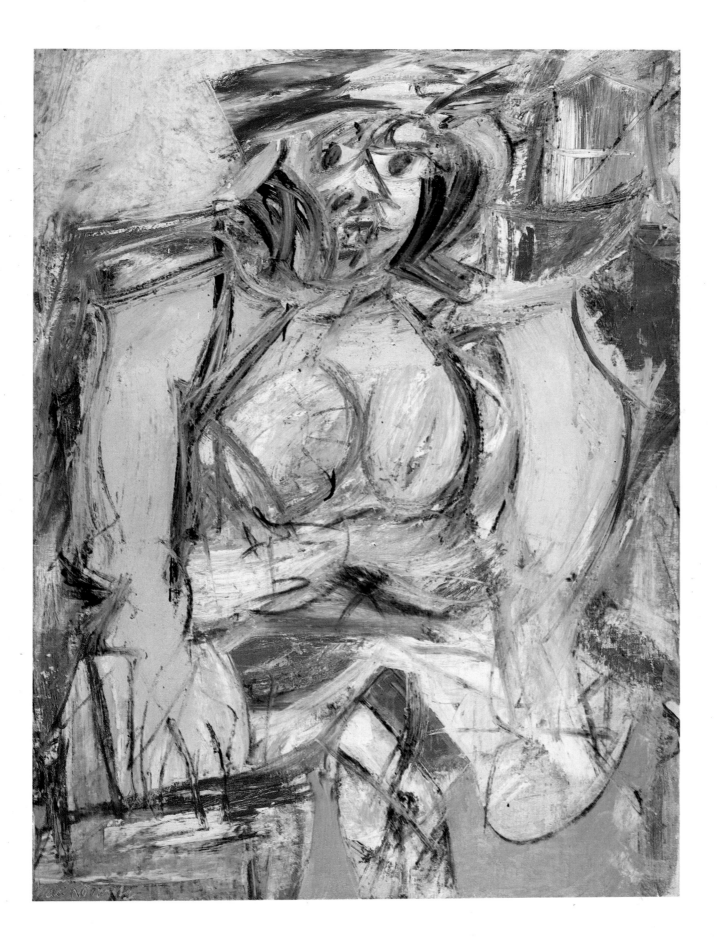

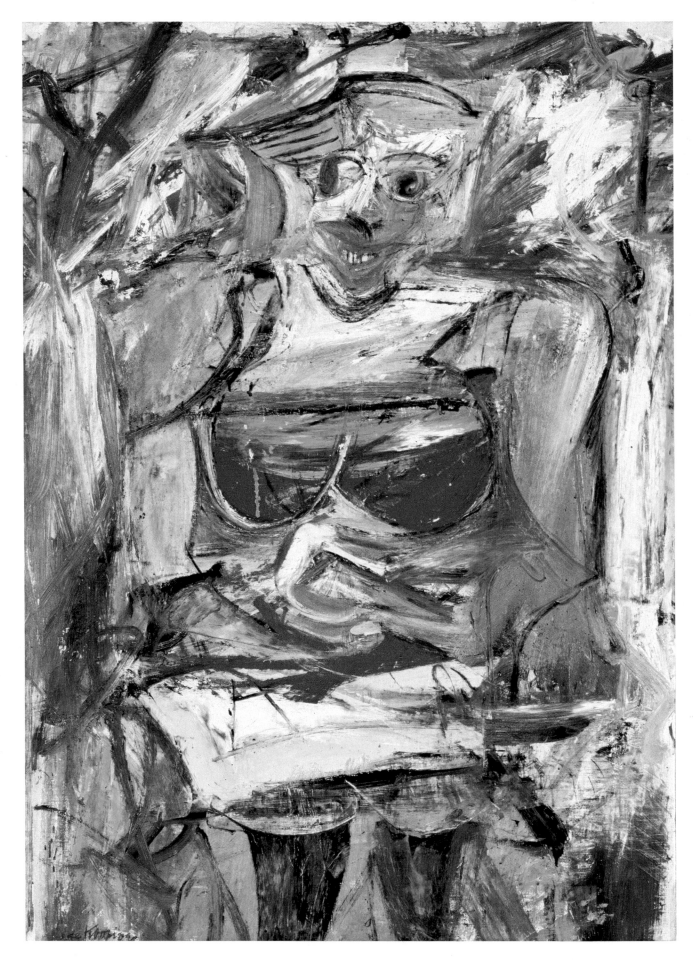

73 *Woman V*

Woman I, de Kooning appears to have cut and collaged disparate parts of female anatomy together without, however, sacrificing their resemblance to the human form. In these canvases de Kooning retains a very high-key color palette, often relying on strident reds, blues, yellows, and greens to offset the flesh tones of his figures. *Woman V* and *Woman VI* become so nearly abstracted that without their heads we would easily mistake them for the later, totally abstract *Composition* of 1955. In these and other related figures of the period de Kooning elects to emphasize the flatness and frontality of the forms; none have the menace or the regal bearing of the first Woman, the original goddess.

De Kooning's Women have been described as a cross between idol, movie star, and whore. De Kooning has said, "The *Women* had to do with the female painted through all the ages, all those idols, and maybe I was stuck to a certain extent; I couldn't go on." And, he added, "It did one thing for me: it eliminated composition, arrangement, relationships, light—all this silly talk about line, color and form—because that was the thing I wanted to get hold of. I put it in the center of the canvas because there was no reason to put it a bit on the side...." (Sylvester, *Location*, 1963, p. 46). In fact, de Kooning added a portion of canvas to the painting so that the figure is not centered.

Freudian and Jungian analysis have figured prominently in the way in which the Women are perceived and the way in which de Kooning is perceived in his attitude toward his subject. De Kooning has said little, but he has acknowledged, "I *like* beautiful women. In the flesh; even the models in magazines. Women irritate me sometimes. I painted that irritation in the 'Women' series" (Rodman, p. 102).

De Kooning is perceived as sexist, his subjects the object of male manipulation. De Kooning has also been perceived as ambiguous toward women, uncertain about his sexuality. According to Hess, he "is involved with preludes, climaxes and postludes—he wants release and control." Hess was speaking of de Kooning's 1940s paintings, but in no uncertain terms he described *Woman I* as depicting "the Black Goddess: the mother who betrays the son, gets rid of the father, destroys the home." He went on to add, "Facing this image and getting beyond it, perhaps, was one of the reasons that it took so many months to finish *Woman I*...." (Hess, 1968, pp. 75–76).

De Kooning, however, viewed the subject from a different perspective. He said: "I wasn't concerned to get a particular kind of feeling. I look at them now and they seem vociferous and ferocious. I think it had to do with the idea of the idol, the oracle, and above all the hilariousness of it. I do think that if I don't look upon life that way, I won't know how to keep on being around" (Sylvester, *Location*, 1963, p. 47).

Jungian and Freudian theory was very much in the air at the time, often the subject of heated discussion in many studios. The Jungian notion of woman as possessing positive and negative, life and death force appears to inform de Kooning's view of Women as he has painted them. The primal sexuality that the Women embody (also occurring in Dubuffet's work of a roughly analogous period) may have been influenced by this Jungian concept, which was developed to

73 *Woman V*

1952–53. Oil and charcoal on canvas, 61 × 44⅞"
Australian National Gallery, Canberra

explain the early goddess figures that dominate matriarchal myth in prehistoric art. However savage and sexual de Kooning's Women often appear, their full meaning for the artist remains as yet unstated.

Some thirty-five years after they were painted, de Kooning's Women still seem "vociferous and ferocious." They are also breathless and chatty, like the funny and vulnerable sex symbol portrayed so successfully by Marilyn Monroe in the film *Some Like It Hot*, operatic, like a Wagnerian Brunhild, and as resplendent as any Venus that has come down to us through the ages. However one chooses to view the artist's attitude toward women, this is how women were perceived in the 1950s. The women in de Kooning's paintings are true 1950s women, the products of male desire, emblems of a sexual fantasy that captivated an era just as today's younger stars symbolize the childlike sexual fantasy of the generation of the 1980s. De Kooning's Women are the pinups of the postwar era, women who were dominated by men but who were, nonetheless, quite capable of exercising control over the men who dominated them. In addressing the subject of Woman, de Kooning seems to be expressing just how complex they are and how far-reaching is the relationship between male and female. He may, in fact, really *like* women; he may also want to continue the dialogue between painter and model in the great tradition of Picasso and Matisse, two artists he greatly admires. As an artist who is enthralled with the concrete experience of reality, de Kooning found in the Women a subject of such complexity as to elicit his most extraordinary response and through which he could best express his existential attitude toward life.

74 *Woman VI*

1953. Oil on canvas, 68½ × 58½"
The Carnegie Museum of Art, Pittsburgh
Gift of G. David Thompson, 1955

Along with Woman VI, Woman I, Woman IV, *and* Woman V *were included in de Kooning's third one-man show, "Paintings on the Theme of the Woman," at the Sidney Janis Gallery in March, 1953. In October–December, 1955, he participated in the "1955 Pittsburgh International Exhibition of Contemporary Painting" at the Museum of Art, Carnegie Institute, which subsequently purchased* Woman VI.

THE IMAGE OF WOMAN

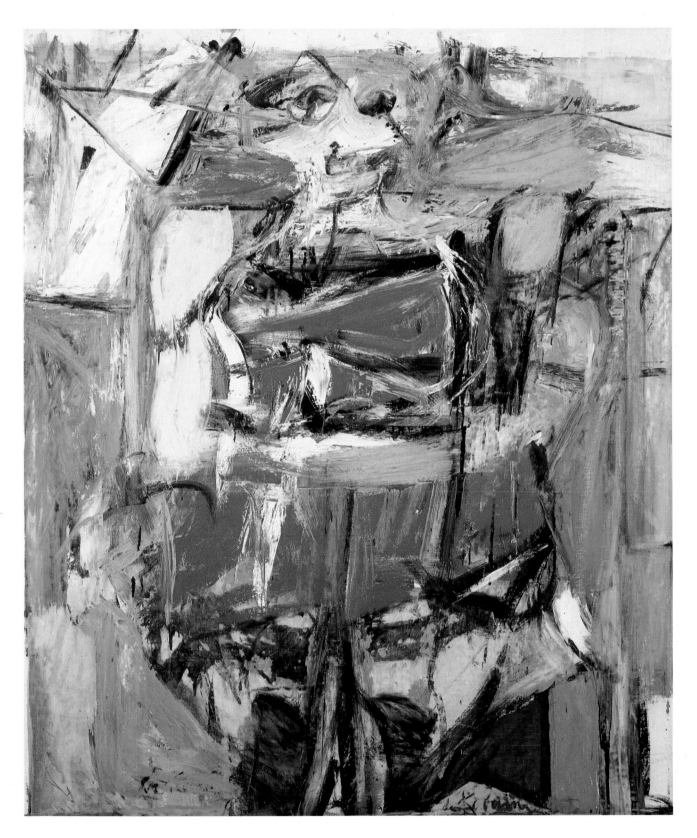

74 *Woman VI*

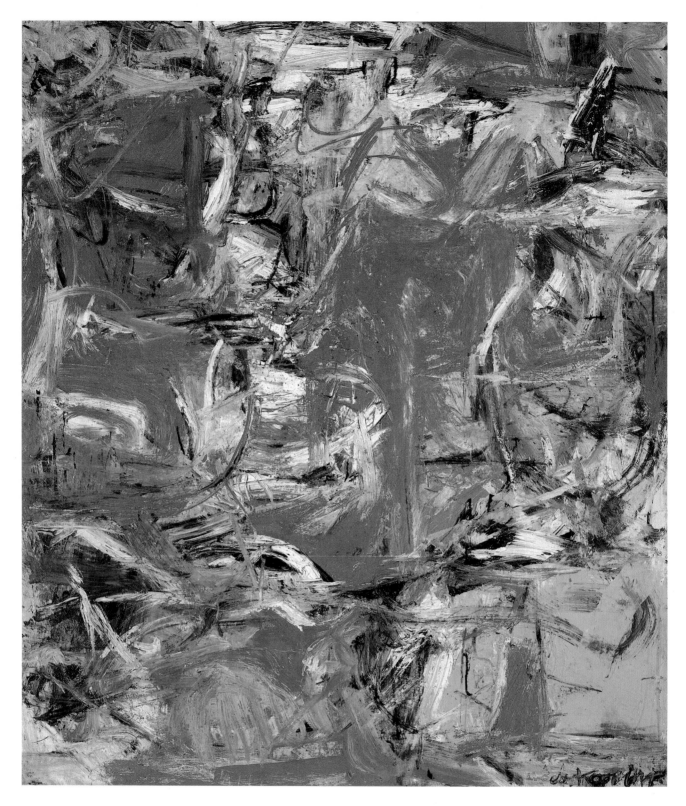

75 *Composition*

VII. Landscape, Abstraction, and Woman

AVING SATISFIED HIS AMBITION to combine a subject from popular culture with prototypes from the great art of the past and, in the process, inventing new icons for the art of the twentieth century, de Kooning began to search for a new theme for his work. By 1955, the image of Woman had virtually disappeared. In its place were images of the landscape based on urban and suburban themes.

A key painting in this evolution, *Woman as Landscape*, 1955 (pl. 77), although unfinished, clearly shows the figure being submerged in the landscape. (According to Hess [1968, p. 102], the artist released this work at the insistence of his dealer.) Another painting, *Composition*, completed in March of the same year (pl. 75), is far more abstract, although it, too, contains vestiges of the female figure. In *Composition*, the female figure is, as before, torn apart and rearranged on the picture plane. Far more compelling, however, than the fragmentary forms is the newly independent brushstroke and color all but freed from form. While *Composition* still clings to a skeletal compositional structure and remains a somewhat transitional picture, it clearly predicts the direction in which de Kooning was going. It is therefore a seminal painting in that it heralds the first significant departure from the Women. With the Women de Kooning resolved the polarities between figure and ground and allover composition by embracing both; he was now free to reinvestigate line, form, and color without sacrificing his real subject—the landscape of the world around him.

By 1955–56 de Kooning had picked up the tempo in his paintings. Two of the most glorious images of the period, *Gotham News*, c. 1955, and *Easter Monday*, 1955–56 (pls. 76, 78), project a boldness and lyricism that are breathtaking. Here, as he had in the Women, de Kooning used a series of composite images, which he collaged together. Now, however, the subject—the urban landscape of the city—becomes part of the dynamic of the painting but as a partner to shape, color, and line.

Unlike the Women, whose subject dominated the character of the paintings, the new "landscapes" are more nearly abstract, related to but different from the black-and-white paintings of the late 1940s. In these paintings de Kooning firmly establishes his vocabulary of marks, a handwriting that he has continued to renew and redefine. Like other paintings of the mid-1950s, *Easter Monday* is titled after specific events, in this instance the Easter Monday of 1956, the date the painting was finished. Other titles refer to the destruction of the famous Wana-

75 *Composition*

1955. Oil, enamel, and charcoal on canvas
79¼ × 69¼"
Solomon R. Guggenheim Museum, New York

By 1955 de Kooning's iconic representations of Women were subsumed by the theme of landscape. While both Woman as Landscape *and* Composition *mark this transition in de Kooning's development,* Composition *is certainly closer to the landscape abstractions to follow.*

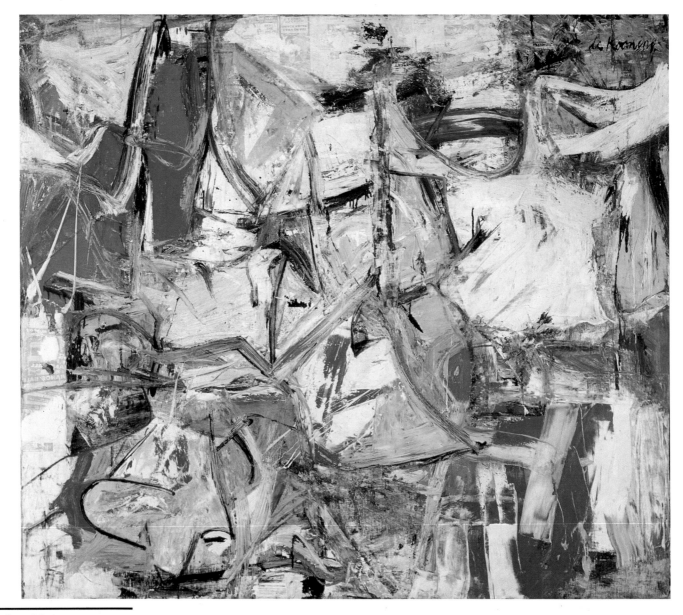

76 Gotham News

c. 1955. Oil on canvas, 69 × 79″
Albright-Knox Art Gallery, Buffalo, New York
Gift of Seymour H. Knox, 1955

In order to slow the drying process, de Kooning often applied sheets of newspaper to his canvases; later, when the newspapers were removed, their images would remain on the surface of the canvas. Gotham News *and* Easter Monday *contain such patches of transferred newspaper imagery. The effect is rather like collage.* Easter Monday, *whose title refers to the day of its completion, also contains vestiges of letters de Kooning often used to conceive his compositions.*

77 Woman as Landscape

1955. Oil on canvas, 45½ × 41″
From the Collection of Janet and Robert Kardon,
Philadelphia

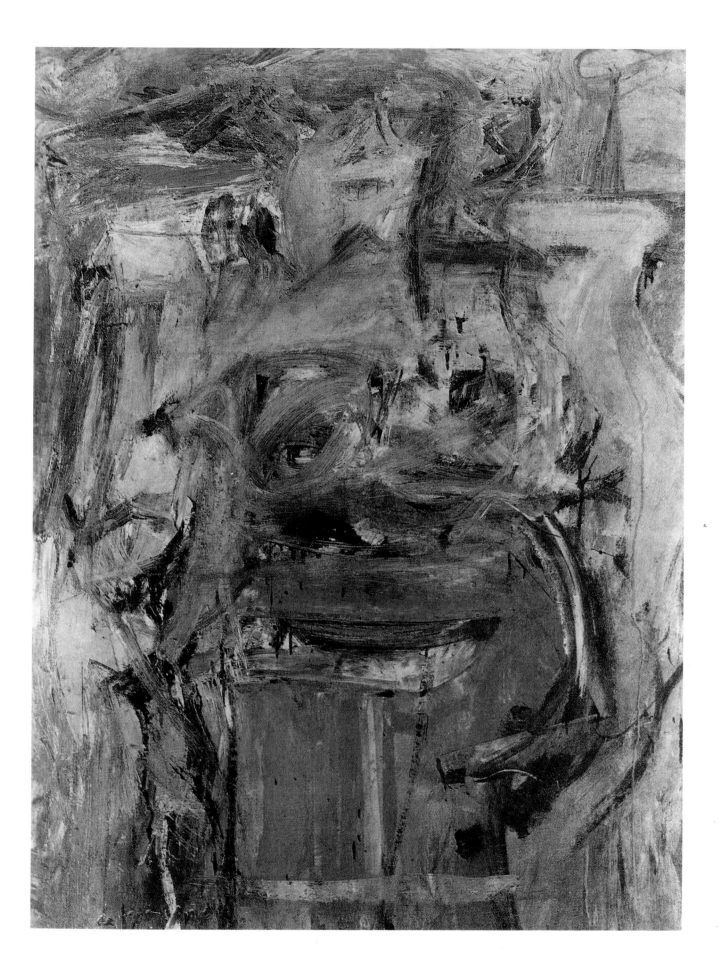

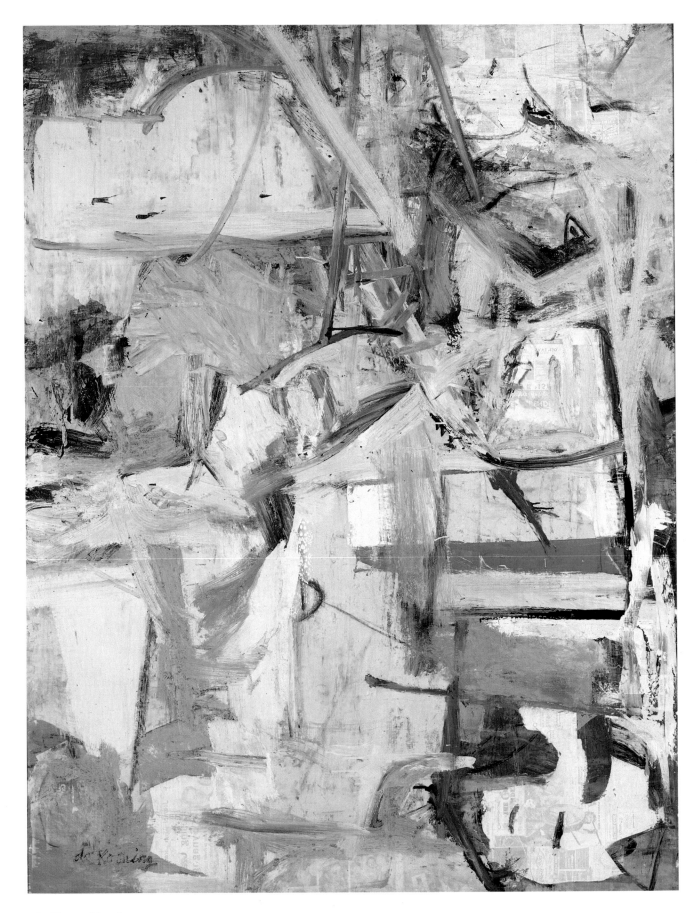

78 *Easter Monday*

maker Department Store near where de Kooning and his friends lived and worked and to other actual events in the vicinity of Tenth Street. (Kline had painted *Wanamaker Block* in 1955.) Although the titles are not meant to be interpreted in the paintings themselves, they do suggest that de Kooning was acutely aware of what was happening in the neighborhoods where he lived and worked, the areas around Greenwich Village and Times Square. In the paintings that follow we witness de Kooning's gradual relocation from the city to the suburban areas surrounding New York and finally to the rural landscape of The Springs, East Hampton.

Gotham News and *Easter Monday* are clearly urban landscapes; in these paintings one can experience the city, its dynamic buildings, its light, its grime. As de Kooning ventured farther from the city, he began to incorporate in his paintings the flatness, horizontality, and the special quality of light on Long Island that he found so appealing. *Palisade* of 1957 (pl. 79) begins to blur the distinction between the vertical structure of the city and the horizontal configuration of the country, a process that is all but completed by 1963 with *Rosy-Fingered Dawn at Louse Point* (pl. 80). In the interim, between 1957 and 1963, de Kooning clarified and simplified his images. He also enlarged the individual areas within his paintings. Those of 1955–56 are a distillation of the way in which de Kooning worked when he painted the Women; his strokes are narrow and individuated, and while freed from form, they are not as expressive of area and mass as they are in paintings like *Suburb in Havana* of 1958 (pl. 81).

In painting his urban landscapes de Kooning continued to rely on methods that had proven so successful in the Women. This involved the collaging of disparate and discrete shapes and a montage-like technique of overlays that resulted in abrupt shifts in scale and a perceptible, if shallow, illusion of space. In *Easter Monday*, de Kooning applied newsprint to the canvas, to cut down on the buildup of paint, and pulled it off, leaving an image in reverse on the surface. The newspaper images in *Easter Monday* add a crucial element of the real world to the otherwise fictional narrative of the painting, a narrative that has less to do with landscape than with the drama of the act of painting.

Here, as he had in his 1940s paintings, de Kooning also uses letters; the painting is strewn with the letter "E." In both his black-and-white paintings of the late 1940s and these newer works, de Kooning began a picture by writing a word or words on the surface of the canvas. In the process of developing the letters into forms or objects, he often obliterated them. As before, the letter "E" succeeds in nailing down the "reality" of the painting through the specificity of its form.

The broad, sweeping gestures that de Kooning employed in these paintings represent the artist at his most liberated. Here, as in Pollock's drip paintings, the act of painting is presented as raw, immediate, and vital. Nothing, not even the landscape, stands in the way of our comprehension of the process of painting. Since the power of the image as icon had diminished, de Kooning could now transform his exquisite draftsmanship into the ultimate painterly gesture.

Just as de Kooning inspired generations of artists, he in turn was inspired by the work of his friend and colleague Franz Kline. Paintings such as *Suburb in Ha-*

78 *Easter Monday*

1955–56. Oil and newspaper transfer on canvas
96 × 74″
The Metropolitan Museum of Art, New York
Rogers Fund, 1956 (56.205.2)

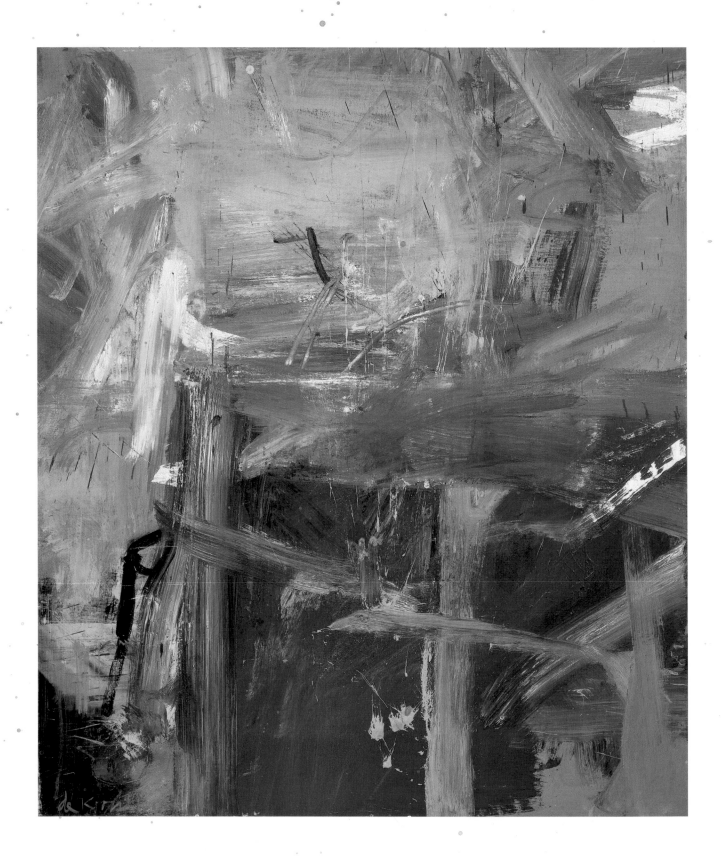

80 *Rosy-Fingered Dawn at Louse Point*

1963. Oil on canvas, 80⅛ × 70⅜"
Stedelijk Museum, Amsterdam

Both Rosy-Fingered Dawn at Louse Point *and* Pastorale *are suffused with the bright light and stretches of potato fields de Kooning knew from his summers on Long Island.* Pastorale *concluded de Kooning's large landscape abstraction series. In June, 1963, he moved permanently to The Springs, East Hampton, and embarked upon a new series of Women paintings.*

79 *Palisade*

1957. Oil on canvas, 79 × 69"
Collection Mr. Milton A. Gordon, New York

In 1957 de Kooning began painting large abstract urban landscapes with simpler forms. Some, such as Palisade *and* Montauk Highway, *are titled after the highways de Kooning viewed as prototypically American.*

81 *Suburb in Havana*

83 Franz Kline
Painting No. 7

1952. Oil on canvas, 57½ × 81¾"
Solomon R. Guggenheim Museum, New York

Characteristic of Kline's mature style, this canvas presents a bold composition of black-and-white forms, reflecting the artist's interest in Japanese calligraphy. The limited palette of black and white in Painting No. 7 is related to the experimentations of artists such as Pollock, Newman, de Kooning, and Motherwell in the late 1940s and early 1950s.

82 *Black and White, Rome D*

1959. Enamel on collage, mounted on canvas
39⅜ × 27¾"
Private Collection

In the winter of 1959 while in Rome, de Kooning resumed using black in his drawings. The imagery and broad gestures point to the work of de Kooning's friend Franz Kline, whom he first met about 1939, while the richness and density of the work derive from de Kooning's masterful use of collage.

81 *Suburb in Havana*

1958. Oil on canvas, 80 × 70"
Collection Mr. and Mrs. Lee V. Eastman, New York

vana, 1958, and *Black and White, Rome D,* 1959 (pl. 82), reflect Kline's tough architectonic forms. Kline's vigorous compositions contain interlocking forms that integrate both black and white with the picture plane. His large, rugged, but precise forms (see, for example, *Painting No. 7*, 1952, pl. 83), his powerful brushstrokes and bold calligraphy had an undeniable impact on de Kooning's late 1950s landscapes. Following Kline's example, de Kooning incorporated powerful architectural elements, but he retained a sense of the intimate gesture that is

absent in Kline's raucous paintings. De Kooning, in turn, influenced Kline's late paintings. The introduction of color in Kline's last paintings of 1959–61 clearly was inspired by de Kooning's example. It was in the nature of their warm and open friendship that both artists profited from such a meaningful exchange.

Palisade, 1957, *Suburb in Havana,* 1958, and *Door to the River,* 1960 (pl. 84), are among de Kooning's major works in this landscape genre. While the term "landscape genre" is useful in a discussion of the subject of de Kooning's paintings of this period, it is by no means an accurate one. De Kooning, having destroyed the premise that representation of the human figure and abstraction were antithetical, proceeded to demonstrate that landscape and abstraction could also coexist in a dynamic relationship.

Although the titles of these paintings proffer clues to their subjects, their images are far from descriptive. Instead of portraying the specifics of nature, de Kooning gives us a few broad swaths of color, some drips and splatters that suggest, rather than represent, landscape. These paintings are especially fascinating because de Kooning has chosen not to depict the landscapes themselves but to

85 *Pastorale*

convey a sense of the countryside. And he has done so within the context of abstraction, so that unlike the Surrealists, whose art is symbol-laden, de Kooning's landscapes, by the late 1950s and early 1960s, are less about the experience of nature or natural phenomena than they are about the nature of painting. And, as hedonistic as these paintings are, they do not relate to the great nature-based paintings of the Impressionists. Color, shape, space, and tactility as they function in relation to the picture plane are his central concerns. References to nature are subliminal. Allusions to a door, a horizon line, the grass, the soft, moist, night air, the dense, dark shade of the trees, the jagged edges of a cliff are cloaked in the mystery of the act of painting.

In 1961 de Kooning began the move from his studio in New York to The Springs, East Hampton. He moved to The Springs to be near his friends, and also because he liked the light, the underbrush, and the water, as well as the flatness of the potato fields in the area. While it did not then occur to him that the landscape is reminiscent of Holland, he later acknowledged the similarity. He had summered occasionally in the Hamptons, but now he purchased from Peter Fried, his brother-in-law, a modest house directly across the street from the cemetery in which his friend Jackson Pollock was buried. The house became de Kooning's temporary working quarters while he began to build his ideal studio on a nearby piece of land. Although the studio's construction occupied much of his attention for the next two years, de Kooning continued to work, producing numerous drawings, some pastels and oils on paper, and a few paintings.

Pastorale, 1963 (pl. 85), the last painting de Kooning executed in his New York studio prior to his permanent move to The Springs, suggests neither the ambience of New York nor Long Island: it is a transitional canvas and also marks the end of a period. Although de Kooning resumed painting after settling into his new space, he did not, as one might expect, make landscapes but instead began a new series of Women. However, as Hess has pointed out, *Pastorale* and the Women of the past and future are closely related: "*Pastorale* marks the end of a series of abstractions which began around 1956 when the last of his Women opened up, becoming so interpenetrated by the background landscape elements that the figure itself turned into a landscape." In Hess' view, "*Pastorale* also signals a new beginning: the emergent shape of a standing figure can be seen if it is assumed for a moment that the left-hand side of the picture is the top.... The idea of Woman is also indicated by the key color, a sun-struck flesh paint. The body is a hill. The legs are cut by tree-trunk verticals. The curves of her breasts are echoed in the sky" (Hess, 1967, p. 16). (It can be argued that the image of a reclining Woman can be discerned if one views the top of the painting as such.)

Thus the ostensibly abstract *Pastorale* and works such as *Rosy-Fingered Dawn at Louse Point*, another New York painting of 1963, share many specific figurative elements and allusions to the Women, so that they seem almost inevitably to point to a new series of Women. A conflict between the inherently three-dimensional nature of the figure and the two-dimensionality of the picture plane was acknowledged and resolved by de Kooning in the Women of the 1950s. The landscapes that followed them in the late 1950s and early 1960s did not provide the

86 *Clamdiggers*

1964. Oil on paper mounted on composition board
20¼ × 14½"
Collection Mrs. Tyler G. Gregory, Beverly Hills

In 1964 de Kooning completed Clamdiggers, *the first important work in his fifth series of Women paintings. Here two giddy, ecstatic blondes sit or lie against tan sand. In their monumental size and erotic vitality they are no different from the Women of the earlier series. But now the dramatic black line, so essential to the Women of the late 1940s and 1950s, is gone; in its place glorious, luminous white infuses these paintings with a light-filled pastoral atmosphere.*

86 *Clamdiggers*

87 *Two Women in the Country*

1954. Oil, enamel, and charcoal on canvas
46⅛ × 40¾″
Hirshhorn Museum and Sculpture Garden
Smithsonian Institution, Washington, D.C.
Gift of Joseph H. Hirshhorn, 1966

necessary figure-ground tension to sustain the artist's imagination for more than a few years. This tension does not exist primarily because de Kooning eliminated all but the most subtle references to his landscape subjects. The intense impact of the totemic Women of the 1950s is vitiated and becomes amorphous in the more undefined and neutral forms of the landscapes. It would, indeed, be difficult to find an image in de Kooning's landscapes as loaded emotionally, as topical and full of psychological ramifications as is the emblematic figure of Woman in the context of the human form.

In 1964 de Kooning finished the first important example of this new group, *Clamdiggers* (pl. 86). Relatively small for the artist, 20¼ × 14½″—the dimensions he usually prefers are approximately 70 × 80″, or just over lifesize—it is, nonetheless, a painting of monumental impact. The golden girls pictured here revert to some degree to the kind of figures in such earlier canvases as *Two Women in the Country* of 1954 (pl. 87). The two figures in both paintings are similarly positioned frontal nudes; in each, portions of the bodies are cut off by the canvas edges. However, the earlier work suggests such prototypes as the *Venus of Willen-*

88 Woman, Sag Harbor

1964. Oil on wood, 80 × 36″
Hirshhorn Museum and Sculpture Garden
Smithsonian Institution, Washington, D.C.
Gift of Joseph H. Hirshhorn, 1966

In 1964 de Kooning began a series of paintings of Women on commercially manufactured door panels. These enormous Women with their fearsome expressions recall de Kooning's early series of Women. Despite their confinement in the long narrow space the doors provide, these figures exude enormous energy and vivacity.

89 *Woman Accabonac*

1966. Oil on paper on canvas, 79×35″
Collection of Whitney Museum of American Art
Purchase, with funds from the artist and Mrs.
Bernard F. Gimbel. (67.75)

dorf and Picasso's *Les Demoiselles d'Avignon*, while the later painting appears to be a hybrid of Rubens and Reginald Marsh.

As before, the earlier de Kooning, like the Picasso, reiterates a respect for the primitive that evolved as a modernist reaction against the stifling nineteenth-century classical ideal. The distortion of the *Two Women in the Country* stems from the emphasis upon and enlargement of their torsos and sex organs in relation to their heads and limbs. In contrast, the proportions of the *Clamdiggers* are naturalistic, if overblown. The angular, flat *Two Women in the Country* seem far more savage than the rounded and fleshy whorish cuties of the *Clamdiggers*. Aggressive nudity becomes luxurious voluptuousness, primarily because the sharp, incisive contours and acrid color of the earlier painting are transformed in the *Clamdiggers* into their opposites—melting contours and soft, dappled color. The predator that is Woman has been tamed, but the female as an object of parody remains intact.

Shortly after finishing his Rubensian blondes, de Kooning began a series of figures painted on doors he had obtained from a commercial manufacturer. They were approximately 80×36″, roughly half the width of his usual canvases, and he exploited their narrow proportions to great effect. The images on these doors represent a return to the more aggressive female of the 1950s. This may in part be due to the narrow format of the doors—they seem to press in upon the women—or their hard surfaces, which resisted de Kooning's touch. Their raucous colors reinforce the generally more violent mood of the panels.

While *Woman, Sag Harbor*, 1964 (pl. 88), floats to the top edge of the canvas and *Woman Accabonac*, 1966 (pl. 89), ascends like an avenging angel, the females of the later 1960s appear more tranquil and are integrated into their surroundings: first they clam or wade offshore; later they merge with the landscape. Severe frontality, the direct confrontation of figures and spectator, gives way as the women recline, complacent and at ease in the countryside. The mood is pastoral. Ultimately the figures become so distorted that it is virtually impossible to disentangle torsos and limbs from the background.

De Kooning achieves the integration of figure and landscape in large part by means of his painterly technique. During the late 1950s and early 1960s his landscapes consisted of a few large blocks of color, interrupted and bound together by smaller patches of pigment and a gridded armature. In these new Women, however, rectilinear superstructure is no longer overt; whiplash line is replaced by large areas of freely brushed color held together by the force and rhythm of his gesture. Here de Kooning achieves a remarkable unification of figure and ground, form and color. The female figure, although still the theme of the painting, no longer dominates its composition. By the late 1960s, landscape assumes a new and more prominent role: de Kooning makes Woman a landscape.

90 *Two Figures in a Landscape*

VIII. The Late Flowering of de Kooning's Art

Athan painters (David Smith the most notable among them), a number of the latter created some of the most arresting sculpture of the period. Gorky and Pollock occasionally carved or modeled sculpture, and Gottlieb executed several painted-steel variants of his Burst canvases. Newman and de Kooning, however, alone among the painters of the New York School, seriously committed themselves to sculpture.

Newman's sculptures, such as *Broken Obelisk* of 1963–67 (pl. 91), speak of eternal truths and capture a sense of timelessness that recalls Giacometti's work. In his painting and in his sculpture he was, like Giacometti before him, able to convey a feeling of boundless space with a single powerful form. Newman's ability to embody in his sculpture the same quiet dignity and authority expressed in his paintings is remarkable, the more so since the artist produced so few works in this medium. While Smith's sculpture speaks of a dynamic physical relationship with exterior reality, Newman's sculptural forms resonate with an inner vision and communicate a sense of the spiritual, the transcendental, the sublime.

Once the female figure had been subsumed into landscape in his paintings, de Kooning turned to sculpture to embody Woman. While vacationing in Rome in the summer of 1969, he ran into an old friend, Herzl Emmanuel, a sculptor who had recently acquired a small bronze-casting foundry. Emmanuel invited de Kooning to visit the foundry, which was a small operation manned by himself with one Italian assistant. Although de Kooning at first resisted the idea of making sculpture, after a while he began to experiment with the clay his friend offered him. He soon produced several objects, which they cast. By the end of the summer, de Kooning had finished a number of small bronzes. In addition, a set of thirteen small untitled sculptures was cast in an edition of six after he left Rome.

Although de Kooning was still ambivalent about sculpture in 1970, he was again encouraged to continue working in the medium. The British sculptor Henry Moore, who was in New York for an exhibition, helped convince him that his sculpture should be enlarged, and de Kooning decided to try this with one of the small sculptures. Interestingly, Moore himself enlarged smaller sculpture to monumental scale and could readily see the potential for such a procedure in de Kooning's work. Salvador Dali also concurred and even suggested that de Kooning paint the pieces, an idea the artist considered but subsequently rejected.

90 *Two Figures in a Landscape*

1967. Oil on canvas, 70×80″
Stedelijk Museum, Amsterdam

119

91 Barnett Newman
Broken Obelisk

1963–67. Cor-Ten steel, 26 × 10½ × 10½'
Collection Rothko Chapel, Houston
Dedicated to Reverend Martin Luther King, Jr.

Though Newman was primarily a paint-er, he created this monumental sculpture by joining the tips of two ancient forms, the pyramid and the obelisk. While the pyra-midal base suggests a secure anchor to the earth, the inverted obelisk ascends with seeming weightlessness toward the sky.

For this experiment de Kooning chose the *Seated Woman* (pl. 92), a piece that very much resembled certain earlier drawings. De Kooning assembled the large version of the sculpture in much the same way he composes the figures in his paintings, pulling apart the body, distorting it, re-creating and reassembling the anatomy so that she managed to acquire an extra pair of legs, which he placed next to her. The work was so complicated that an assistant was required to finish much of it by hand. At this time de Kooning experimented with numerous alter-natives to bronze, such as polyester resin coated with a bronzelike patina. Eventu-ally he abandoned the idea of increasing the size of smaller pieces in favor of working directly on a large scale.

In 1970 de Kooning began to work on a group of figures and produced a number of important pieces, among them *Clamdigger* and *Seated Woman on a Bench*, both finished in 1972, and *Large Torso* of 1974 (pls. 93, 94, 95). The sculp-

92 *Seated Woman*

1969–80. Bronze, 26½ × 36 × 21″
Courtesy: Xavier Fourcade, Inc., New York

In June, 1969, de Kooning traveled to Italy for a one-man exhibition of his work. While there, he visited the foundry of a friend, the sculptor Herzl Emmanuel, who encouraged him to try his hand at this medium. De Kooning executed some small works in clay that were subsequently cast in bronze at the foundry. As in his painting and drawing at this time, de Kooning's sculpture embodied the figure.

ture mirrors, indeed grows from de Kooning's paintings such as *Woman Acca-bonac*, 1966, or *The Visit*, 1967 (pl. 96). The kneaded and pummeled surfaces of the sculpted figures are the direct extension of his painting techniques. The tactility and bulk of the forms also relate to the sculpture of Medardo Rosso and Auguste Rodin. The twisted, knotted shapes of de Kooning's paintings assume an even more dramatic presence in the massive volumes of his sculpture. Although the sculptures possess concrete reality, there is about them an element of ambiguity, a sense of solitude that recalls the mood, if not the form, of Giacometti's isolated existentialist figures.

In the early 1970s sculpture seemed to become more important to de Kooning than painting. In 1975, however, he began to focus his attention once again on painting and since then has produced an astonishing body of work, which is extensive, versatile, extraordinary in quality, and in many ways different from the canvases that preceded them. One of the most dramatic changes is in the realm of color. Always a superb colorist, de Kooning had alternated among black-and-white abstractions with brilliant jewel-like interstices, pastel figures, and urban landscapes in which intense blues clashed with bright yellow and acidic green. He often offset his vibrant colors by contrasting them with substantial areas of white or compartmentalizing them with line. More recently, however, he softens the somewhat strident juxtapositions of color, line, and shape that result from these devices by introducing flesh tones, which range from reddish to pink to blond. The strong value contrasts in the earlier work have given way to an astonishing range of subtle and voluptuous color—sun-drenched pinks and greens, mauves, blue-greens, reddish oranges, and the familiar but revitalized electric blue. Although de Kooning's color in many ways is similar to the palette of Pierre Bonnard, its effect is noticeably different. De Kooning's paintings have

93 *Clamdigger*

1972. Bronze, 59¾×29×23″
Collection of Whitney Museum of American Art
Gift of Mrs. H. Gates Lloyd. (85.51)

In 1970, at Henry Moore's urging, de Kooning began experimenting with enlarging small-scale sculpture, producing works in the large scale favored in his paintings. Soon he began working directly on large-size figures. He also investigated different materials, such as polyester resin with a bronzelike coating.

none of the cloistered hothouse quality of Bonnard's and clearly reflect the out-of-doors.

Another significant departure is de Kooning's diminishing interest in drawing, except as it figures in his painting. During the 1930s and early 1940s many of his drawings were distinguished by their smooth silhouette and closed contour. As his paintings matured, his line became more fluid, contours were broken, shapes fragmented. In the late 1940s de Kooning abandoned any semblance of reality, and in his drawings as well as his paintings he relied on barely recognizable fragments of human anatomy to convey a subliminal sense of complete anthropomorphic form.

From the 1950s on, de Kooning arrived at dislocations of form through the same procedures he established in his paintings. Parts of the female anatomy—breasts, mouths, vaginas, legs—are torn from the figure and repositioned at various places in a work. Although he distorts anatomy, he does not destroy it, and a sense of a whole figure persists. De Kooning, like many of his colleagues, adapted the techniques of both Cubist collage and the random or chance methods of composition advocated by the Dadaists to evolve this working method. This process usually consists of cutting or tearing, shifting, and reassembling a series of images

95 *Large Torso*

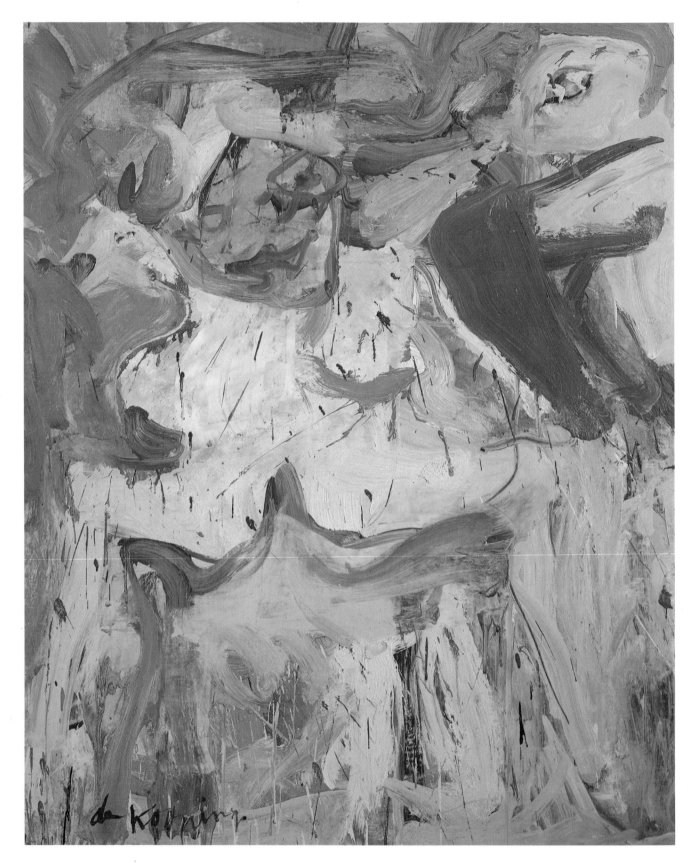

96 *The Visit*

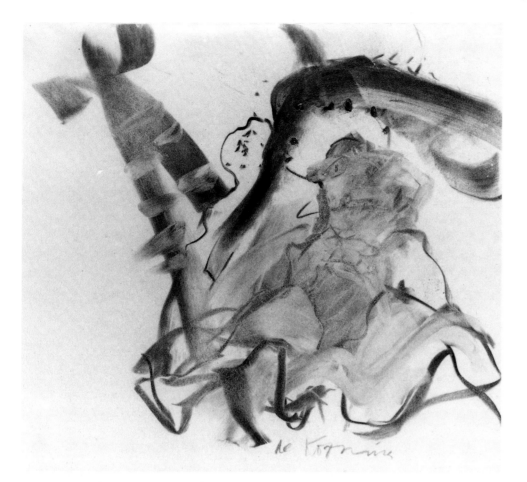

until he achieves a relationship between the parts that is both visually and emotionally compelling.

Although the drawings and paintings of the 1960s have a close family relationship to one another, and the drawings were in many instances the inspiration or catalyst for the paintings, they differ in one important respect. The images in the drawings, usually of one or two figures, tend to be clustered together, alternating between filling the page or leaving some of the pristine surface of the paper untouched. The compact forms in such drawings as *Untitled (Figures in a Landscape)*, 1966–67 (pl. 97), serve both as inspiration for his paintings and a prediction of the sculpture de Kooning began in 1969. Moreover, the forms in the drawings are often bunched off-center, resulting in a kind of composition that is at odds with the placement of the figures in the paintings, which, if not always centered, are at least symmetrically disposed and parallel to the horizontal and vertical edges of the canvas. In the paintings the figures are spread out so that parts of the images are strewn over the entire surface of the canvas. In their allover surface articulation, the forms of these paintings relate both to the hidden imagery in the so-called "abstract" compositions of the late 1940s to early 1950s and the baroque calligraphic drawings of the late 1960s.

The sweeping curves of the more recent paintings contrast decidedly with the more angular structure of the fragmented but nonetheless compact forms of

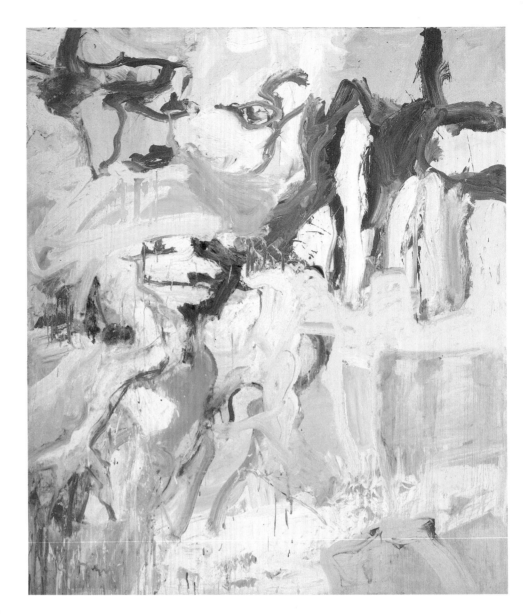

98 *Montauk I*

1969. Oil on canvas, 88×77″
Wadsworth Atheneum, Hartford
The Ella Gallup Sumner and
Mary Catlin Sumner Collection

99 *Flowers, Mary's Table*

1971. Oil on canvas, 80×70″
Collection Mr. and Mrs. Graham Gund, Cambridge

De Kooning's paintings of the 1970s are sometimes titled after specific objects or places; however, his work at this time recalls the abstraction inherent in his work of the late 1940s. All that remains of nature now is the sensation and reflection of its color and light.

the Women of the 1950s. The drawn line, so important in the earlier work, is not as prominent a feature of the paintings of the 1970s. Line is subsumed in the increasing painterliness and abandon of the whole. The function of the drawn or cut edge, which defined the boundaries of forms and separated them from one another in earlier paintings, is carried by de Kooning's use of color, light, and pigment. Much of this change in direction can be attributed to de Kooning's sensitivity to his new environment.

De Kooning works during the day in order to take advantage of natural light. His crammed studio, which has been compared to a ship, plays a part in the creative process: the juxtaposition of the paintings suggests innumerable possibilities for arranging and rearranging his compositions. Until recently, his technical process was one that he began in the late 1950s. He used oil paint thinned with water and adds kerosene, benzine, or safflower oil as a binding agent. Pigment is applied with house painter's brushes and then overlaid with sheets of pa-

THE LATE FLOWERING OF DE KOONING'S ART

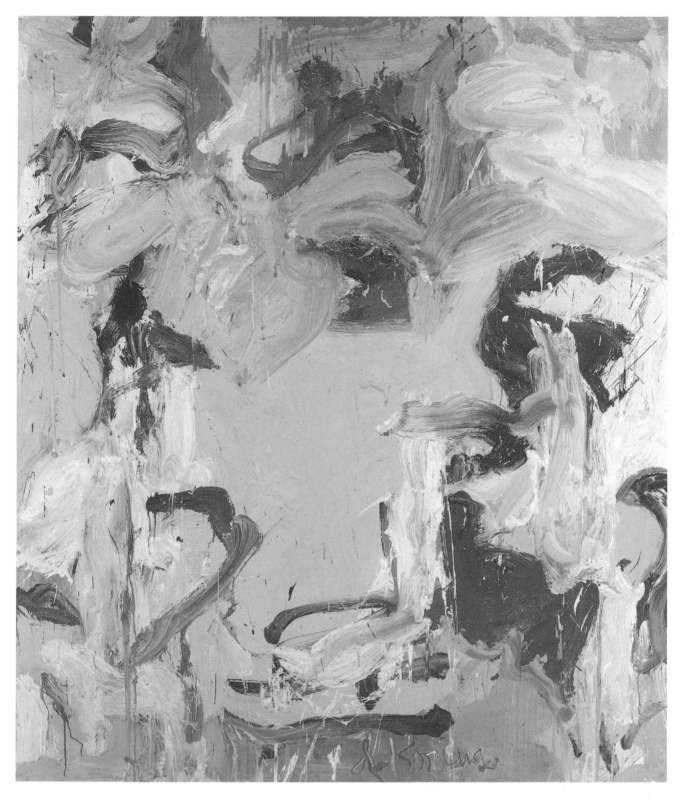

99 *Flowers, Mary's Table*

per, cardboard, or vellum, which are subsequently pulled off, leaving the surface free of brushstrokes but marked with the texture of the material that was placed upon it. This technique results in strong contrasts between velvety textures, rough, pitted surfaces, or blurred areas of paint and permits jumps from one area to another. De Kooning employs spatulas and knives for some of the smaller details, but the most remarkable elements of his enormous technical repertory are his unorthodox methods of applying and removing paint. The ultimate effect of these calculated procedures is freedom and improvisation, and nowhere is this spontaneity more evident than in his paintings of the mid-to-late 1970s.

Unlike the works of the late 1960s, which seem to bulge and strain the two-dimensional integrity of the picture plane, those of the mid-to-late 1970s are a marvel of innovation. They achieve a new reconciliation of three-dimensional form with the canvas surface and an even further integration of figure with landscape. The "no-environment" of the earlier work, the subsequent emphasis upon the figure, upon landscape, and finally the integration of Woman and landscape into Woman as landscape have given way to a new synthesis that is as close to abstraction as the efforts of the late 1940s.

When de Kooning first settled in the Hamptons, he was so carried away by the light and color that he attempted to incorporate the feeling of the place quite literally in his paintings. As he remarked:

I even carried it to the extent that when I came here I made the color of sand—a big pot of paint that was the color of sand. As if I picked up sand and mixed it. And the grey-green grass, the beach grass, and the ocean was all kind of steely grey most of the time. When the light hits the ocean there is kind of a grey light on the water.... Indescribable tones, almost. I started working with them and insisted that they would give me the kind of light I wanted. One was lighting up the grass. That became that kind of green. One was lighting up the water. That became that grey. Then I got a few more colors, because someone might be there, or a rowboat, or something happening. I did very well with that. I got into painting in the atmosphere I wanted to be in. It was like the reflection of light. I reflected upon the reflections on the water, like the fishermen do. They stand there fishing. They seldom catch any fish, but they like to be by themselves for an hour. And I do that almost every day (Rosenberg, 1972, p. 56).

The beaches, marshes, scrub oaks, and potato fields of The Springs, East Hampton, and Montauk and the image of Woman are still very much the basis of these canvases. But de Kooning has wrested from his environment elements of coolness, warmth, and sunlight and has made the tangible forms of figure and landscape submit to them, so that they appear almost as afterimages. Atmosphere fuses with and transfigures form. De Kooning's preoccupation in these paintings with the sensations and reflections of color and light may be compared to that of the late Monet. Since 1975, he has moved from the specific to the general, from concentration on particular areas to a more even articulation of the surface, away from shaping and placing colors and contours so that they resemble identifiable parts of the human anatomy or nature. Although some of the paintings of 1975 were given names that tied them to specific identifiable locations,

100 *Untitled I*

1975. Oil on canvas, 80×70″
Private Collection

In 1975 de Kooning embarked upon a succession of untitled works that suggest the breathtaking beauty of nature. Their vivid, richly impastoed surfaces nearly envelop the viewer in a highly charged atmosphere of color and light.

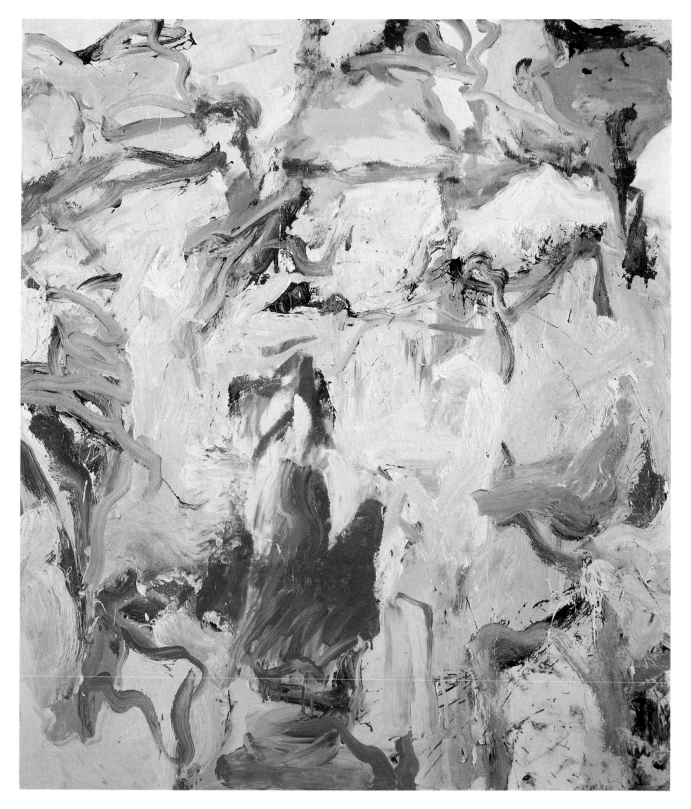

100 *Untitled I*

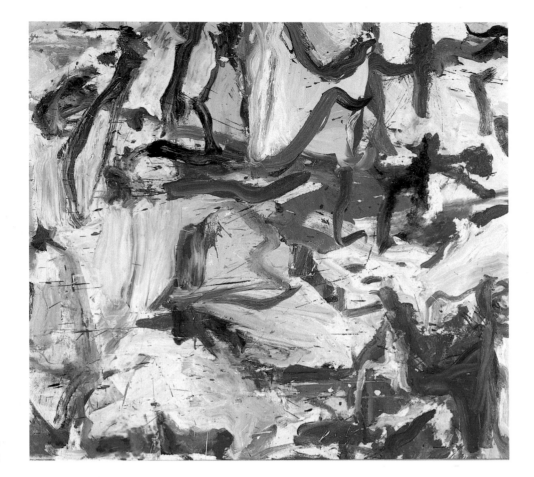

101 . . . *Whose Name Was Writ in Water*

1975. Oil on canvas, 77 × 88″
Solomon R. Guggenheim Museum, New York

102 *Untitled V*

1977. Oil on canvas, 79½ × 69¼″
Albright-Knox Art Gallery, Buffalo, New York
Gift of Seymour H. Knox, 1977

such as *Back Porch*, 1975, the work of the late 1970s is appropriately designated *East Hampton* or *Untitled*. Color may or may not suggest a figure, grass, or sky; freed from depiction, liberated from shape and contour, these paintings initially appear to be even more random than his earlier canvases. Like everything else he has touched, however, they are far from random, subject instead to his masterful control.

De Kooning himself, albeit rather reluctantly, said, "I guess I am an Expressionist" (Hess, 1967, p. 36) as he looked at one of his more distorted figures. Of course, the presence of distortion does not in itself define art as Expressionist. Indeed, Cubism combines elements of distortion with a rational structure, as Duchamp combines logic and the illogical; the Surrealists, order within disorder, the rational with the irrational.

Expressionism, as it is embodied in the work of such German painters as Max Beckmann, Ernst Ludwig Kirchner, Emil Nolde, Karl Schmidt-Rottluff, and others, often focuses to a large extent on the morbid or decadent aspects of life and may contain a significant element of social criticism. It often reflects a desire to communicate the individual's inner state, a highly emotional state of mind from which feelings of misery, pathos, and degradation emerge and dominate the more purely formal elements of art. While certain features of de Kooning's works, such as satirical and violent imagery and tempestuous brushstrokes, may be loosely categorized as Expressionist, the basic nature of his oeuvre defies easy

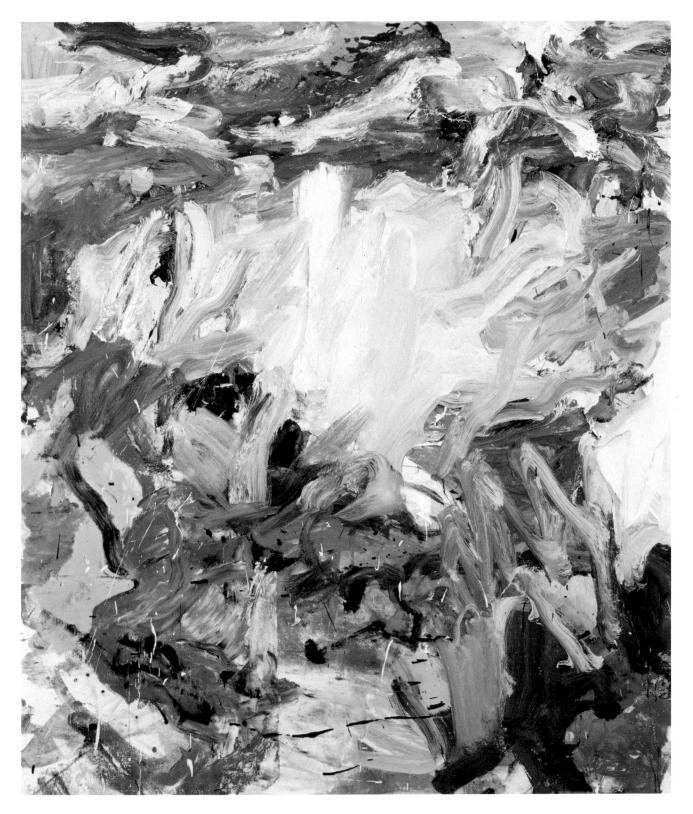

102 *Untitled V*

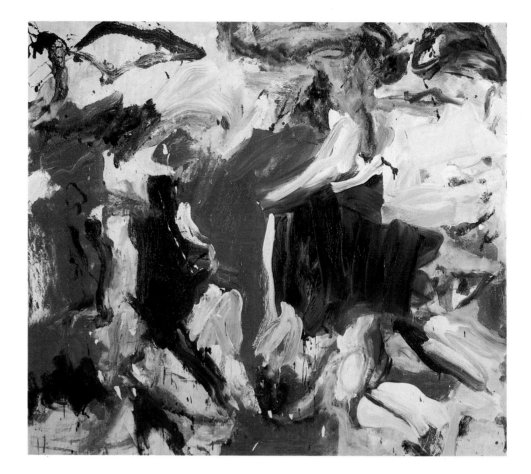

103 *Untitled V*

1976. Oil on canvas, 77 × 88"
Collection Mr. and Mrs. Oscar Kolin, New York

104 *Untitled X*

1977. Oil on canvas, 59 × 55"
Collection Mr. and Mrs. Graham Gund, Cambridge

categorization and, in fact, reflects a sensibility that embraces both classic and romantic tendencies. Wit, humor, and the element of parody, particularly important in de Kooning, have no place in the stormy Expressionist temperament. Nor does his appreciation of the American idiom—its pop culture—fit within the concept of the Expressionist. Moreover, de Kooning's isolation of his Women in a "no-environment" invests them with a sense of order sharply in contrast to agitated German Expressionist figures, which are usually shown in an unstable relationship with surroundings that are themselves in a state of turmoil.

It is more appropriate to point out de Kooning's relationship to El Greco and Chaim Soutine—two other artists who have been characterized as Expressionists but do not entirely fit into this tradition. De Kooning was drawn to the physicality and lusciousness of Soutine's paint. Soutine and de Kooning not only handle paint similarly but also treat their subjects in a remarkably like manner: whether a carcass of beef or a human figure, it is splayed out, frontal, straightforward. Although the art of both Soutine and de Kooning has been described as brutal, the savagery involved is not primarily in the attitudes the painters express toward their subjects but in their handling of material. Of the two, de Kooning is far more extreme in his treatment of subject and its materiality, especially where the Women are concerned.

No matter how radical, each artist salvages not the figure or landscape but traditional concepts of how such subjects should be treated. De Kooning's link is

104 *Untitled X*

105 *Untitled XIX*

1977. Oil on canvas, 80 × 70″
Collection Philip Johnson

106 *Untitled III*

1979. Oil on canvas, 60¼ × 54″
Margo Leavin Gallery, Los Angeles

evident not only to Soutine but beyond him to Rembrandt and the Baroque emphasis upon tactility, motion, and light as a dynamic force. El Greco appeals to de Kooning not by virtue of his tortured and twisted figures but because of his active paint handling and abstract forms. Of Soutine and El Greco, de Kooning has stated:

I've always been crazy about Soutine—all of his paintings. Maybe it's the lushness of the paint. He builds up a surface that looks like a material, like a substance. There's a kind of transfiguration, a certain fleshiness, in his work.

I remember when I first saw the Soutines in the Barnes Collection. In one room there were two long walls, one all Matisse and the other, all Soutine—the larger paintings. With such bright and vivid colors the Matisses had a light of their own, but the Soutines had a glow that came from within the paintings—it was another kind of light.

[El Greco is] someone else I've always liked. In his paintings the material is broken into only a few enormous planes. It's so much more interesting to look at than all those intricate creases painted so naturalistically by someone like Tintoretto (Staats and Matthiessin, pp. 70–71).

The East Hampton paintings of the 1960s and 1970s demonstrate that de Kooning, unlike most of his New York School colleagues but in the rare tradition of such masters as Monet and Matisse, has produced a great and innovative late body of work. In the 1950s he had established once and for all that the female form was as relevant to contemporary art as pure abstract subject matter. In the 1960s he continued to experiment with the female figure, depicting it as blonde Venus in paintings that are often compared to those of Rubens. As the New York works are infused with the feel of the city, so the East Hampton paintings convey the sense of the ocean. The hermetic space of New York is replaced by the atmospheric play of light as it bounces off the water. Indeed, de Kooning said of these canvases:

I'm working on a water series. The figures are floating, like reflections in the water. The color is influenced by the natural light. That's what is so good here. Yes, maybe they do look like Rubens. Yes, Rubens—with all those dimples.... I have to be careful not to make them look too watery (Quoted in Charlotte Willard, "In the Art Galleries," *New York Post*, August 23, 1964, p. 44).

De Kooning has habitually worked and reworked the surfaces of his canvases. In the process of painting *Woman I* he obliterated numerous other versions; this lengthy procedure was by no means unusual. In other paintings, such as *Asheville*, 1949 (pl. 55), de Kooning attached to the surface a piece of canvas he had taken from another painting. That, too, was not unusual. More recently, however, de Kooning has formed the habit of scraping down the entire surface, leaving a film of paint as a residue of the first stage of working. From this residue, as from his earlier letters or words, he culled images that suggested yet other ways of beginning the painting anew. The process reminded him of his days as a house painter when he and his fellow workers would scrape the paint down to the plaster and begin again. The process also reminded him of his earlier days paint-

107 *Pirate (Untitled II)*

1981. Oil on canvas, 7′4″ × 6′4¾″
Collection, The Museum of Modern Art, New York
Sidney and Harriet Janis Collection Fund

In the 1980s thick, dense paint surfaces have given way to smoother, more transparent skins of paint. In these works the preponderance of white and yellow fills them with light.

107 *Pirate (Untitled II)*

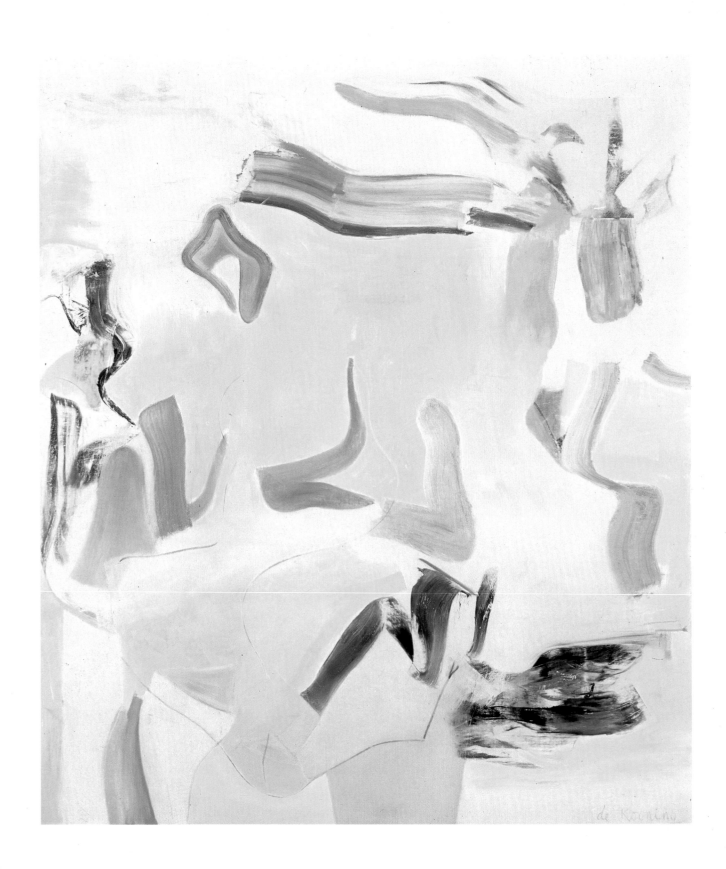

108 *Untitled III*

1981. Oil on canvas, 88 × 77″
Hirshhorn Museum and Sculpture Garden
Smithsonian Institution, Washington, D.C.
Partial gift of Joseph H. Hirshhorn by exchange
and museum purchase, 1982

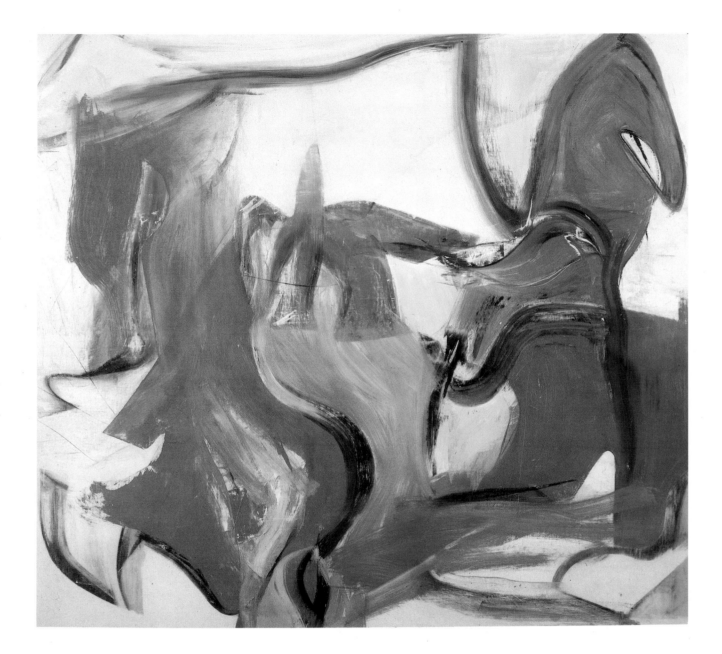

109 *Untitled XII*

1982. Oil on canvas, 70 × 80″
Courtesy: Xavier Fourcade, Inc., New York

Like many of de Kooning's works of the early 1980s, this painting is filled with large patches of color. The broad black lines recall de Kooning's use of black in his Women paintings of the 1940s and underscore his superb draftsmanship.

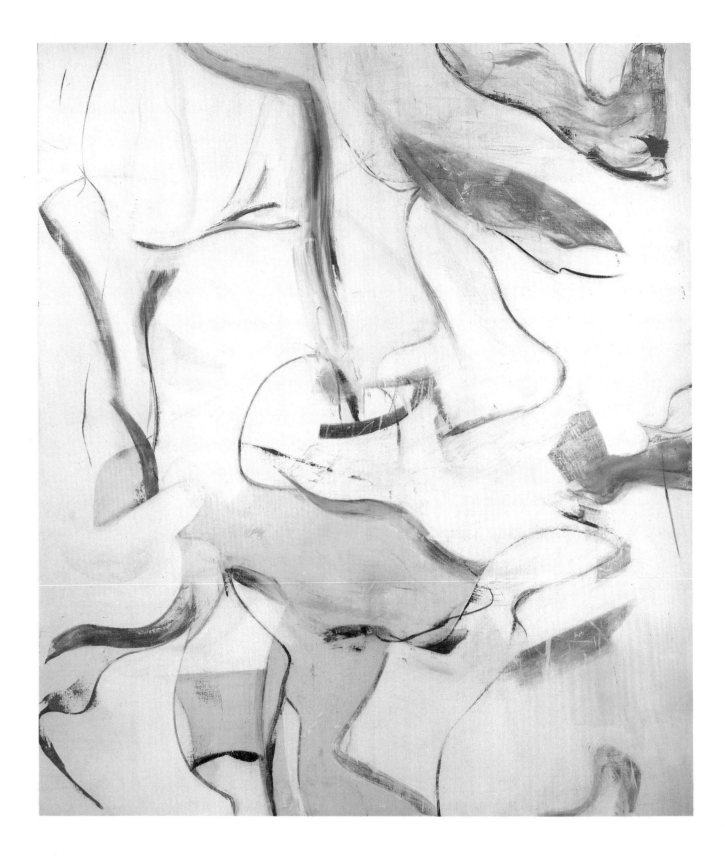

110 *Morning, The Springs*
(formerly *Untitled I*)

1983. Oil on canvas, 80 × 70″
Stedelijk Museum, Amsterdam

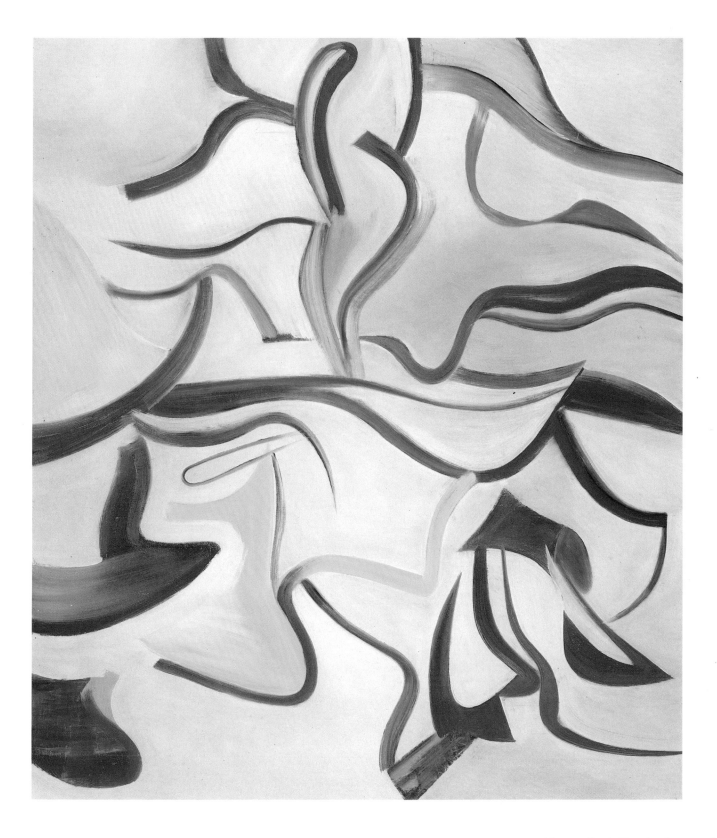

111 *Untitled XVII*

1984. Oil on canvas, 80 × 70"
Courtesy: Xavier Fourcade, Inc., New York

About 1982 de Kooning began painting on a white ground, producing intensely luminous works. His earlier broad swaths of color were reduced to thin, almost calligraphic lines. The masterful handling of expressive line, now in color, recalls de Kooning's earlier charcoal drawings.

ing trompe-l'oeil effects, marbleizing, and so on. It also reminded him that he had an ancestor in Braque, who had learned to paint imitation marble while working for his father. De Kooning was fascinated by their parallel training and the way in which both painters had put their craft at the service of their art.

In conversation, de Kooning mused on the meaning of art versus artifice, how much demeaned both craft and artifice had become in the modern world, and how honorable and noble such traditions had been in the past. On yet another day he had been investigating the origins of the words "to draw," interpreting drawing as literally dragging or pulling, emphasizing the making of a mark rather than the conceptual idea of drawing as a scheme to be executed from plan by assistants. For de Kooning, the method and the meaning are still open to question; the end is just the beginning.

De Kooning's late style has persisted now for over a decade. The paintings of the 1980s form a distinct contrast to those of the mid-to-late 1970s in their openness, their whiteness, their emptying out of all but essential shape, line, and color. Now de Kooning has used color as stroke, color as area or shape, color—usually white—as plane. The ferocious struggle for identity that erupted in the Women series of the early 1950s has ceased to interest the master painter. In the most recent paintings, as in such works of the late 1930s as *Elegy*, there is once again a spirited and animated response to organic form.

Like Picasso, de Kooning revels in the human figure; here, as before, de Kooning's images alternate between the erotic and the ambiguous. The vocabulary of forms is clearly de Kooning's, but there are some surprises: several of the most recent paintings allude to a figure that may have been posed for the artist or to figures in a landscape used in such a way that they are unfamiliar to the viewer. References to Gorky, Picasso, Matisse, and Cézanne—his friends and heroes—abound in these works.

Equally new is the way in which de Kooning articulates a canvas, positioning his forms so that they build out from the center, congregate at the edges, cascade from one or another perimeter of the painting. As before, however, there is symmetry and balanced asymmetry. As is his custom, de Kooning works with the near square, using canvases that measure 70×80″ or 77×88″. His expressed preference for the near square has, characteristically, been thought through: it allows the artist the feeling of intimacy that he has always sought in his work. These late canvases reiterate de Kooning's need for intimacy. Here, however, he brings us even closer to the picture, allowing us to share his pleasure in the human form, in line, color surface, and the voluptuousness of paint. In these recent works de Kooning reveals a new lyrical dimension in his oeuvre and reaffirms his central position in American art. Exuberant, free, and innovative, they are a great late flowering of his painting.

112 *Untitled V*

1986. Oil on canvas, 77 × 88″
Courtesy: Xavier Fourcade, Inc., New York

112 *Untitled V*

Chronology

1904 Born April 24 in Rotterdam to Leendert and Cornelia Nobel de Kooning. His father owns a wine and beverage distribution company; his mother owns a bar.

1909 Parents divorce. Court assigns Willem to his father, but his mother appeals the decision and wins custody.

1916 Leaves grammar school and is apprenticed to the local commercial art and decorating firm of Jan and Jaap Gidding. Attends night classes at the Rotterdam Academy of Fine Arts and Techniques for the next eight years. His training combines academic discipline and craft skills, fine and applied art. Influenced by Professor Jacob Jongert, a teacher at the Academy.

1916–24 Wins the State Academy Award and Silver Medal, Academy of Plastic Arts.

1920 Leaves the Giddings to work with Bernard Romein, art director and designer for a Rotterdam department store. Through Romein becomes acquainted with Jugendstil, de Stijl, Piet Mondrian, Jan Toroop, Frank Lloyd Wright, the Paris modernists, and Walt Whitman.

1924 Travels to Belgium with friends. Visits museums and studies at the Académie Royale des Beaux-Arts, Brussels, and the Van Schelling Design School, Antwerp. Supports himself by working at various jobs, including painting signs, designing window displays, and drawing cartoons.

1925 Returns to Rotterdam and completes his studies at the Rotterdam Academy. Graduates as a certified artist and craftsman. Decides to leave Holland.

1926 First issue of *Cahiers d'Art*, founded by Christian Zervos, is published in Paris in January: important link for American artists to European avant-garde. In 1926 articles appear on Giorgio de Chirico, Fernand Léger, Joan Miró, Pablo Picasso, and others.

 Emigrates illegally to the United States on the *S.S. Shelly* with the intention of becoming a commercial artist. Arrives in Newport News, Virginia, on August 15. Then travels to Boston; Rhode Island; South Street Seaport, New York; and settles in Hoboken, New Jersey, at a Dutch seamen's home, with the help of a friend, Leo Cohan. Works as a house painter.

1927 First issue of *Transition* is published in Paris in April: devoted to contemporary literature, drama, cinema, art; subsequent number includes first English translation of poems by Paul Eluard. Reproductions of work by de Chirico, André Masson, and Miró appear in late 1920s and 1930s.

 The Gallery of Living Art, New York University, opens at Washington Square in December: Albert E. Gallatin's collection of works by artists "living or recently deceased" includes Georges Braque, Giorgio de Chirico, Joan Miró, and Pablo Picasso.

 Moves to New York City and lives on West Forty-second Street.

 Sees Matisse show, which is important to his development, at Dudensing Gallery, New York.

1928 Wildenstein & Co., New York, presents "Loan Exhibition of Paintings by Paul Cézanne" in January.

 Dudensing Gallery presents "De Chirico," his first one-man exhibition in the United States, in January and February.

 Spends summer at artists' colony in Woodstock, New York.

1929 Meets John Graham in March at the opening of his exhibition of oil paintings at Dudensing Gallery.

 The Museum of Modern Art, New York, opens in November with its first loan exhibition: "Cézanne, Gauguin, Seurat, Van Gogh."

1930	The Museum of Modern Art exhibition "Paintings in Paris," from January to March, includes fifteen Picassos, eleven Matisses, several de Chiricos, Légers, and Mirós.
	Valentine Gallery (formerly Dudensing Gallery) presents "Joan Miró," his first solo exhibition in the United States, in October and November.
	John Graham begins yearly trips to Paris; becomes friendly with Picasso, André Breton, and Paul Eluard. He keeps friends in New York abreast of artistic developments in Europe.
Early 1930s	Meets Arshile Gorky and Stuart Davis. Gorky becomes one of his closest friends. Together they visit the Metropolitan Museum of Art, the Frick Collection, and galleries and pore over reproductions.
1930s	Works as assistant painter at American Music Hall Night Club.
1931	"Abstractions of Picasso" at Valentine Gallery, New York, in January.
	"Fernand Léger" at Durand-Ruel Inc., New York, in February.
	"Newer Super-Realism," first major Surrealist exhibition in the United States, opens at the Wadsworth Atheneum, Hartford, Connecticut, in November; travels to Julien Levy Gallery, New York, as "Surrealist Group Show," in January, 1932. Includes Joseph Cornell, de Chirico, Salvador Dali, Max Ernst, André Masson, Miró, and Picasso.
1932	Pierre Matisse Gallery, New York, mounts first of almost yearly one-man exhibitions of Miró's work, of great interest to de Kooning and Gorky.
	Julien Levy Gallery presents exhibitions of Man Ray and Max Ernst.
1934	Julien Levy Gallery presents "Abstract Sculpture by Alberto Giacometti," his first one-man exhibition in the United States, in December.
	Begins a series of color abstractions, often with dominant ovoid shapes, for example, *Untitled*, c. 1934. Continues this work through 1944, concurrent with figurative imagery.
	The Artists' Union, which publishes *Art Front* through 1937, is formed in New York; de Kooning, Gorky, Graham, Davis, and Mark Rothko are among the members.
1935	The W.P.A. Federal Art Project is established in August, with Holger Cahill as director. De Kooning joins the Mural Division, which is supervised by Burgoyne Diller. Involved in a mural project for the Williamsburg Federal Housing Project in Brooklyn (three studies extant; never executed). Leaves W.P.A. after one year because he is not a U.S. citizen. Works for one year under Fernand Léger on a project for the French Line pier (never executed). Decides to commit himself to painting full-time.
1936	Participates in preliminary discussions in January at Ibram Lassaw's studio about the need to establish a group of abstract artists, which results in the formation of the American Abstract Artists; he does not participate in A.A.A.'s first exhibition in 1937.
	"Cubism and Abstract Art," organized by Alfred H. Barr, Jr., is presented at the Museum of Modern Art from March to April.
	His work included for the first time in a museum exhibition, "New Horizons in American Art," presented by the Museum of Modern Art in September and October; other artists represented are Davis, Ilya Bolotowsky, Balcomb Greene, and Gorky. Exhibits a study for a mural for the Williamsburg Federal Housing Project.
	Julien Levy publishes *Surrealism*, the first book in the United States on this subject.
	"Fantastic Art, Dada, Surrealism," organized by Alfred H. Barr, Jr., is presented at the Museum of Modern Art from December to January, 1937.
	Moves to 143 West Twenty-first Street. Neighbors include photographer Rudolph Burckhardt and dance critic and poet Edwin Denby, who becomes one of the first collectors of de Kooning's art. Meets the art critic Harold Rosenberg about this time.
	Begins series of men in interiors, c. 1936.
1937	Receives commission through Burgoyne Diller to design one section of a three-part mural, *Medicine*, for the 1939 New York World's Fair Hall of Pharmacy.
	Meets Elaine Fried, an art student, who becomes his student. Meets musician Max Margulis; other friends and acquaintances at this time include Bolotowsky, Byron Browne, Francis Criss, Davis, Philip Guston, Jan Matulka, George McNeil, David Smith, and Barnett Newman.
	The Solomon R. Guggenheim Museum is incorporated in the State of New York and endowed to operate the Museum of Non-Objective Painting.
	John Graham's *System and Dialectics of Art* is published in New York.
Late 1930s	Constructs a mannequin from which he often draws.
c. 1938	Begins first series of Women, which culminates in *Pink Lady*, c. 1944.

1939	First United States exhibition of Picasso's *Guernica* at Valentine Gallery in May.
	"Picasso: Forty Years of His Art," an exhibition pivotal to de Kooning's development, is presented at the Museum of Modern Art from November to January, 1940.
	The Museum of Non-Objective Painting opens; renamed the Solomon R. Guggenheim Museum in 1952.
	Meets Fairfield Porter through Edwin Denby.
	Paints *Elegy*, c. 1939.
c. 1939–40	Meets Franz Kline, who becomes his best friend, at Conrad Marca-Relli's studio at 148 West Fourth Street.
1939–42	Amédée Ozenfant, Stanley William Hayter, Fernand Léger, André Breton, Echaurren Matta, Kurt Seligmann, Yves Tanguy, Max Ernst, Salvador Dali, André Masson, Pavel Tchelitchew, and Piet Mondrian seek refuge in America during World War II.
1940	De Kooning's fashion illustrations appear in the March issue of *Harper's Bazaar*.
	Commissioned to design costumes and sets for Nini Theilade's ballet, *Les Nuages*, with music by Claude Debussy, for the Ballet Russe de Monte Carlo, performed at the Metropolitan Opera House on April 9.
	Exhibition of Matta's work at Julien Levy Gallery in April and May.
	First issue of *View*, the Surrealist magazine founded by Charles Henri Ford, is published in September; continues until 1947.
1941	The Museum of Modern Art presents first Joan Miró retrospective, organized by James Johnson Sweeney, and "Salvador Dali," organized by James Thrall Soby, from November to January, 1942.
	Designs murals for the U.S. Maritime Commission for *S.S. President Jackson*, American President Lines.
1942	First group gallery exhibition, "American and French Paintings," organized by John Graham for McMillen, Inc., a decorating firm, in January; includes Stuart Davis, Lee Krasner, Jackson Pollock, Picasso, Braque, and Matisse. De Kooning shows *Standing Man*, 1939.
	"Artists in Exile," an exhibition of work by fourteen artists, is mounted by the Pierre Matisse Gallery in March; includes Breton, Marc Chagall, Ernst, Léger, Jacques Lipchitz, Matta, Mondrian, Ozenfant, and Tanguy.
	"First Papers of Surrealism," an exhibition sponsored by the Coordinating Council of French Relief Societies, Inc., appears at the Whitlaw Reid Mansion in New York.
	Begins friendship with Pollock.
	Marcel Duchamp arrives in New York. In 1951 de Kooning will proclaim him "that one-man movement—for me a truly modern movement."
1943	Selected by George Keller for "Twentieth Century Paintings" exhibition in February and March at Bignou Gallery, New York, where he shows abstractions. *Elegy* is purchased by Helena Rubinstein.
	Marries Elaine Fried in December. Max Margulis is best man. Separated in 1956; reunited in 1979.
	Remodels studio on Fourth Avenue between Tenth and Eleventh streets.
1944	"Abstract and Surrealist Art in America," an exhibition organized by Sidney Janis in conjunction with publication of his book of the same title, travels throughout the United States. Opens in New York in November at Mortimer Brandt Gallery. Includes de Kooning, William Baziotes, Adolph Gottlieb, Robert Motherwell, and Mark Rothko.
	Moves to Carmine Street in Greenwich Village.
1945	Julien Levy Gallery mounts Gorky's first one-man exhibition in New York in March.
	Designs backdrop for dance by Marie Marchkowsky entitled "Labyrinth," performed at New York Times Hall on April 5, 1946.
	Paints larger abstractions with close-value colors, for example, *Pink Angels*, c. 1945.
	Begins to use enamel with oil, painting with increasing frequency on paper mounted on canvas.
c. 1946	Begins series of black-and-white abstractions using household enamels, which he continues until 1949, for example, *Light in August*.
1947–49	Second series of Women paintings, including *Woman*, 1948, which he continues until 1949.
1948	First one-man exhibition at Egan Gallery, New York, in April and May; shows primarily black-and-white abstractions begun around 1946. The Museum of Modern Art purchases *Painting*, 1948.
	Gorky commits suicide in July.
	Teaches during the summer at Black Mountain College, North Carolina, headed by Josef Albers. Renews acquaintance with Buckminster Fuller and John Cage.
	William Baziotes, David Hare, Robert Motherwell, and Mark Rothko establish a small cooperative school, called Subjects of the Artist, in a Greenwich Village loft; it includes a Friday-evening lecture series. The school is dissolved in May, 1949, but Tony Smith and others take over the loft and continue the Friday-

evening lectures as Studio 35—named after the address—until April, 1950. De Kooning participates occasionally and in February, 1949, delivers a lecture, "A Desperate View." The Club, a highly informal artists' organization, grows out of Subjects of the Artist; de Kooning is a charter member and often participates.

Included for the first time in the "1948 Annual of American Painting" at the Whitney Museum of American Art, New York, held from November to January, 1949; exhibits *Mailbox*, 1947. Subsequently included in the Annuals of 1949, 1950, 1963, 1965, 1967, 1969, 1972 and the Biennials of 1981 and 1987.

Meets art critic Thomas B. Hess.

Paints *Black Friday*.

1950 Robert Motherwell delivers de Kooning's lecture, "The Renaissance and Order," at Studio 35 in February.

Picketing of the Metropolitan Museum of Art, New York, in May by "The Irascible Eighteen"; among them are de Kooning, Baziotes, Adolph Gottlieb, Hans Hofmann, Kline, Motherwell, Pollock, Ad Reinhardt, Rothko, and Still, in protest of the museum's lack of interest in contemporary American art.

Selected by Alfred H. Barr, Jr., as one of six artists to be given one-man exhibitions surrounding a large John Marin retrospective at the XXV Venice Biennale, held from June to October. Finishes his largest abstraction, *Excavation*, in time for inclusion in the Biennale. Other work included in Biennales of 1954 and 1956.

Chaim Soutine retrospective at the Museum of Modern Art from October to January, 1951.

At invitation of Josef Albers commutes to New Haven as visiting critic at Yale University School of Art and Architecture for one semester (1950–51).

Begins *Woman I*, which is completed in 1952, first painting in third Women series.

1951 *Excavation* is the highlight of the installation of the Museum of Modern Art's "Abstract Painting and Sculpture in America" exhibition from January to March. Writes "What Abstract Art Means to Me," which is delivered at the Museum of Modern Art by Andrew Carnduff Ritchie at a February symposium in conjunction with the exhibition.

Second one-man exhibition in April at Egan Gallery presents color abstractions and enamel drawings; the show is reconstituted at the Arts Club of Chicago as a three-man exhibition with Pollock and Ben Shahn.

Wins the Logan Medal and Purchase Prize for *Excavation* in the "60th Annual American Exhibition: Paintings and Sculpture" at the Art Institute of Chicago in October.

Included in I Bienal do Museu de Arte Moderna, October to December, in São Paulo, Brazil, in the U.S. section organized by the Museum of Modern Art. Subsequently included in II Bienal in 1953.

1952 Included in the "1952 Pittsburgh International Exhibition of Contemporary Art" at the Museum of Art, Carnegie Institute, in October. Also included in "Internationals" of 1955, 1958, 1961, 1964, and 1970.

1953 "Willem de Kooning: Paintings on the Theme of the Woman" at Sidney Janis Gallery, New York, in March and April. The Museum of Modern Art purchases *Woman I*, 1950–52, which soon becomes one of the most widely reproduced works of the 1950s.

First retrospective exhibition at the School of the Museum of Fine Arts, Boston, in April and May; travels to Washington, D.C.

Robert Rauschenberg erases a de Kooning drawing given to him by de Kooning.

1954 One of two painters selected by Andrew Carnduff Ritchie for the Museum of Modern Art to represent the United States in the XXVII Venice Biennale; shows twenty-six works.

Millionaire Huntington Hartford publishes a full-page letter, "The Public Be Damned?" in most major American newspapers in May. Attacking modern abstract artists, it singles out de Kooning and thereby gives him national publicity.

Included in "The New Decade: 35 American Painters and Sculptors" at the Whitney Museum of American Art from May to August.

Sells large group of pictures to Martha Jackson, who exhibits a selection of them in her New York gallery in November. Several are sold to West Coast dealers, who then show his work in the Los Angeles area.

1955 Begins series of abstract urban landscapes, such as *Gotham News*, c. 1955, and *Easter Monday*, 1955–56. Women and landscapes begin to merge. Paints *Composition*, 1955.

Participates in "1955 Pittsburgh International Exhibition of Contemporary Painting," October to December, at the Museum of Art, Carnegie Institute, which purchases *Woman VI*, 1953.

1956 One-man show of urban landscapes at Sidney Janis Gallery in April.

Included in XXVIII Venice Biennale, "American Artists Paint the City," June to September. Organized by Katharine Kuh for the Art Institute of Chicago.

147

Daughter, Lisa, is born.

Subject of documentary film.

1957 Makes first print, an etching for Harold Rosenberg's poem "Revenge"; published in 1960 by the Morris Gallery, New York, in the portfolio of *21 Etchings and Poems*.

Begins painting large abstract landscapes with simpler forms, some named after highways, for example, *Palisade*, 1957; continues until 1963.

1958 Moves to a larger loft at 831 Broadway. Makes brief visit to Venice. Visits David Smith at Bolton Landing and Josef Albers in New Haven.

1959 One-man show of parkway and landscape abstractions at Sidney Janis Gallery in May.

Exhibits at "Documenta II" in Kassel, Germany, July to October. Subsequently included in Documenta exhibitions of 1964 and 1977.

Spends time in Southampton, New York, during summer. Does series of crayon drawings.

1959–60 Spends winter in Rome. Works in the artist Afro's studio on the via Margutta. Makes abstract black enamel drawings on paper.

1960 Elected to the National Institute of Arts and Letters, New York, in May.

Visits San Francisco. Makes first two lithographs in black and white at the invitation of Nathan Oliveira and George Mayasaki at the University of California, Berkeley.

Begins fourth series of Women paintings; continues through 1963.

1961 Included in the Solomon R. Guggenheim Museum's October–December exhibition "American Abstract Expressionists and Imagists," organized by H. H. Arnason.

Buys a cottage in The Springs, East Hampton, New York, from Peter Fried, his brother-in-law, and starts to build a studio.

1962 "Recent Paintings by Willem de Kooning" at Sidney Janis Gallery in March.

Becomes a United States citizen in March.

Two-man exhibition, with Barnett Newman, at Allan Stone Gallery, New York, in October and November. Subsequently exhibits at the gallery in 1964, 1965, 1966, 1971, and 1972.

1963 *Pastorale*—the last painting executed in his New York studio prior to his permanent move to The Springs —concludes the large landscape abstraction series.

In June moves permanently from his loft on Broadway to The Springs.

Begins his fifth series of Women paintings, including *Clamdiggers*, 1964.

1964 Receives the Presidential Medal of Freedom from President Lyndon B. Johnson in September.

Participates in "Guggenheim International Award 1964" exhibition at the Solomon R. Guggenheim Museum.

Begins painting Women on door panels, for example, *Woman, Sag Harbor*.

1965 Files suit on March 30 against dealer Sidney Janis for breach of contract.

First United States museum retrospective, held at Smith College, Museum of Art, Northampton, Massachusetts, in April and May.

1965–67 Paints Women singly and in pairs in poses that grow increasingly animated. Begins enormous series of very free charcoal drawings of figures.

1967 Participates in "XXIIIè Salon de Mai" at the Musée d'Art Moderne de la Ville de Paris in April and May and in "Dix Ans d'Art Vivant, 1955–65" at Fondation Maeght, Saint-Paul-de-Vence, from May to July.

Included in "Two Decades of American Painting," organized by the International Council of the Museum of Modern Art, from June to July. Subsequently presented in the Far East, India, and Australia.

"De Kooning: Paintings and Drawings Since 1963" at M. Knoedler & Co., New York. Subsequent exhibition at gallery in 1969.

1968 Visits Paris in January with Thomas B. Hess and the art dealer Xavier Fourcade prior to first one-man European exhibition at M. Knoedler & Co., Paris, in June. Sees an Ingres exhibition at the Musée du Petit Palais and visits the Louvre and Fontainebleau for the first time. Returns to New York via London, where he meets Francis Bacon.

Returns to Holland for the first time since 1926 to attend the September opening of his first major solo traveling exhibition at the Stedelijk Museum, Amsterdam, through November. Organized by Thomas B. Hess for the Museum of Modern Art, New York, the show travels to London, New York, Chicago, and Los Angeles. Awarded the first Talens Prize International in Amsterdam.

1969 Travels to Japan in January with Xavier Fourcade. Visits Osaka with artist Isamu Noguchi to see the waterworks he is building for the World's Fair. Becomes interested in Japanese drawing methods and materials.

Travels to Spoleto, Italy, in June for one-man exhibition, "de Kooning: Disegni," at the XII Festival dei Due Mondi at Palazzo Ancaiani. In Rome executes first small sculptures in clay, which are later cast in bronze with the help of Herzl Emmanuel, who has recently bought a small foundry.

Begins Montauk series, for example, *Montauk I*.

Begins to make large-scale sculptures based on figures, for example, *Seated Woman*, 1969–80.

1970 At sculptor Henry Moore's urging, begins work on enlarging small sculptures in different materials (including polyester resin with a bronzelike coating).

1972 "Willem de Kooning: Selected Works" at Sidney Janis Gallery from October to November. Exhibition, part of the settlement of de Kooning's 1965 suit against the gallery, is the first to include sculpture.

1974 Receives the Brandeis University Seventeenth Annual Creative Arts Award, including $1,000 honorarium, on May 6.

In September Australian National Gallery, Canberra, purchases *Woman V* for $850,000, a record sum at that time for a work by a living American artist.

1975 "de Kooning: New Works—Paintings and Sculpture," his first one-man exhibition at Fourcade, Droll, New York, presented in October. His work is extensively shown at the gallery (renamed Xavier Fourcade, Inc.) in 1976 and through the late 1970s to the present.

Receives the Gold Medal for Painting awarded by the American Academy of Arts and Letters, New York.

Receives the Edward MacDowell Medal for "outstanding contribution to the arts" from the MacDowell Colony.

With Romare Bearden, Jacob Lawrence, and Bill E. Caldwell organizes the Rainbow Art Foundation to encourage young artists and printmakers.

Begins a new series of abstractions strongly reflecting his East Hampton environment.

1976 One-man exhibition of sculpture and lithographs presented by the Stedelijk Museum, Amsterdam, in March and April; travels with changes and additions to Duisburg, Geneva, and Grenoble.

1977 "Willem de Kooning: Paintings and Sculpture," an exhibition organized by the U.S. government's International Communication Agency and the Hirshhorn Museum and Sculpture Garden, Smithsonian Institution, Washington, D.C., opens at the Museum of Contemporary Art in Belgrade, Yugoslavia, in October and travels to eight European countries through summer, 1979.

The Arts Council of Great Britain organizes "The Sculpture of de Kooning with Related Paintings, Drawings and Lithographs," which is presented in London and Edinburgh.

1978 "Willem de Kooning in East Hampton," organized by Diane Waldman, presented at the Solomon R. Guggenheim Museum from February to April.

Elected to the American Academy of Arts and Letters, New York, in December.

1979 The Dutch government makes de Kooning an Officer of the Order of Orange-Nassau on his seventy-fifth birthday in April.

Joint recipient with Eduardo Chillida of the $50,000 Andrew W. Mellon Prize as part of the "Pittsburgh International Series: Eduardo Chillida/Willem de Kooning" at Museum of Art, Carnegie Institute; work by both artists exhibited from October to January, 1980.

1980 Included in "L'Amérique aux indépendants" at the Grand Palais, Paris, in March and April.

Included in "The Fifties: Aspects of Painting in New York" at the Hirshhorn Museum and Sculpture Garden, Smithsonian Institution, Washington, D.C., from May to September.

1981 Included in "Amerikanische Malerei, 1930–1980," organized by Tom Armstrong and presented at the Haus der Kunst, Munich, from November to January, 1982.

1982 Elected a member of the Akademie der Künste, West Berlin, in June. Becomes Associate Elect, National Academy of Design, New York. Made an honorary member of the Royal Academy for the Visual Arts, the Hague, on the occasion of its tercentenary.

1983 Retrospective of the past twenty-three years of work, "Willem de Kooning: The North Atlantic Light, 1960–1983," presented at the Stedelijk Museum, Amsterdam, May to July; travels to Denmark and Sweden.

"Willem de Kooning: Drawings, Paintings, Sculpture" presented at the Whitney Museum of American Art, New York, from December to February, 1984; travels to Berlin March and April, 1984, and to Paris June to September, 1984.

1984 Selection of works from the recent retrospective shown in May and June at Städelsche Kunstinstitut und Städtische Galerie, Frankfurt am Main, on the occasion of de Kooning's receiving the Max Beckmann Prize from the city of Frankfurt.

Included in Merian-Park, Basel, "Skulptur im 20 Jahrhundert" exhibition from June to September.

Exhibition at Das Mönchehaus Museum, Goslar, Germany, in September and October on the occasion of de Kooning's receiving the Kaissering.

Two Women, 1954–55, sets a new record when it sells for $1.98 million in an auction at Christie's, New York, in November.

Included in "La Grande Parade" at the Stedelijk Museum, Amsterdam, from December to April, 1985.

1985 Receives 1985 Governor's Arts Award from New York State Governor Mario Cuomo in May.

"Willem de Kooning, New Paintings: 1984–85" at Xavier Fourcade, Inc., New York, in October and November.

1986 "Willem de Kooning: Selected Drawings" at Margo Leavin Gallery, Los Angeles, in January and February.

Included in "The Painter-Sculptor in the 20th Century" at Whitechapel Art Gallery, London, from March to May.

Receives Mayor's Liberty Medal from New York City Mayor Edward I. Koch in July.

One of twelve recipients of the National Medal of Arts from United States President Ronald Reagan in July.

"Willem de Kooning: The Complete Prints" at Fabian Carlsson Gallery, London, in August and September.

"Willem de Kooning: Recent Paintings 1983–1986" at Anthony d'Offay Gallery, London, from November to January, 1987.

Photograph Credits

The author and publisher wish to thank the museums, galleries, libraries, and private collectors who permitted the reproduction of works of art in their possession and supplied the necessary photographs. Photographs from other sources (listed by page number) are gratefully acknowledged below.

Allan Stone Gallery, New York: 25, 30, 39; Rudolph Burckhardt, New York: 24, 53, 88–89; James Chambers: 80; Geoffrey Clements, New York: 21; David Anderson Gallery, New York: 20; Tom Ferrara, New York: 141, 143; Xavier Fourcade, Inc., New York: 18, 19, 35, 129, 132, 134, 135, 140; David Heald, New York: 72; Greg Heins: 127, 133; Scott Hyde, New York: 73; Bruce C. Jones, New York: 129, 132, 139, 140; Michael Katz: 49; Balthazar Korab, Troy, MI: 120; Paulus Leeser, New York: 25; Robert E. Mates, New York: 63; Frank Lotz Miller, New Orleans: 111; Museum of Fine Arts, Boston: 90; Betty and Stanley K. Sheinbaum: 44; Ivan Dalla Tana, New York: 135.

Selected Bibliography

MONOGRAPHS, CATALOGUES OF ONE-MAN EXHIBITIONS

ARKUS, LEON. *Willem de Kooning* (exhibition catalogue). Pittsburgh: Museum of Art, Carnegie Institute, 1979. Includes preface by Arkus, statements by and interview with the artist.

BLESH, RUDI, AND HARRIET JANIS. *De Kooning.* New York: Grove Press, 1960.

CUMMINGS, PAUL, JORN MERKERT, AND CLAIRE STOULLING. *Willem de Kooning: Drawings, Paintings, Sculpture* (exhibition catalogue). New York: Whitney Museum of American Art in association with Prestel-Verlag, Munich, and W. W. Norton & Company, New York, 1983.

GAUGH, HARRY F. *De Kooning.* New York: Abbeville Press, 1983.

HESS, THOMAS B. *Willem de Kooning.* New York: George Braziller, 1959.

———. *De Kooning: Recent Paintings* (exhibition catalogue). New York: M. Knoedler & Co., Inc., 1967.

———. *Willem de Kooning* (exhibition catalogue). New York: The Museum of Modern Art, 1968. Distributed by New York Graphic Society, Greenwich, Connecticut. Includes statements by the artist.

———. *Willem de Kooning Drawings.* Greenwich, Connecticut: New York Graphic Society, 1972.

LARSON, PHILIP, AND PETER SCHJELDAHL. *De Kooning: Drawings/Sculptures* (exhibition catalogue). Minneapolis: Walker Art Center; New York: E. P. Dutton, 1974.

ROSENBERG, HAROLD. *Willem de Kooning.* New York: Harry N. Abrams, Inc., 1974. Includes statements by and interviews with the artist.

SCHJELDAHL, PETER. *De Kooning: Paintings, Drawings, Sculpture 1967–1975* (exhibition catalogue). West Palm Beach, Florida: Norton Gallery and School of Art, 1975.

WALDMAN, DIANE. *Willem de Kooning in East Hampton* (exhibition catalogue). New York: The Solomon R. Guggenheim Museum, 1978.

Willem de Kooning: The North Atlantic Light, 1960–1983 (exhibition catalogue). Amsterdam: Stedelijk Museum, 1983. Includes foreword by Edy de Wilde and essays by de Wilde and Carter Ratcliff.

YARD, SALLY E. *Willem de Kooning: The First Twenty-Six Years in New York, 1927–1952.* Ph.D. dissertation, Princeton University, 1980. New York and London: Garland Publishing, Inc., 1986.

ARTICLES AND REVIEWS

ALLOWAY, LAWRENCE. "Sign and Surface: Notes on Black and White Painting in New York." *Quadrum,* no. 9 (1960), pp. 49–62.

———. "The Biomorphic Forties." *Artforum,* 4 (September 1965), pp. 18–22.

———. "De Kooning: Criticism and Art History." *Artforum,* 13 (January 1975), pp. 46–50.

DENBY, EDWIN. "My Friend de Kooning." *Art News Annual,* 29 (1964), pp. 82–99, 156. Reprinted as "Willem de Kooning" in Edwin Denby, *Dancers, Buildings and People in the Streets.* New York: Horizon Press, 1965.

———. Untitled essay. Patricia Passloff, ed. *The 30's: Painting in New York* (exhibition catalogue). New York: Poindexter Gallery, 1957, unpaginated.

GOLDWATER, ROBERT. "Master of the New." *Partisan Review,* 29 (Summer 1962), pp. 416–18.

GREENBERG, CLEMENT. "Art." *The Nation,* April 24, 1948, p. 448.

HESS, THOMAS B. "De Kooning Paints a Picture." *Art News,* 52 (March 1953), pp. 30–33, 64–67.

ROSENBERG, HAROLD. "The American action painters." *Art News,* 51 (December 1952), pp. 22–23, 48–50.

STEINBERG, LEO. "Month in Review: Willem de Kooning shows recent painting in 'Woman' series...." *Arts,* 30 (November 1955), pp. 46–48.

YARD, SALLY E. "Willem de Kooning's Women." *Arts,* 53 (November 1978), pp. 96–101.

———. "Willem de Kooning's Men." *Arts,* 56 (December 1981), pp. 134–43.

ARTIST'S STATEMENTS AND INTERVIEWS

DE KOONING, WILLEM. Letter to the editor (a tribute to Arshile Gorky). *Art News*, 47 (January 1949), p. 6.
———. "The Renaissance and Order" (talk delivered at Studio 35, New York, February 1950). Published in *Transformation*, 1, no. 2 (1951), pp. 85–87.
———. "What Abstract Art Means to Me" (talk delivered in conjunction with the exhibition *Abstract Painting and Sculpture*, The Museum of Modern Art, New York, February 5, 1951). *Bulletin of The Museum of Modern Art*, 18 (Spring 1951), pp. 4–8.
———. Statement. In *De Kooning Drawings*. New York: Walker and Company, 1967, unpaginated.
GOODNOUGH, ROBERT, ed. "Artists' Sessions at Studio 35 (1950)" (excerpts of round-table discussions at Studio 35, New York, April 1950). In Robert Motherwell and Ad Reinhardt, eds. *Modern Artists in America*. New York: Wittenborn Schultz, Inc., 1951, pp. 8–23.
HESS, THOMAS B. "Is Today's Artist With or Against the Past?" (interview). *Art News*, 57 (Summer 1958), pp. 27, 56.
RODMAN, SELDEN. "Willem de Kooning" (interview). In *Conversations with Artists*. New York: Devin-Adair, 1957, pp. 100–5.
ROSENBERG, HAROLD. "Interview with Willem de Kooning." *Art News*, 71 (September 1972), pp. 54–59.
STAATS, MARGARET, AND LUCAS MATHIESSIN. "The Genetics of Art" (interview). *Quest/77*, 1 (March–April 1977), pp. 70–71.
SYLVESTER, DAVID. "Painting as Self-Discovery," BBC broadcast, December 30, 1960. Transcript edited and published as "Content Is a Glimpse..." *Location* (New York), 1 (Spring 1963), pp. 45–53, and as "De Kooning's Women," *Sunday Times Magazine* (London), December 8, 1968, pp. 44–57.

OTHER PUBLICATIONS

ASHTON, DORE. *The Unknown Shore: A View of Contemporary Art*. Boston and Toronto: Little, Brown & Co., 1962.
———. *A Reading of Modern Art*. Cleveland: Case Western Reserve University, 1969.
———. *The New York School: A Cultural Reckoning*. New York: Viking Press, 1972.
HESS, THOMAS B. *Abstract Painting: Background and American Phase*. New York: The Viking Press, 1951.
HUNTER, SAM. *Art Since 1945*. New York: Harry N. Abrams, Inc., 1958.
———. *American Art of the Twentieth Century*. New York: Harry N. Abrams, Inc., 1972.
ROSENBERG, HAROLD. *The Tradition of the New*. New York: Horizon Press, 1959.
———. *The Anxious Object: Art Today and Its Audience*. New York: Horizon Press, 1964.
SANDLER, IRVING. *The Triumph of American Painting: A History of Abstract Expressionism*. New York: Praeger Publishers, 1970.
SEITZ, WILLIAM C. *Abstract Expressionist Painting in America: An Interpretation Based on the Work and Thought of Six Key Figures*. Ph.D. dissertation, Princeton University, 1955. Published for the National Gallery of Art, Washington, D.C., by Harvard University Press, Cambridge, Massachusetts, and London, England, 1983.

Index

Page numbers printed in *italic* refer to the illustrations.

153

154